Critical Acclaim for Wendy Hornsby

"Hornsby...won the Edgar award for Best Short Story with the title story in this collection.... Hornsby specializes in noir fiction, and this collection is a solid punch in the gut of noir. Her characters include the tough and the bent.... Edgy, menacing, and masterful..."
—*Booklist* [on *Nine Sons*]

"Hornsby has created a true heroine for our times—a professional woman who is intelligent, feminine but tough, clever without resorting to cuteness and as resourceful as a Navy SEAL with a Swiss Army knife. Long may she survive."
—Dick Lochte, *Los Angeles Times* [on *A Hard Light*]

"No mystery novelist since Raymond Chandler may have captured downtown Los Angeles the way Hornsby does.... In addition to writing with suspense and style, Hornsby shows an enormous humanity. The pathetic gallantry of burnt-out police comrades-in-arms, and the very real, very sexy romance between MacGowen and Flint all add depth and warmth to a pretty hard-boiled story. *Requiem* is a taut, emotionally charged mystery."
—Les Roberts, *Cleveland Plain Dealer* [on *77th Street Requiem*]

"Attention-grabbing, fast-paced entertainment: a story bristling with energy, striking characters, plot twists, filmmaking lore, sexy interludes, and a happy conclusion."
—*Kirkus Reviews* [on *Bad Intent*]

"Wendy Hornsby doesn't fool around. In *Midnight Baby* ...she lets her well-drawn characters speak their minds and bare their flaws. Refreshing... real and raunchy."
—Marilyn Stasio, *New York Times* [on *Midnight Baby*]

"Hornsby's cinematic eye for detail, witty dialogue, and credible surprise ending yield a compelling and evocative read."
—*Publishers Weekly* (starred review) [on *Telling Lies*]

WENDY HORNSBY

In the Guise of Mercy

A MAGGIE MacGOWEN MYSTERY

PERSEVERANCE PRESS / JOHN DANIEL & COMPANY
PALO ALTO / MCKINLEYVILLE, CALIFORNIA / 2009

A Perseverance Press Book
Published by John Daniel & Company
A division of Daniel & Daniel, Publishers, Inc.
Post Office Box 2790
McKinleyville, California 95519
www.danielpublishing.com/perseverance

Distributed by SCB Distributors (800) 729-6423

Book design by Eric Larson, Studio E Books, Santa Barbara,
www.studio-e-books.com
Cover design and illustration by Peter Thorpe

10 9 8 7 6 5 4 3 2 1

LIBRARY OF CONGRESS CATALOGING-IN-PUBLICATION DATA
Hornsby, Wendy.
 In the guise of mercy : a Maggie MacGowen mystery / by Wendy Hornsby.
 p. cm.
 ISBN-13: 978-1-56474-482-1 (pbk. : alk. paper)
 ISBN-10: 1-56474-482-5 (pbk. : alk. paper)
 1. MacGowen, Maggie (Fictitious character)—Fiction. 2. Women motion picture pro-
ducers and directors—Fiction. 3. Cold cases (Criminal investigation)—Fiction.
4. Street life—California—Los Angeles—Fiction. 5. Los Angeles (Calif.)—Fiction.
I. Title.
 PS3558.O689I6 2009
 813'.54—dc22
 2008055728

Paul Robinette
Always

In the Guise of Mercy

— 1 —

MONDAY BEGAN as an ordinary day. I won't say perfectly ordinary because we had long ago given up on perfect and, considering the circumstances, were happy enough to get just an ordinary day now and then.

Shortly after dawn I opened my eyes to find Mike watching me.

"How are you?" I asked.

"So far, okay," he said, holding out his arms to me. "How's my girl?"

"You're here, I'm fine." I moved against him and rested my head on his shoulder. There, with my eyes closed, still sleepy, listening to his heartbeat, I could pretend for just a few seconds that the latest round of chemo he had endured to earn a few extra decent months had worked some miracle and Mike was actually okay again.

Mike broke the spell when he spoke. "Maggie, who's coming over this morning? Rich?"

I had to think for a moment. Mike's friends took turns keeping him company during the day while I was at work; Mike had a long list of friends and a full calendar.

I said, "Yes, it's Monday, so it's Rich."

"Good, I want to talk to him about something."

"Nick is coming around noon," I said. "I'll be home by four."

"So I'm covered," he said.

"You're covered."

We got up and showered. I helped him dress in sweats and a T-shirt. Mike picked out a baseball cap from his collection, Cardinals that day, to keep his bald head warm and to cover the dent in his cranium where a piece of skull was missing. Last thing, he slipped on his wedding ring, putting it on his middle finger because he had lost so much weight that it slipped off his ring finger.

Rich Longshore was already in the kitchen when we got downstairs, standing at the stove stirring a pot of oatmeal. Rich and Mike became good friends years ago when they worked together on a serial murder case, Rich for the Los Angeles County Sheriff's Homicide Bureau, and Mike for the LAPD, Robbery–Homicide Division.

Rich retired from the County Sheriffs a year ago, but the department hired him back to work cold cases. On Mondays he went in late so that he could cover a shift with Mike.

"Good morning," I said, kissing Rich's freshly shaved cheek.

"Morning, Maggie. Hey, Mike, how does oatmeal sound?"

"I'll give it a try." Mike sat at the kitchen table, pale from the effort it had taken for him to walk down the stairs.

While I set out bowls, brown sugar, raisins, butter, and milk, Rich and Mike discussed the cold case Rich was currently working on, an unsolved murder, one they had both worked on at its beginning and had re-examined from time to time over the years.

All detectives, when they walk out the door for the last time, leave behind a few open cases that continue to haunt them. This was one that Rich was happy to have another chance at.

After a few minutes, Mike turned the conversation to one of his own troubling unsolveds, the one that most frequently kept him awake during the darkest hours of the night: About a decade ago, a teenage boy named Jesús Ramón got out of the backseat of Mike's official car at high noon in downtown Los Angeles, and was never seen again. Not dead. Not alive. Jesús just vanished.

As Mike and Rich plumbed the intricacies of evidence and witnesses, color came back into Mike's cheeks. There was a terrible thing growing inside Mike's head, but that Monday morning all the synapses in his brain were firing. Maybe he would manage to keep down some of his oatmeal, I thought, hopeful.

With Mike in Rich's care, I felt no guilt that Monday morning when I left for work. Indeed, when the two men started talking about detective work I was a bit of a third wheel. Besides, there were medical bills that had to be paid, a pile as big as the Ritz, and the only way we were going to chip away at them was if I kept showing up at the studios of the television network that pays me to make pithy documentaries, and somehow managed to finish my

next project on deadline. On that Monday morning I did not mention to Mike that, though the network's deadline loomed this side of the near horizon, I had made no progress on a coherent film.

As it began, that Monday wasn't exactly an ordinary day, after all; I hadn't seen Mike in such a happy frame of mind for months. When I kissed Mike good-bye and walked out the door, I had no presentiments about the day ahead.

Sometime during the morning Mike called his afternoon companion, his last partner in Robbery–Homicide, Nick Pietro, and told Nick that he had a doctor's appointment, told Nick not to come over until two o'clock. Then he told Rich that Nick would be a few minutes late, and that he would be fine alone for a bit after Rich left. In fact, he said, he would be taking a nap; what could happen?

Rich Longshore left at noon. Sometime between noon and two when Nick arrived, during that interim when Mike was alone, Mike laid out some files on his desk, banded together with a note on top, and a stack of letters addressed to his near and dear. He opened a very good bottle of pinot noir that we had saved for a special occasion, and poured himself a glass.

Carrying the wineglass in one hand and his service Beretta in the other, Mike went out to the backyard and sat down on the ground under our massive old avocado tree. There, under a magnificent leafy green canopy, on a beautiful spring afternoon, Mike Flint once again took control over the course of his life.

Mike sipped the wonderful wine. Then he set the glass safely aside before he leaned his head back against the tree, put the business end of his Beretta into his mouth, and kissed the world good-bye.

— 2 —

I KNEW the news was bad when a brace of gray-suited homicide detectives came to call on me at work. When I saw that one of them was the chief of LAPD Robbery–Homicide Division, Lt. Kenny Noble, Mike's boss, I knew the news was dire.

Guido Patrini, my production partner, escorted the pair into my cubbyhole of an office at the studio. One look at Guido's ashen face told me all that I really needed to know. He dropped to his knees beside my chair, wrapped his arms around me, and began to weep softly against my shoulder.

"Mike," I said, not a question, though I had many. I was fairly certain I knew the ultimate answer, whatever the details. In the past, if Mike had a medical emergency when I was at work, he was taken to the hospital and I got a phone call. No one needed to tell me that this time any emergency had passed and a phone call wasn't within protocol for delivering information of a certain gravitas.

"Maggie," was all Kenny managed to say before he choked up.

The second detective, Harvey Bing, a good friend, clapped a hand on the boss's shoulder as he tried to compose himself enough to deliver the message, but couldn't.

"Where is Mike?" I asked, patting Guido on the back—something to do with my hands.

The detective pair did some foot shuffling and exchanged panicky glances before Kenny cleared his throat.

"He's still at the house, Maggie," Kenny managed to croak. "In the yard."

"Did he..." I couldn't finish the question; a very vivid image flashed behind my eyes.

Kenny nodded. "He did."

Guido took my bottle of medicinal scotch out of the bottom

drawer, uncorked it and handed it to me. I swallowed a dose. The shock and burn of it reminded me to breathe.

"Mike seemed so fine this morning," I said, fighting against the black fog swirling at the edges of my vision. My little office was so full of gray worsted and starched white shirts that there didn't seem to be enough space for light to get in, let alone air. "I should have known. I should have stayed home this morning."

Harvey shook his head. "You had to leave the house sometime, honey. He would have waited you out. He didn't want you to be the one...."

At the thought of what had happened, Harvey choked back a sob.

Kenny took the bottle from me and handed it to Harvey, who threw back a goodly slug before returning the bottle for Kenny to have a shot, too.

"Who found him?" I asked.

Harvey shuddered. "Nick Pietro."

"Poor Nick. How cruel." I disentangled myself from Guido. "I need to get home."

"I'll drive you," Guido said. "Harvey said he'll follow us in your car."

I thought I was in better shape to drive than Guido was, but I didn't argue; when I stood, the room suddenly, unaccountably, tipped onto its side and bucked me off my feet.

— · —

Mike and I lived in a tall, narrow house built into the side of a mountain, overlooking a treacherous and primal canyon deep inside the Santa Monica Mountains about equidistant from the movie star beaches at Malibu and the 101 freeway that runs through the San Fernando Valley. An island of wilderness surrounded by LA sprawl. The road in is a winding, twisting, curvy tribute to engineering and plain chutzpah, and is just wide enough for one car to travel at a time.

For the last quarter mile up the hill, Guido had to navigate an obstacle course of official vehicles parked higgledy-piggledy along the steep edges of the road. Probably a dozen black-and-whites from the LAPD, a phalanx of the dark Crown Victorias detectives drive, a goodly representation of County Sheriff's SUVs—we

lived in the sheriff's jurisdiction—and in the driveway, a van from the county coroner. Guido managed to squeeze past the cars and make it up the steep driveway. Next to the horse corral we shared with the neighbor he found a flat spot big enough for us to park.

Our house was isolated enough that we didn't get much traffic. The appearance of one strange car made the horses—Mike's big gelding, Duke, my little quarter horse mare, Rover, and the neighbor's sorrel, Red—a little nutty. Not knowing what to make of this police armada, they ran in erratic figure eights from one end of their enclosure to the other, colliding, bucking, throwing off sweat and spit, crying out, nipping at each other, stomping their hooves. I was afraid they would hurt themselves.

When bad things happen, you deal with what comes your way in layers as they present themselves. The horses presented first. I got carrots out of the tack shed, fed them chunks off my palm, as did Guido, scratched their forelocks, talked to them. Distracted by their treats, they let us lead them into their stalls and lock them down. There was some muttering and stomping, some conversation among them before they settled their muzzles into the bundles of alfalfa hay we dropped into their feeding troughs.

"I know how they feel," I said to Guido, looking past the corral toward the house and the gauntlet of policemen, all eyes on us, that we would have to walk through to get inside. The officers didn't intend to be rude, I'm sure, but they are observers by nature, professionally nosy, trained to intimidate. I heard the crisp sibilance of their whispered conversations about what had happened and who I was, wafting my way like a noxious plume, a chorus of "Mike Flint, Maggie MacGowen," and wished I could buck and run from what certainly lay ahead.

I gripped Guido's arm for support.

Guido is a spare, wiry man, all sinew-wrapped bone, nothing cuddly about him. He is dear to me; we had worked closely together for many years. I let myself relax against him for just a moment, drew some support from him, before I took a deep breath and straightened up, mustering the courage to walk that path through Mike's colleagues.

Guido put a reassuring hand over mine and looked at me with such concern in his beautiful brown eyes that I teared up, finally.

"You'll get through this, Maggie," he said. "I know you, no matter what it is, you'll be okay, and I'll be here with you."

Guido has a face chiseled out of pure Italian marble, square jaw, high forehead, ridges for cheekbones, an anvil of a nose. Yet somehow, set into all that stone are big, lush Bambi eyes framed by long, curly black lashes. Doesn't matter what Guido is saying, when he turns his eyes on you, you have to believe him.

"I need a tissue," I said, drawing my shoulders back.

"Let's go in," he said, handing me a handkerchief that still had a dry corner.

For the number of people milling around outside, the house, inside, was oddly quiet. As soon as the front door closed behind us, Nick Pietro, Mike's partner, good friend, the man Mike set up to discover him in the yard, stepped out of Mike's home office. His eyes were red and swollen.

"I'm sorry," I said, walking into his outstretched arms.

"Me, too," Nick said, patting my back. "How you doing, honey?"

"I don't know yet," I said. "I'm numb."

"I understand that." He blew his nose into a handkerchief and wiped his eyes.

"I'm ashamed to say it," I said. "But I'm angry with Mike for putting you in this awful situation."

"No shame." He hugged me tightly for just a moment; his body quaked with profound emotion. "Sitting here waiting for folks to show up, I've had a little time to think things over. Mike left me a letter, and I think I understand. Some of it, anyway. I guess I should be proud he trusted me to…"

Nick's voice faltered.

"Where is he now?" I asked.

"Out back still. They're waiting for the coroner to sign off before they transport him." Nick held my arm as I turned to go. "You don't want to see Mike that way. Mike didn't want it."

Our backyard was a patio with a terraced mountainside behind it. I could hear people out there, voices and footsteps on the patio's stone pavers, something with wheels bumping along. I didn't need to see what was happening to know.

Guido excused himself and went off toward the back of the house. I knew he couldn't stay away. I also knew that Guido, the

filmmaker, had a couple of cameras in his shoulder bag. If I ever wanted to see them, there would be pictures.

Kenny and Harvey arrived just as Nick began showing me the papers that Mike left for us on his desk. There was a stack of neat files banded together with a note addressed to me, and a rank of envelopes addressed to various people. I saw one for Mike's son, Michael, and had to sit down. How was I going to tell Michael, a captain in the army, deployed to Afghanistan?

Mike left funeral instructions for Kenny. He had made arrangements with a cremation society. He asked for a simple service in the rock garden at the old Police Academy in Chavez Ravine followed by a send-off lunch at the banquet room where he had received his badge twenty-five years before. No bagpipes, no cortège of cop cars. No fuss. Drinks on Mike.

We all agreed that the funeral would take place the following Saturday morning. The police chaplain would officiate; Nick had already called the chaplain, who was on his way over. With my blessing, Kenny and Nick would take charge of arrangements.

I held the letter addressed to me, weighing it for a while before I could open it, curious but wary.

The bread-and-butter estate issues had long ago been taken care of. Mike and I had put the major part of our assets, this house and our cottage in Humboldt County, up on California's Lost Coast where we had planned to retire one day, and various bank accounts, into a living trust so that there would be no need for probate or a waiting period before assets could be tapped. He knew I would look after his father, Oscar, now resident in a VA care facility in Sonoma. I already had a copy of Mike's pour-over will and his power of attorney so that I could take care of anything else that arose.

With all the details covered, I expected that the thick letter in my hands would be a heart-wrenching, heartfelt outpouring of his grief over departing this life too soon and leaving me with so much to handle. I was surprised, when I began to read, to find instead that Mike had handed me one last job to take care of. A big one.

Mike asked me to find Jesús Ramón.

I picked up a little figure Mike kept on his desk, a netsuke no more than three inches tall, carved from ivory, that I bought him

when I was on an assignment in Japan. Malice in the guise of the Goddess of Mercy, it was called. The top part of the figure was a beautiful rendition of Kuan Jin, the Buddhist Goddess of Mercy, but peeking out through her graceful silk robes was the hideous face of Malice, pocked, weeping pustules, teeth like daggers.

With the figure in my hand growing warm, I sat down behind the big desk Mike had lugged home from a flea market one Sunday afternoon and read through his instructions. Mike wrote that he believed he was close to finding an answer, but that he had run out of time. Maybe, he wrote, fresh eyes, mine, would find that which had eluded him. Maybe people who wouldn't talk to a cop ten years ago would talk to me, a civilian, now. And there was a new lead, a potential bomb, to pursue, he said.

Nelda Ruiz, one of the original witnesses to the events of that day Jesús Ramón disappeared, had been paroled from the state prison for women at Frontera a month ago. Nelda never reported to her parole officer and had no known address. But a patrol sergeant named Harry Young who worked out of Central Division had a line on her whereabouts. I should follow that line, Mike wrote, maybe find Nelda. Away from the prison mafia and prison snitches, maybe she was ready to talk.

Most of the letter was his summary of the investigation to date, the mistakes that had been made, the good leads, the holes, the stone walls, and a long list of people to talk to and where to find them, if he knew where they were.

"Go back to the beginning and walk it down," he wrote. "And be careful who you trust. Watch six, Maggie. There are people who won't want anyone opening this up again."

Mike also asked me to take his ashes to the cottage in Humboldt County. If there was a heaven, he said, he wasn't sure he'd pass the entrance exam. The next best thing to heaven, he said, was the wild redwood coast where we'd built the cottage, and that's where he wanted to remain.

At the end of his letter Mike asked for forgiveness and made a declaration of love. He did it gracefully, intended to offer whatever comfort he could. I wasn't at all ready to be comforted, but I understood the decision he had made.

Kenny, Nick, and Harvey had all discreetly stepped from the

room to give me some privacy while I read Mike's letter. I could see Kenny standing just outside the office door, signing some forms on a clipboard held by a woman whose jacket identified her as a technician from the coroner.

I appreciated the time alone, in Mike's place, surrounded by his things. For just a few more moments, before he was taken away, I wanted to imagine that he might walk in, talk to me. Pushing back against the reality of the moment and what was happening outside our house, I took advantage of what I expected were the last quiet minutes I would have for a while and opened the top file folder to read the narrative from the initial investigation report.

Jesús Ramón disappeared the year before I met Mike, but I knew the story, I had read this report before, and I had lived with the fallout. I knew what the case did to Mike and to his reputation. A simple tale, it would seem, an obvious one: a gangbanger wandered into enemy territory and was made to disappear. But nothing is simple in the community politics of media-rich Los Angeles.

I read the investigation summary again, making notes on the back of my envelope, listing names, times, places. There was quite a cast of characters: a spoiled cop now serving a life sentence, witnesses who decamped for Mexico rather than talk, gangbangers who "never saw nothing." The case summary was a straightforward account, but there was never anything straightforward about the case itself.

I read: January 16, 1999, 1200 hours. The temperature was seventy-four degrees and dry. Service area of Central Division.

Sixteen-year-old Jesús Ramón, five feet four, one hundred and ten pounds, walked with his girlfriend, fifteen-year-old Teresa Galba, to his mother's *bodega* on Lake Street, west of downtown Los Angeles, to drop off a cousin's two-year-old daughter. At the *bodega*, Jesús bought a pack of Marlboro filters and promised his mother that he would stay out of trouble. The mother was well aware that her son's gang set, the Sleepy Lagoon Crips, was in a declared war with longtime rivals, the Thirteenth Street Bloods. Jesús promised he would take care of himself.

Walking arm in arm, Jesús Ramón and Teresa Galba left the *bodega* and turned west, walking toward Alvarado Avenue. They

arrived at the intersection of Alvarado Avenue and Lake Street just as Officer Eldon Washington, working an observation post near that intersection, observed nineteen-year-old Nelda Ruiz selling drugs out of a public telephone booth. Officer Washington placed Nelda Ruiz in custody.

As instructed during his morning briefing, Officer Washington called Detective Mike Flint, who wanted to question Nelda about a drug-related homicide committed the previous month. A drug dealer named Rogelio Higgins had been gunned down in the driveway of his Bel-Air home.

Officer Bonifache Erquiaga, working the gang detail, intercepted Officer Washington's call. He arrived at Alvarado Avenue at 1210 hours, transferred custody of Nelda from Officer Washington to himself, and put her, handcuffed, into the backseat of his patrol car. He told Officer Washington that he would transport Nelda to Parker Center, police headquarters, for a meeting with Mike.

Before Officer Erquiaga left the scene, however, Mike arrived. Mike sent Erquiaga ahead to Parker Center with Nelda, with instructions to hold her in an interview room until Mike got there.

At that point, Mike took Jesús into custody, handcuffed him, and put him into his own backseat, just for show. Jesús was one of Mike's gang snitches and Mike wanted to protect him in case any of his gang set had seen them talking. Jesús asked to be dropped off downtown where his aunt, who owed him money, ran a taco cart.

When Mike drove away with Jesús in his backseat, leaving the little girlfriend, Teresa Galba, standing on the sidewalk sobbing, Jesús was very much alive.

After Jesús got into Mike's car, myth and fact became so muddied by speculation, obfuscation, personal agenda and moral attitude that Jesús, the actual boy, a missing child, was forgotten. Out of the inevitable distortions that came from the endless telling and retelling of events imperfectly known, in his absence Jesús Ramón emerged as a sort of mythic giant, a symbol for something far larger than anyone who was present on Alvarado Avenue that January day could ever have imagined. His disappearance became a ten-ton gorilla on the back of the Los Angeles Police Department, and on Mike Flint's heart.

The others? Quite a cast. Boni Erquiaga was now serving a life

sentence for stealing drugs out of the LAPD evidence locker and selling them on the street; his girlfriend Nelda Ruiz drew twenty to life. Teresa Galba decamped to Mexico rather than testify before a grand jury that convened later to determine whether there was evidence that a crime had been committed. Eldon Washington retired.

"In remembrance of me," Mike had closed his letter, "find Jesús. No matter what you dig up, make it public. Do this one last thing for me."

His gift to me, and mine to him: I was going to go look for Jesús, and while I was doing it I was going to make one hell of a film. For both of us.

I folded Mike's letter and looked up at Kenny, who had been watching me.

"Need anything, Maggie?" Kenny asked.

"Just some time to think," I said. I didn't get that for a while.

The rest of the week was a blur. From Monday afternoon until the funeral was over on Saturday, the house was always full of people. My daughter, Casey, a freshman at UCLA, was the first to arrive, with her roommate, an hour after I called her. My mother and my aunt and a number of my childhood friends all flew down together from the San Francisco Bay Area that evening. My best friend and her husband flew in from New York on a red-eye flight. Mike's son, Michael, was on his way out of Afghanistan on the first flight that could be arranged. He arrived at the house very late Wednesday night, exhausted after forty-eight hours in transit. Every newcomer needed comforting, no matter the hour they arrived, as well as housing and meals until the funeral.

Friends, neighbors and the police chaplain organized pick-up trips to the airport, beds for out-of-towners, meals for the multitudes. Because there was no mortuary or viewing room to send people off to, the house was the hub. Parking on our narrow street became an issue, so overflow parking was arranged down at the old Ronald Reagan Ranch on Mulholland Highway, now part of the Malibu Creek State Park, and police cadets ran a shuttle service up the mountain to the house; the horses were taken down the road to a friend's stable until it was all over.

The press came and went Monday evening.

Flowers began to arrive as soon as word got out. By Tuesday noon, great profusions of flowers in baskets, in wreaths, in bright bouquets, covered the patio table and the ground underneath, lined the back steps and spilled across the barbecue island; Mike knew an amazing number of people. Again the chaplain came to the rescue. He arranged for the cadets shuttling people to also shuttle flowers to local hospitals and nursing homes and to the homes of injured or ailing police and firemen across the county. Cards, a basket full of cards.

I walked through every day like a somnambulist, fell into bed every night, started over the next morning. People talked to me; I don't know what they said. Now and then I managed to slip into Mike's office to read through his Jesús files, but I couldn't concentrate. Everything in his room distracted me, became the seed from which a new problem would sprout. What would I do with his cap collection? His softball trophies? His mug full of pens?

The funeral went according to Mike's instructions; Mike would have been pleased. Immediately after the funeral lunch at the Academy, houseguests began to make their way home. Suitcases went out the door. Bedding from stripped beds went into the wash. Flowers stopped arriving. Even the telephone took a rest.

On Sunday morning Michael, Mike's son, borrowed his father's car and drove, with my mother for company, up to Sonoma to visit his grandfather, Oscar; Michael would remember the visit even if Oscar did not. After breakfast, my daughter, Casey, and her roommate, Zia, and our next-door neighbor, Early Drummond, walked down the road, fetched the horses, and brought them home. Then the girls got into their car and went back to school. As I stood on the driveway waving after them, I felt a wave of panic. Suddenly, I was alone.

I went up the stairs and sat on the front deck for a while, looking out across the canyon, and tried to decide what to do first. Exhausted, I dozed off. I slept until Duke set up a fuss. I went to the rail to see who or what was coming up the road.

Kenny Noble, Nick Pietro and Harvey Bing got out of a civilian car wearing casual Sunday clothes, jeans and Hawaiian print shirts.

"Morning," I said, relieved to have company though a couple of days earlier I had longed for solitude. "Come on up. There's coffee. Is it too early for a beer?"

Harvey opened the back car door and lifted out a white box and handed it to Kenny, the boss. The box could have held a small hat, but from the careful way Harvey handled it and Kenny carried it, its contents had to be fragile. I was curious. They were oddly subdued as they followed me inside.

Kenny looked around for a place to put the box.

"What do you have there?" I asked.

"Kenny, Nick and I drove down to San Pedro last night," Harvey said, looking to the others for help.

"Maggie," Nick said, "we went down and picked up Mike's remains from the crematorium. His urn is in the box." Nick handed me a manila envelope he had tucked under his arm. "The death certificates, honey. We got you eighteen copies. You'll need them."

We decided the mantel was the appropriate place for the box until I could get up to the Humboldt cottage with it, as Mike had requested. Kenny placed the box ceremoniously and we had a quiet, awkward moment, after which we retreated to the kitchen for coffee.

I set a carton of milk on the kitchen table in front of Kenny. "Where is Boni Erquiaga now?"

"Corcoran," he said. "In a high-power segregation unit the California State Department of Corrections set aside for convicted ex-cops."

"Can you get me in to Corcoran to talk to Boni?"

Kenny frowned, puzzled. "Why in the world?"

"Did you know Nelda Ruiz was paroled?"

Kenny turned to Harvey. "Didn't you testify against her at the Parole Board a couple months ago?"

"Guess they weren't listening," Harvey said. He narrowed his eyes, watching me, as he thought that over. "You want to talk to Boni about Nelda?"

I nodded. "Mike asked me to."

"You can arrange a press visit, Maggie," Kenny said. "You don't need me. Anyway, my signature might complicate things between you and Boni."

Clutching my mug, I said, "I don't have time to wait for approval for a press visit. That can take weeks. Months."

Kenny glanced at Harvey. "What did Boni draw?"

"Twenty-five-to-life for stealing cocaine out of the police evidence locker and selling it, followed by life with possibility of parole for ordering a hit on a witness. That adds up to pretty much the rest of his miserable life."

"Okay, so he's not going anywhere soon," Kenny said. "What's the hurry, Maggie?"

"Indulge me," I said a little too forcefully. I felt edgy, restless.

"All right." Kenny stole a quick glance into the backyard, focused on the avocado tree. "When things have settled down a little, after you get some rest, give me a call, remind me."

"I don't need some rest," I said. "I need to get back to work. How soon can you arrange access?"

He turned to Nick for support. Nick frowned at first but then, after some thought, he shrugged.

"You know how Mike is when he has a bone to chew," Nick said, by habit using the present tense. He looked at me. "Maggie's the same."

Kenny smiled ruefully. "Yeah. Okay, honey, I'll see what I can arrange. When do you want to go?"

"I have some housekeeping things to do around here this afternoon, and I want to spend more time with Mike's files," I said. "But I can drive up to Corcoran tonight. How about arranging for me to visit first thing tomorrow morning?"

"Tomorrow?" he barked. "But this is Sunday."

"Jeez, Maggie," Nick said, beginning a protest rant, arms flung wide as the other men joined in; a thousand reasons they had for me to just stay put.

I felt something suddenly burst. Must have been a dam because flood waters began to spill down my face. I groped for the box of tissues on the kitchen counter.

"Hey, guys!" I shouted to get their attention. They fell silent, looked at me, horrified, chagrined as if they were responsible for the sudden tears. The tears made me angry, which only triggered more tears.

"But—" Kenny tried again.

"I am not sleeping in this house tonight," I blurted. "I am not ready to get back into Mike Flint's bed, alone. But I am ready to take care of his unfinished business. With your help or without, I intend to see Boni Erquiaga tomorrow morning, and I'm leaving here as soon as I can get out the door."

Nick came over and put an arm around me. "Maggie, honey, you know, there are five stages of grief. The first is denial."

"Been there," I said, snuffling. "I liked it there."

"The second is anger."

I said, "Or it's a descent into alcohol, or a dive into Mike's stash of medical marijuana."

"Mike has medical marijuana?" Kenny said, eyes wide: shocked? Intrigued? "Is it in the house?"

"This is California," I said, wiping my face with a gob of tissues. I opened a kitchen drawer and pulled out a quart-size Baggie stuffed with a gray-green tangle of bud. "Medical marijuana is legal in California for people on chemo. It increases the appetite, suppresses the pain, or makes you not give a damn that you can't keep food down and that you hurt all the time. I can roll you a joint as big as a stogie, if that's your deal, but there are brownies in the freezer. That was Mike's preference. There are always brownies in the freezer."

"It's just…" Kenny looked as if he had just been hit with a big wet bag of shame. He was pale, *désolé*; big, tough street cops can't bear making a woman cry or face their own mushy emotional core. "Excuse me, I'll go make some calls. We'll get you in to Corcoran. Tomorrow."

— 3 —

THAT NIGHT, I dreamed about Mike. Maybe the dream seemed so real because the circumstances in it were so utterly ordinary, so easily a part of any day. Or maybe, because I wanted so very much to speak with Mike, I made more out of that ephemeral encounter than was merited. Whatever the reason, all during the day afterward I had to remind myself that I had not, in fact, seen or spoken with Mike. Could not have spoken with Mike, no matter how much I wanted to do so.

After Kenny and the others left, I moved Mike's computer from his office into my workroom and set it up. The files he wanted me to read and two white file storage boxes he had written my name on were already in my room. I spent the rest of Sunday sorting the material, making notes, making a plan.

By the time I managed to haul an overnight bag and Mike's files out to the car that night, it was long after the weekenders had made their way home and were off the road. The only traffic headed north with me over the Grapevine, the single mountain pass that connects the southern coast with the state's interior, was container trucks making the overnight run out of the LA–Long Beach Harbor full of stuff from China and headed for points north. The trip to the small town of Corcoran in California's agricultural San Joaquin Valley, where the eponymous state prison is, took me just over two fast hours. Still, it was almost midnight when I exited the freeway.

I found a room in a generic chain motel about a mile south of the prison. It was April, early spring. It should have been cool. But the air outside at midnight was a muggy ninety-two, the air inside the room about the same.

Exhausted, hot, I stripped naked, sprawled across the bed closest to the window-mounted air conditioner, and tried to sleep. But

25

I was too tired, my thoughts too fragmented, to shut down enough to drift away. Even the constant whir of distant freeway traffic, a night sound not unlike pounding surf, did not calm me.

At some point before dawn I got up and showered. Afterward I managed to fall into a light, dream-filled sleep. In that nether zone, not awake but barely asleep, dream and reality can seem separated by the thinnest veil. And that was when Mike came to see me.

In the dream, I walked into the diner across the street from the TV studio where I work, as is my lunchtime routine. Mike and a woman I did not know were already seated in my usual front booth. My impression of the woman was that she was attractive. I couldn't remember her face or anything she said, only a single gesture: she put her hand possessively on Mike's arm when I sat down opposite them.

Mike and I said the things old friends might say during a chance meeting after a long separation, not as lovers who had been apart for less than a week. I told him that my film project was in a stall and that my daughter, Casey, had broken her ankle during a dance rehearsal. We talked about his son Michael's deferred wedding plans because of his deployment, and wondered when the VA hospital in Sonoma would again bring up ejecting Oscar, his father, because his drinking exacerbates his Alzheimer's.

Six months ago my father sat down on a bench in his garden and quietly left this world. Mike apologized for missing Dad's funeral, said he had always admired my dad, always enjoyed arguing politics with him, though in life, Mike had given the eulogy.

When I told Mike I didn't know what to do next, he rose to leave. I reached for his hand to stay him, asked what I should do with all of the stuff he left behind. He laughed, he put his warm hand against my cheek, I woke up.

The warmth of his hand lingered on my cheek as I emerged, reluctantly, from sleep. I felt vaguely angry with Mike for leaving, again, but I was also glad to see him looking so well. A mixed bag of emotions.

For a moment, I lay with my eyes closed, trying to remember everything we had said, trying to conjure up his face. But he was gone, and I could not bring him back from that dark place where he had chosen to go.

I rose, feeling groggy and raw, showered again, and found some breakfast at a coffee shop next door to the motel. Most of the tables were empty so I lingered until it was time for my meeting at the prison. I read again the notes about the disappearance of Jesús Ramón that Mike had left me, trying to reconcile those notes with everything Mike had ever said about Jesús.

Mike had told me many versions of the Jesús Ramón story. The police reports end when Mike let Jesús out of his car at the mouth of an alley off Third Street downtown and watched the boy walk away toward Broadway. From that point, Mike would spin the moral of the tale to suit whatever point he wanted to make at the moment, making Jesús Ramón a sort of multipurpose allegory. Maybe, I thought sometimes, Mike had been involved with enough crap while working in the City of Angels that he merely lumped together various situations and encounters for story-telling purposes and hung them on Jesús. Or, maybe, Jesús was never very far from his thoughts. The one ending I never heard from Mike was that he had set up the boy to die, though that accusation had certainly been made.

After my third cup of coffee I got back into my car and drove up the freeway for my appointment at the prison where former LAPD officer Bonifache Erquiaga was consigned to be a lifetime resident.

— · —

The guard called him Enríquez.

Boni didn't correct him. Ever since the first time some guard called him by the wrong name, three years ago when he was being led from the courtroom to a holding cell after his conviction, Boni never corrected any of the dozens of guards who had, through carelessness or ignorance or intended insult, made a mistake with his name.

Boni told me later that every time he was called Enríquez or Edwards or Esquivel, he let himself savor, if only for an instant, the hope that his incarceration was itself a mistake, that his name, Bonifache Erquiaga—his father's name and his grandfather's—was not properly entered on the roster of lifetime guests housed by the California Department of Corrections. Affirmation that he did not belong in that shit-hole of a place.

Boni moved up the line queued in the narrow hallway be-
tween the cellblock and the portal, waiting for his turn to be strip-
searched before he could enter the visitors' room where the guard
told him his attorney waited. Like the other waiting prisoners,
Boni kept his eyes straight ahead and disengaged his heart from
any ordinary human sensibility until the ordeal of the search was
finished.

An attorney visit meant an extra shower as well as half a day off
from raking the gravel exercise yard. With luck and persistence, an
attorney visit could also mean there would be some extra money
deposited into his commissary account. If the price Boni paid for
all of this possibility was to submit once again to some form of
gratuitous institutional humiliation, then so be it.

Other than his name, there was a second mistake in this event
that Boni also did not bother to point out to the guard who had
called him in from his work detail: Boni had no attorney. Had
had no attorney of record since he ran out of both money and
appeals.

This lawyer, Margot Duchamps, he thought obviously had
come to see someone else. Possibly some con named Enríquez was
missing out on a lawyer meeting, and maybe it was an important
meeting, who knew? Should Boni feel bad? The mistake wasn't his,
Boni told himself, so why should he say anything?

Later, when he told me, in a long spill of his fathomless, saved-
up grief, how he had felt that first day we spoke, he said that when
he walked into the visitors' room he expected that as soon as I saw
him, saw the mistake, he would be sent right back out to finish
raking the yard under the intense morning sun; he was reluctant
to make eye contact with me.

Like Boni, I did not correct the "mistake" that I was his lawyer
because it got me inside the prison for an interview much faster
than the protocols for journalists' visits would have allowed. The
name on the form, Margot Duchamps, was not a mistake. That is
my legal, pre-marriage, pre-TV-career name. The name my family
gave me.

When he walked in, Boni Erquiaga looked smaller than I re-
membered him at the time of his trial. His black curly hair was
now thinner on top and steel gray—hair dye is not allowed in

prison—the contours of his square jaw had softened, and much of his open good humor and cocky self-assurance belonged to the past. The pride that some interpreted as stubbornness was still evident, undiminished by the fetters that hobbled his gait and chained his hands to his waist. He shuffled into the narrow passage on the prisoner's side of the visiting room with his chin thrust forward, resolute, apparently unbroken and unrepentant after a few years of the humiliations of the high-security segregation unit set aside for defrocked, dishonored, convicted cops.

The woman in the seat next to me, a woman who had gone through the security check point ahead of me at the visitor reception center, and had cried the entire time, began to sob anew. As a small, dispirited man took his place opposite her, she flattened her palm against the thick glass screen that separated prisoners from their visitors. I wondered if human heat would pass through the barrier; sound did not. The woman could only cry into her telephone handset, and the little man could only listen to her sob.

When Boni sat down opposite me, I didn't know if I was expected to put my palm against the glass, did not know how intimate that gesture was meant to be. I was certainly not on handholding terms with Boni, but some sort of handshake seemed called for. Instead, tentatively, nervously, I rested the fingertips of my free hand, my left hand, on the little ledge at the bottom of the glass when I picked up the telephone handset and waited for Boni to pick up his.

The guard sat Boni on the stool opposite me, freed his left hand from the handcuffs, but kept the right hand locked to his waist chain. As Boni settled himself, the guard met his eyes and delivered a warning of some sort that I could not hear but could certainly read the intention of. Some firm version of "Behave yourself."

It was only after the guard had gone down the line that Boni looked directly at me. First, he paled. And then he crossed himself, jerking on the chains so that he could touch his fingertips to his lips. He managed to say, "You?"

I pointed to his handset and waited for him to pick it up. When I heard his breath through the line, I said, "Mr. Erquiaga, I'm Maggie MacGowen."

"I know who you are. I just didn't expect *you*. They said an

attorney visit, someone named Duchamps. But it's you." He leaned so close to the window that his exhalation made a circle of steam on the glass. "You look good. Damn good. How are you, honey?"

"Fine, thanks." Smarmy, horny bastard, I thought, but I kept what I hoped passed for a polite smile on my face.

There was something I sensed about Boni the first time I saw him in court that made me want to stand back from him, for self-preservation. He's a textbook example of a sociopath, a man with immense charm but absolutely no conscience or empathy. Perhaps the only person other than himself that he cared about was the recently paroled con, Nelda Ruiz. He never snitched on her, even when it could have helped him.

I said only, "How are you?"

"Seeing you, it gives me hope I'm not buried in here, forgotten," he said. Tears filled his eyes and he dropped the receiver to flatten his free hand against the glass. I declined to put mine against his, and I must have looked confused or maybe alarmed by his raw emotional state—or was he a good actor?—because he withdrew his hand. I pointed to his handset and he put it against his ear again.

"Are you all right, Mr. Erquiaga?"

"You don't know how it's been," he said, wiping his eyes on his sleeve. His words poured out in an agitated rush. "For the last three years it's like they locked me up and lost the key when I shouldn't have been locked up to begin with. The charges against me were all political, anti-cop BS. But I have no one who'll listen to me, no one with the balls to stand up and help me. Then I see you and I think maybe you will do something. I know who you are, I see your reports on TV, I know you aren't afraid to go after anyone. Maybe you'll tell my story. I know you're my old friend Mike Flint's girl for a long time. I think you understand what we cops have to put up with out there."

"I do my best to understand," I said. "It isn't always easy."

Boni canted his head as if perhaps looking at me from a different angle might reveal something. He asked, "How is Mike? He still working detectives out of Robbery–Homicide?"

"He went out on medical leave a while ago," I said. True as far as it went. I knew Boni was a practiced liar, but chances were he

had not been told about Mike. "I've decided to look into the Jesús Ramón disappearance for my next film. I hoped you would talk to me about what you remember from that day. Anything about the boy, any ideas about what might have happened to him."

"Yeah?" The intensity of Boni's scrutiny of me was disconcerting. "That's why you're here?"

"That's why I'm here."

"I remember your eyes," he said, off on a new tangent. "I come in here today and I see those eyes and I think, What is this, a ghost? I am so rattled, my hand is shaking. See?"

He held out the hand to show me. "It's been a long time since anyone visited me."

"I'm no ghost," I said.

"I guess not." He smiled wryly. "So, this lawyer couldn't show and you took her place? They told me a lawyer was coming."

I glanced at the guard at the far end of the room. "Maybe a friend of mine checked the wrong box on the visitor-request questionnaire. It can take months for a journalist to get into this place."

"You lied?" His eyes were dark slits; a seasoned prisoner is always wary. "What's the hurry to see me? I'm going nowhere. They catch you in a lie and all kinds of shit can come down on me. You trying to get me in trouble?"

"Do you want me to leave?"

First he checked to see if the guard was watching, then he shook his head. "Maybe I can help you. Get me the Jesús Ramón investigation book. I'll put my nose in it and see what I can find out."

"I can't bring in anything." I showed him my empty hands. One of Boni's convictions was for arranging a hit on a witness from the county jail. I thought it was a bad idea to give him access to police reports that might mention any potential witnesses. I asked, "What is it you expect to find in those reports?"

"I have a lot of time to think in here," he said. "I just thought that if I could spend a little time with the investigation files for half a day I might find something that's been missed. Maybe I can help you out."

"With all the charges that were brought against you, the drug involvement, you aren't worried that a connection might be suggested?"

"Me?" He shrugged. "Had nothing to do with Jesús. Had a good alibi, in case you're wondering."

I said, "Nelda Ruiz."

"Nelda." He nodded. "I was at the Glass House with Nelda when Jesús was last seen. Up at police headquarters, waiting for Mike to come in."

Without a pause or segue, I said, "Nelda Ruiz was paroled from the women's prison at Frontera about a month ago."

"Paroled, you say?" His head snapped back as if I had slugged him on the chin. Then he thought that over for a moment. "She's out." A statement, not a question. His handsome face grew bloodless, white. He took a few shallow breaths, then he slumped forward. I half rose, afraid he had fainted.

"Enríquez!" The guard came over and shook his shoulder. "You sick?"

"No." Boni pulled himself together so that the guard wouldn't take him away. His face glistened with cold sweat. When he saw me staring at him he sat up straight again.

"Where is Nelda?" he asked.

"That's one of the questions I have for you. She hasn't checked in with her parole officer," I said. "You're an old friend, I thought she might try to contact you."

"There's no way she can do that."

"You used to write to her," I said.

"For a while, yeah. Until they put a stop to it."

"Who are 'they'?"

"They. Just *they*. For her in that place and me in here, *they* decide everything. *They* said no more contact."

"I read some of your letters to her," I said.

He shrugged. There was nothing he could do to stop me, on the outside, from doing anything, and his gesture said so. Convicts have no expectation of privacy.

I said, "You told her you would always take care of her."

"Men say things to women," he said. "Protecting Nelda got me deep into something I knew better than to get involved with. That man-woman thing is very powerful, you know. Can screw up your good judgment."

I said, "Been happening since Adam met Eve."

"Yeah." He sighed, contemplative for a moment. "I gotta tell you, it's been a whole long time since I was as close to a pretty woman as I am to you right now. You can't know how much it hurts for a man to be cut off from women for so long. Nelda and me, we had something good for a while. She had her problems, no denying that. Big problems. But when I think about her, I see her as a shining angel; she was good to me. You might think I'm crazy for saying this—I know she's a junkie, a tweaker—and getting involved in her 'business' got me in here. But I would do anything, put up with any grief they can dish out to me, if I could believe that one more time before I die I would feel Nelda's flesh against my flesh. Do you understand what I'm saying?"

"I understand." I did. Nelda Ruiz was a convicted crack cocaine dealer, a user. But I had read in Boni's letters to her his immense and genuine passion for her. Love, I suppose.

Boni was right when he said that man-woman thing could screw up a reasonable person's good judgment. In the back of my head, where I supposed reason might still lurk, I replayed the question Boni had asked. What was I doing there? If Mike couldn't find Jesús, how could I? I didn't know. This I did know: remote as the possibility was, Boni had a better chance of someday putting his flesh next to Nelda's than I did of ever again cuddling up next to Mike Flint.

Boni pulled himself together. "How does Nelda look?"

"I don't know," I said. "As I told you, no one seems to know where she is. Have you any idea where she might be?"

He narrowed his eyes again. "Where's her father?"

"He passed away."

"Yeah? Well, rest in hell." The words snapped with venom. "If the old man's really and truly gone, she'll go home. It's her house, you know, passed down to her from her grandfather. Her old man set himself up in the property like he's the don of the hacienda, but he was just a nobody, a do-nothing low-life. It was her house and he tried to steal it from her."

Boni took a deep breath, seemed again near tears. "We were going to live there together, when we got straight again."

"Women say things, too."

"She couldn't lie to me."

I asked, "How did you hook up with Nelda?"

"We grew up in the same neighborhood."

"Childhood sweethearts?"

"Not exactly. She's a few years younger. More than a few. But I knew her family. I ran into her later."

"When you arrested her on a drug charge?"

"Yeah." A little shrug, dismissing the importance of this tidbit.

"The day Jesús Ramón disappeared?"

"Long time before then." Boni looked around for the guard, always knew exactly where the guard was.

"So Nelda was your friend before she was your alibi," I said. "It just occurred to me that you're also her alibi for that afternoon."

He turned his face to me again. "I don't want to talk about Nelda anymore."

"Jesús was a Sleepy Lagoon Crip. So was Nelda. At least, she was in the girls' auxiliary. Were they close?"

"I don't remember." Same little shrug.

"What inducement can I offer you to remember?"

Boni smirked. "Short of a parole?"

"Short of a parole."

"Okay." He sat up taller and looked me in the eye, ready to bargain. "Get me a good appellate lawyer. I don't belong in here."

"No promises, but I may know some people. I'll make some calls. Anything else?"

"When you came in, did they tell you in Reception how you can deposit a few dollars in my commissary account?" he asked. "You know, so I can get some little things like candy and writing paper and telephone cards and such."

"Yes."

"I think the limit's fifty bucks a month. You give it to the guard in Reception and he gives you a receipt." Boni grinned. "Maybe you can deduct it from your income tax. Call it charity."

"I'll make a deposit on my way out."

"Okay." He seemed cocky again. "What's the fifty-dollar question?"

"The truth. You said you wanted to go over the case files. But is there anything you know that might not be in those case files that could help me find out what happened to Jesús?"

"Holy Mary, Mother of God," Boni groaned. "Don't ask me that. I'm already serving one life sentence."

"At the moment, I don't have anyone else to ask, just you and Nelda."

"Ask Mike."

"I can't ask Mike."

"Then leave it." The color rose in his face again.

"I can't do that either," I said.

"You have some beef with Mike?" Boni said, "Why bring that up so long after? You have any clue what people in the neighborhood were saying about Mike? You ready to risk getting Mike put inside like me?"

"That won't happen," I said. "Mike can't be touched."

"Says who? Doesn't matter what the truth is, there are people out there who can put a spin on some nothing situation and make it seem like mass murder if they want to," he said. "Look at me. I don't deserve to be in here for the rest of my life for what I done."

"Tell me about the day Jesús Ramón went missing."

"You're persistent," he said, shaking his head. Then he sighed, looked me in the eye, and said, "Jesús was a snitch, okay? From time to time I helped him out in exchange for inside information about his gang set. If police don't use snitches, letting us know what's going on, we'd have open gang warfare on the streets all the time.

"On the day you're talking about, we were bringing in some Thirteenth Street gangsters to Central Division based on a tip from Jesús. Thirteenth Street and the set both Jesús and Nelda belonged to, Sleepy Lagoon, have been at war for as long as I can remember. When a call came in that Nelda was getting arrested, I went out to make sure she didn't show up at Central when the rival Thirteenth Street set were there because you never know who might say something stupid and get something started. I knew Mike wanted to talk to her about some homicide. This dealer who got shot; Higgins was his name, Rogelio Higgins. So, I thought I'd go out there, get Nelda and take her downtown to talk to Mike.

"I went over to Alvarado Avenue. Eldon had Nelda hooked up and he was talking to her. I told Eldon what was going down at Central. He said he wanted to stay on observation and didn't want

to take the time to go all the way to Parker Center, so I agreed to take Nelda downtown.

"Right about then, Jesús walks up. Mike arrived right after him. Mike hooked up the kid and popped him into his car for his own protection, made it look like he was getting busted, to keep him out of trouble. Nelda was already in my car. So Mike tells me to go ahead downtown with her and he'd be right along, after he dropped off Jesús. And that's all I know. I took Nelda downtown and waited for Mike."

"Why didn't Mike take Nelda if he wanted to talk to her?"

"Like I said, she was already in my car."

"And you wanted to talk to Nelda." I looked at him hard. "Mike did you a favor."

"Okay, yeah, he did. And, yeah, I wanted to talk to Nelda. Give her a little friendly advice."

"What did you ask Mike to do with Jesús?"

"I didn't ask him to do anything. Mike was a Detective Three. A street cop doesn't tell a D-Three what to do. I just told him what was going down at Central." Boni seemed exasperated, a very bad temper bubbling near the surface. "Mike knew what to do."

"And you took Nelda downtown for the same reason, to get her away from rival gangbangers?"

He nodded. "Look, maybe a situation got out of hand. Something bad probably happened to that kid, Jesús, and I'm sorry for the rest of my life that it did. So's Mike," he said. "We were doing our job the best way we knew how, trying to keep the bad guys off the streets. Unless you've been on the job you don't know what goes on out there. Things happen sometimes, you know. You make a wrong call, a misjudgment, someone gets hurt.

"I'll tell you this: Whatever Mike or me or anyone else did or did not do, the one single person responsible for anything that happened to Jesús Ramón was Jesús Ramón. He chose who he wanted to hang with, and maybe he paid the price for it."

"He's not the only one paying that price, is he?"

Boni looked at me, hard. "How'd you get in here, anyway? Who checked the wrong box?"

"Kenny Noble."

"*Lieutenant* Noble?" Boni said, lights coming on behind his

dark eyes. "Head of Robbery–Homicide lied for you? You have some powerful friends."

"Ken Noble is Mike's friend."

"Good for Mike." Again, Boni looked for the guard. "We finished?"

"You haven't answered my question."

"You going to put something in my commissary account?"

"On my way out. I won't forget."

"I'll have to think about your question."

"I'll be back," I said.

"Suit yourself." I tried to read the expression that dropped over him. He said, simply, "I'll be here," put his handset on the hook, turned away from me, and signaled the guard that he was ready to go.

"Mr. Erquiaga." I knocked on the window glass to get his attention, but he pointedly did not respond. I stood and called out to him. "Boni."

The guard came for Boni. He locked Boni's free hand to the chain at his waist, pulled him up by his elbows, and turned him toward the door. Boni would not look at me.

I put my open palm against the glass.

The guard picked up the handset. "Enríquez says he don't want to talk to you anymore."

On my way out I stopped to make a deposit in Boni's commissary account. As I handed cash to the clerk, I said, "Please make sure this is credited to Bonifache Erquiaga, and not some guy named Enríquez."

"Uh-huh." The clerk gave me a little smile that looked more like a sneer as he slid me a receipt. "The thing is, there used to be a cop on the job named Erquiaga. The guards in here? They don't like to be reminded where he ended up."

I took the receipt and turned to walk away.

"Too bad about Mike Flint, miss," the clerk said, sounding sincere. "I'm sorry for your loss."

"Thank you," I said. "So am I."

— *4* —

I WALKED OUT of the prison into the bright glare of late morning, head feeling leaden, eyes burning as if I had come out of a dark cave. There were too many disconnected bits and pieces of information, like free-floating helium balloons, and I couldn't seem to grasp any of their strings to reel them in. I knew something of substance would emerge when, if, I got the pieces put together. I just hadn't figured out yet how I was going to accomplish that.

The car was hot. I turned on the engine, flipped the AC to high, took out my laptop, and began typing notes so that I would have a complete if not exactly contemporaneous record of everything Boni and I had said, as well as a record of what I had seen. I wanted Boni on camera, but getting permission from both Boni and the state to film inside Corcoran would take some major effort. We would probably have to settle for the outside shots I took as I walked back to the car and fill with some file footage, add a voiceover narration; illusion is the magic of film.

I called Guido and filled him in on my proposal for the new project. He had some qualms about the subject being too personal, and wondered whether I was ready to take it on, but he agreed that the topic could be good. The next person to sell would be our executive producer, Lana Howard. Guido and I talked about the pitch we would give her.

Lana is generally supportive of the projects we bring her. But I always have to remember that she is also a functionary of the network, and can be a very tough sell. Our pitch needed to beguile her at the same time it made clear how the project met network objectives, meaning viewer share, sufficiently well that we would get approval, which would translate to time and a budget from the people she reported to. A brief potent pitch—an overview and

a hook—were all that Lana usually needed before she gave the go-ahead, but that short teaser could be the most difficult aspect of a project. It's alleged that Mark Twain said that the reason *Huckleberry Finn* was such a long book was that he didn't have time to write a short one. I fully understood what he meant.

As Guido and I talked, I began to see, as I do sometimes, an entire film in the rough begin to play, even though we had very little content yet for the script. I could hear in Guido's voice a rising excitement, an enthusiasm that fed my own. Neither of us had any idea where the project would take us, or what we would know at the end. Addressing the puzzle was the point.

We decided that I would rough out a five-minute presentation for Lana, and he would begin to comb archival footage and shop through our stock of LA background footage—B-roll—for a quick preview of the visual possibilities. We agreed on the tone, the mood, we wanted to convey. When we ended the call, I felt more confident about meeting with Lana.

Lana was in a teleconference with the studio biggies in New York when I called. Her assistant told me that Lana's day was packed, but that she could schedule me for six that evening.

The next call was to Harry Young, the patrol sergeant from Central Division who had told Mike that he had a line on the whereabouts of Nelda Ruiz. Mike had left me Harry's contact numbers, home, cell, work.

I knew Harry Young. He was a friend of Mike's from the old days before the federal consent decree, when there weren't so many shackles on LA law enforcement. Harry was currently a patrol sergeant working morning watch, the overnight shift when stuff goes down, out of LAPD's Central Division, the downtown beat. I looked at my watch. It wasn't yet noon. Because morning watch signs in at ten at night and signs out at about seven the next morning, it was way too early to talk to Harry. But I called his house anyway to leave a message that I wanted to speak with him.

Harry's wife, Yuen, after offering condolences, told me it would be best to try again at about four when Harry got up for dinner with his family. She took down my contact numbers and promised that Harry would be waiting for my call later.

It was after two when I arrived back at the studio. I found Guido cloistered at an editing bay. He had cobbled together shots from the video archives, scenes of the inner city where Jesús Ramón lived his short life, and was putting together a rough but provocative draft disc to accompany my narrative spiel. Bless his heart, he was even adding a music track, a discordant sort of alternative Latino hip-hop.

I pulled up a chair next to Guido's, opened my laptop on the counter beside his console, and wrote the narrative. When I left him at four to go talk with Harry, he was busily synching *son et lumière*, the sound and light.

I dumped my files and computer on the little sofa in my office, sat down beside them, and called Harry Young.

Harry came to fatherhood late in life, and cherishes the hurly-burly of kids as if all that noise and messiness is a gift, something like season tickets to the circus. When I called back, Yuen summoned him in from the backyard where he was practicing tae kwon do with his eight-year-old son.

"Harry," I said, "it's Maggie."

"Glad you called. Sorry I missed the service, honey, but someone had to cover the shift and I drew the short straw." He sounded out of breath. "I am so sorry for your loss. Hell, Mike and I go back a long, long way. One of a kind, that guy. I'll miss him."

"We'll all miss him," I said. "Thank you for your concern."

"What can I do for you, Maggie?" I heard him take a drag on a cigarette; Harry was old school.

"Mike asked me to look into Jesús Ramón," I said. "He left me a note that you had a possible line on the whereabouts of Nelda Ruiz."

"Yeah. I might," he said. "When Mike heard Nelda was paroled, he asked me to keep a lookout for her, he wanted to talk to her. So, I did, as a favor to an old friend. Started from scratch, though. The address Nelda gave the parole board was a house she inherited from her grandfather. But the house got sold a long time ago to pay her lawyer, so that was a dead end.

"Then about a week ago..." I heard the click and flame of a lighter, and Harry's first drag on a fresh cigarette. "About a week ago,

one of my patrolmen brought in a strawberry—you know, trades sex for crack—on a solicitation charge. I saw she was in Frontera during the same time as Nelda Ruiz, paroled out about three months ago. So I asked if she knew Nelda and might know where she is now.

"I know if she's a user, then she's a scam artist, too. She wants to know if there's reward money for talking," Harry said. "I told her there is no reward except heaven, but that I'd step forward for her next time she got brought in on charges if she gave me something useful."

"She can get you to Nelda?"

"Indirectly. Maybe," he said. "She told me where one of Nelda's old cellmates is working. Someone she thinks Nelda would stay in touch with. The name checks out; another Frontera alum, and she was Nelda's roommate for a while."

"Can you get me to her?" I asked.

"You?" He paused. "Get *you* to her?"

"Yes, me."

"Hmm." Another pause. "You doing this for TV or for you or for Mike?"

"Maybe all the above," I said.

Harry exhaled, and took some time doing it. "Mike ever talk to you about Jesús Ramón?"

"Of course he did. Often."

"I don't know what to do here. Like I said, Mike and I go back a long way. Now that he's out of the picture, I don't want to get his name dragged through the mud again. Not when he can't defend himself."

"What if we can clear his name?" I said.

"I know you cared a lot for him, honey," Harry said, obviously uncomfortable. "But…"

"How close are you to Nelda?" I asked, changing the trend of the conversation away from Mike and me. "If you find her, will she talk to you?"

"We go back a long way." He took some time to think, and I waited for him. "I first brought her in a dozen, fifteen years ago. She was just a kid."

"All the time you've known her, what's the longest she stayed off drugs?"

"Outside of the slam?" he said. "A day, maybe two."

"Chances of her long term-survival out there?"

"Zip to none."

"I have to talk to her, Harry. She was a witness the day Jesús got into Mike's backseat."

"All right, honey." Harry seemed to have set aside some qualms. "I'll make some calls, set something up."

"Tonight?" I asked.

He paused. "Yeah," he drawled, taking more time to think. "I can sign you in as a ride-along. While we're on routine patrol, there's no reason we can't drop in on Nelda Ruiz's old cellmate."

He told me to meet him at Central Station at ten, in time for roll call.

"Maggie," he said in parting, "I'm doing this for Mike. Don't let me down."

"I won't," I said. "I'm doing this for Mike, too."

— · —

At ten minutes to six when Guido walked me to the elevator, we were fairly confident about our show-and-tell; his cheeks were flushed and his eyes gleamed with anticipation. He wished me good luck as I punched the button for the executive office floor atop the network's Burbank studio. Guido and Lana had some issues, so for the sales job, I was flying solo.

"Maggie." Lana greeted me with a quick hug and a pair of air kisses as she ushered me into her office. Lana thrives on high intensity. That evening she seemed unusually nervy, which ratcheted up my own already spinning levels of adrenaline.

"I've been damned worried about you, Maggie," Lana said, nailing me with a practiced sincerity. "And I'm damned surprised to see you here today. My dearest, it's so soon."

"I need to work through what's happened in my own way," I said. "I'd rather be here, busy, than shopping for black dresses, if you know what I mean."

"Yes. I do." She studied me, then took and released a great, dramatic breath, the signal that it was time to get down to business.

She said, "You've no idea how happy I am that you feel up to work. Network is pushing me to get the fall schedule set. I need to pitch them a series of Maggie MacGowen films that will knock their silk shorts off. And I need you to give me the hook they can hang their passion onto. Tell me that what you have for me is fabulous."

"I think you'll like this project," I said. "I do."

"Excellent." Lana rang her assistant and told her to hold all calls. As she walked me toward her conference table she began to deliver her own pitch. "I'm in New York all next week with the programming people. They want a full two-hour Maggie MacGowen production they can broadcast during May sweeps week, something blockbuster. It's that hook for fall you need. Tell me you have it."

"Lana," I said, with more confidence than I felt, cringing at the phoniness in my voice, "have I ever let you down?"

"Something to drink?" She smiled at me, her eyes bright, remembering the thrill and tension of the film process, perhaps, or expectant about the next one. Lana loves her work. Or was it fear that made her so bright? "Water?"

"Thanks," I said.

Lana walked over to the bar on the far side of her office and began fussing with ice cubes, crystal glasses, and bottles of fizzy Pellegrino water.

Lana's office is a shrine to her status at the network, furnished to look hip, young, powerful: everything leather, granite, competence and chrome. One entire wall is window. Early evening sun poured in, bounced off every hard, polished surface in the huge room. I reached for the console panel on the conference table and pushed the button that closed her drapes, leaving the room washed in soft gray light, taking the harsh reflected glare off her row of TV monitors, off the row of Emmy statuettes hovering on a shelf above them.

I slipped Guido's video disc into the player on the table, waited for the "ready" light to appear in the corner of a monitor across the room, and pushed more buttons. Suddenly, Boni appeared onscreen, shot during his arraignment two years ago. On Pause, his bright orange county-jail jumpsuit glowed hot in contrast to the gloom.

"Want a lime slice in your water?" Lana had a paring knife in her hand. "Doesn't add calories or carbs."

"Please," I said. I imagined Guido rolling his eyes.

Lana, in common with many women in her industry, is anorectic. Or maybe it's bulimic. Or maybe it's both. Intentionally, she is as narrow and as curveless as a pencil. Indeed, backlit against the window, she seemed no wider than one of the pleats in her filmy drapes. Guido Patrini, of the Sicilian Patrinis, son of Mama Gina, neither understands nor fully trusts people who choose not to eat. But that was only one of the issues between him and Lana. I was often the buffer between them.

"Hmmm, very photogenic," Lana said as she studied Boni's frozen image; Guido had put it in only as a color test. She set tinkling glasses on coasters in front of us, and then took her usual seat at the head of the long table.

As always, while she listened to a pitch, Lana rested her chin on tented fingers and gave away no reactions by either expression or gesture. Now and then she wrote something on the yellow legal pad in front of her. Otherwise she was a sphinx.

"When you're ready," she said, glancing up, pen poised.

I started the disc. Just for form, Guido had appended my series logo. The series title, MAGGIE MACGOWEN INVESTIGATES, emerged from a background montage, pictures of me—usually in motion—and the city, as our heroic theme music built. The title of the new project came up: THE MIKE FLINT LEGACY.

When Mike's name appeared, Lana looked up sharply.

"Mike?" was her single word.

I looked her in the eye and nodded. She frowned, but I could see that I had her full attention.

I took a breath and I began to deliver the pitch:

"Every cop, when he leaves the job, leaves behind at least one unsolved case that will haunt him for the rest of his life. For Detective Mike Flint of the Robbery–Homicide Division of the Los Angeles Police Department, that case was the unexplained disappearance of a teenage boy named Jesús Ramón. The case had special meaning for Mike because he was the last known person to see the boy. Jesús Ramón got out of Mike Flint's car at noon on a

busy downtown Los Angeles street, and seemed to vanish, never seen or heard from again.

"His family and the many people who searched for Jesús were left in an emotional limbo, never knowing what happened to the teenager with the crooked smile. Never able to lay him to rest.

"Mike Flint was my husband. I lost Mike recently. The mystery around Jesús Ramón followed him to the very end of his life. When he died, Mike left me an unusual legacy. He asked me to find Jesús Ramón.

"For Mike, for the family of Jesús, tonight 'Maggie MacGowen Investigates' opens the files, finds the survivors, combs the city to answer the question: Dead or alive, where is Jesús Ramón?"

Onscreen, as a preview for Lana of the tone and texture we planned to convey, the carnival that is daily life in LA's *barrio* neighborhoods streamed past, filmed through the open window of a moving car by Guido's video crew early that afternoon: street vendors selling cheap, brightly colored children's clothes strung on makeshift racks; carts offering food made God knows where, crushed fresh fruit frozen on a stick, steaming handmade tamales wrapped in dried corn husks, fish tacos fried on the sidewalk in an oil drum kettle—for a feast for the brave, a guaranteed bad belly for the uninitiated.

Bus benches advertised legal services for problems with *La Migra*—the U.S. Department of Immigration—or offered cheap international telephone calling cards or bail bonds or Mexican national identification cards. A mixed crowd, people of all ages, filled the sidewalk. At one corner a group of teenage boys saw the camera and obliged by flashing the gang's hand sign; here was a gaggle of authentic Sleepy Lagoon Crips, one of them already in a wheelchair.

For the body of the pitch, as the video images rolled, I paraphrased and embellished the essential parts of the original police report, retelling the events on Alvarado Avenue on a bright January day in 1999, the day Jesús Ramón disappeared. I related the arrest of Nelda, told about the prisoner hand-off between Eldon Washington and Boni Erquiaga, all observed by Jesús and Teresa, the girlfriend. I revealed that Jesús was a police snitch.

I gave a brief where-are-they-now summary: a mug shot of Nelda Ruiz showing a pretty young woman with a thin, worn-out face surrounded by a mass of dark curls; Boni Erquiaga in his county jail jumpsuit.

When Mike's face appeared onscreen, I had to stop to catch my breath. This was his story, of course, but I was still surprised to see him. Lana took note of my reaction, wrote something on her pad.

I managed to pick up the narrative again, retelling Mike's version of the story about taking Jesús downtown and dropping him off.

Fade to: close-up, face of Jesús Ramón: big brown, doe eyes, crooked teeth in a wide smile. The frame widens to show that the face is on a missing person poster; the edges of the poster are torn, stained with age. One corner flaps loose.

"Mike Flint never gave up his search for Jesús," I said, as Mike, onscreen, grinning, squinted at the camera in a snap Guido took at one of our backyard parties a couple of years ago. "As a memorial to Mike Flint, tonight we try to solve his last case."

The onscreen images faded to black.

Lana was thoughtful for a long and painful moment; I could not read her reaction. Finally, she turned to me.

"This is what it will look like?"

"Generally," I said. "Hand-held cameras, sharp color contrast, interviews with faces in close-up, streaming panoramas of the *barrio* sections of the city, cops in action, raucous background audio—Latino music, traffic, people. Edgy, noisy."

I paused, gave Lana a moment for note-writing. After another excruciating silence, Lana roused herself.

"But what happened to the kid?" she asked.

"Don't know yet," I said.

She looked up, seemed a bit dubious. "You'll have it all figured out by airtime?"

"Maybe not all of it," I said. "Maybe none of it. That isn't the point, is it? We're going to look at two cultures in the city, law enforcement and street criminals. Minimally, we'll explain some of the complexities of their relationship. Maximally, we'll find Jesús."

"Hmmm." Lana looked over the notes on her yellow pad, added

something to them. She sat very still for another moment before she spoke again.

"Maggie, do you believe Mike did something to that boy?"

"I have no proof yet either way. Except that I know Mike."

"But you believe the project has legs?"

"Yes," I said. "I'm committed to it. The story has great dramatic potential."

Lana wrote, "Great dramatic potential. Provocative. The Mike Flint Legacy, A Maggie MacGowen Investigates documentary." Without looking up, she said, "Will you be able to distance yourself enough to get through to the end?"

"As usual," I answered. "No more, no less."

"Than the usual." Lana chuckled.

"Trust me," I said.

"As your friend, I ought to say you're too close to the subject, you could get hurt more than you already have been, so dump this project and go find something or somebody else to pick on." She set her pen on the table. "As your exec producer, however, I say, *do* it. Petey, our baby program director, and his strategy boys in New York want something daring and different, provocative and promotable. I think that 'filmmaker solves dead husband's last case' fits that card just fine."

"Tries to solve," I said.

"Whatever." Lana's smile was full of calculation. "Maggie Mac-Gowen will expose the lies."

"Hopes to uncover the truth," I said. "Not exactly the same thing."

"Darling, remember this is network TV." She smiled broadly, relaxed back in her big chair, wheels in her head spinning. "Keep in mind that the truth just isn't as important in prime time during sweeps week as audience share."

"I'll keep that in mind," I said, laughing at her frankness. "And deny you ever said it."

"I know you'll find your angle, Maggie." Smile gone, Lana peered deep into my eyes. "Just don't let Mike get in your way."

"It's a good project," I said. "We'll do you proud."

She turned to a fresh page on her legal pad and picked up her

pen again. "Now, tell me how this leads to a fall series? We're talk-ing four to six docs."

I had to pull a rabbit out of a hat here, because I had given no thought to a pitch for a fall series until she brought it up a few minutes earlier.

"As I said," I said, "every cop goes out bothered by an unsolved case. Why that case resonates, well, that's usually the story. We'll bring in a different retiree for each episode, let him or her tell the story, explain why this one stays with him. We'll go back through each investigation, go back to the scene, talk to the surviving in-vestigators, victims, and witnesses, initiate new investigations. Maybe, if we're lucky, we'll actually solve a couple of them. I want to call it 'The Legacy Series.'"

"You just made that up, didn't you, Maggie?"

"But I like it."

"I like it, too," she said. "Get me a couple of those cases, to sup-port the pitch."

Without looking up from her pad, she said, "And get me a pro-duction budget estimate for Mike's story right away." Lana stood, meeting over. "I'll run this past Petey for approval, but don't wait for the bastards to finish the paperwork. Get your crew together now, get started. In the meantime, I need something to take to New York with me Thursday night."

"This is Monday," I said.

She shrugged as if I had offered a ridiculous non sequitur. "Plane leaves at ten P.M."

"Guido and I will get you something more polished than this be-fore you take off," I said, feeling less confidence than I expressed.

She gripped my arm, a bit too hard. "This one could be big for you."

"Of course," I said. "As always, the biggest."

She chuckled. "Boffo."

I rode the elevator down from the executive floors to the work zone of the production peons where my office is. Adrenaline let-down, or meltdown, or a long day and too much input, or all of it, hit me hard. Let's not forget profound sadness. I needed some thinking time, alone.

Fergie, my long-time assistant, was on vacation until Friday, fishing in the Gulf of California. If no one knew my meeting was over, I had a chance of having my office to myself for at least a little while. To avoid running into anyone, I took a back hallway route and a shortcut through a janitorial closet to get to my office unnoticed.

My office is nothing more than a long cubbyhole divided into two parts by a movable partition with a door in it. Fergie, a woman with ambition, hates it when people refer to her work area as the reception room, because she doesn't want to be mistaken for a reception*ist* when her title is production assistant. So her desk is in the "outer" office, and mine is, therefore, in the "inner" office.

I am Fergie's boss, so my share of the space is a little larger. Still, my area is barely large enough for a standard desk, some storage shelves, and a small sofa, with very little walking-around space between them.

When I came in, I found Guido napping on my sofa, exactly where I had intended to land. He looked very peaceful, sleeping with his mouth half-open, a fine line of drool coursing down his unshaven chin. I tried not to disturb him as I took care of some business details.

Guido and I have worked together, off and on, since the beginnings of our careers. We met at an independent TV station in the heart of Kansas. I was an on-camera newsreader then—what they call "talent" in the business—and he was an apprentice cameraman. In Kansas he was witness to my transformation from Margot Duchamps, somewhat idealistic philosophy grad with an interesting but too-large-for-TV nose, into Maggie MacGowen, news hen with a pert new nose, perky delivery and a promising new husband—his name, MacGowen, stuck, the marriage didn't. Over the years, I watched Guido morph from skinny genius with residual adolescent acne into skinny genius with a powerful résumé. We share three Emmys, and he has a Pulitzer of his own.

After Kansas, we went in different directions. But his jobs behind the camera and mine in front managed to intersect regularly enough for the two of us to keep up with each other. After a while, I ran out of my quotient of pert-and-perky and struck off on my

own to make documentaries. Guido grew weary of ducking incoming objects in war zones and riot epicenters and took a faculty position at the UCLA film school.

When I signed on with the network, needing the certainty of a regular paycheck when my daughter, Casey, saw college on her horizon, and a permanent home base when Mike and I merged our domestic spheres, Guido came with me as part of the package. The pay is good, Lana protects us, the work is interesting, my daughter is fine, and though I'd like to have my original nose back and I'd like to reclaim my own name, I have few legitimate complaints.

Guido still teaches a graduate seminar in film-making, giving us access to a small cadre of very talented youth who are willing to work with us just for the privilege, and for the additions our projects make to their résumés. The union regularly gives us hell for using students, but Guido generally finds ways to mollify them or bargain our way out of the union minefields.

While he slept, I logged in the meeting with Lana and made some notes, dialed my voice mail, and went through the messages.

Casey called to make sure I was all right and to ask for money, an almost weekly occurrence. I went online and made a transfer from my checking account to hers. My mother called to report on the visit she and Michael made to Mike's father, Oscar. He had no idea who they were but he still managed to pat Mom's bottom. Michael was staying at her Berkeley house for a couple of days, and then he was going up to the cottage. She suggested that, when I felt up to it, she and I take a trip. Italy maybe.

The next call was from my neighbor, Early Drummond, telling me that he had taken care of the horses that morning as promised and that he was around for me if I needed anything. Oh, and he had worked on the garage-door opener.

Early was not only my neighbor, we worked together. He was downstairs in Studio 8 or Studio 10 on the first floor, a technical director in the news division. It was Early who had told Mike and me when the house next door to his, now our house, went on the market. We bought it. Early was a good neighbor and a good friend, the kind who keeps an eye on things but doesn't intrude.

We shared the horse corral with Early and his big sorrel horse very amicably.

Harry Young called to confirm that I would show up for roll call at ten that night. He gave me directions to Central Station and said he would meet me at the guard house at the parking lot entrance.

Tired, knowing better, I opened the bottom desk drawer and took out the bottle of medicinal scotch—good, old, single malt sipping scotch—poured a modest dose into a coffee mug and took a sip. Just one. I closed my eyes, leaned back, and let the scotch do its work. When I opened my eyes again, Guido was staring at me.

"You sharing that?" he asked.

I passed the mug to him, he took a drink. Then he yawned and scratched his flat chest.

I said, "You don't have a sofa of your own to sleep on?"

"You were with Lana for a long time," he said. "How did it go?"

"Lana likes the Jesús project for May sweeps and as a promo for our fall season. She's taking it to Peter Kleinman in New York Thursday."

"Sweeps, huh? That mean we get a big, fat budget for a change?"

"It means they want two hours, and we have only a month to get it done," I said. "You still aboard?"

"Whither thou goest, go I." Guido stood and stretched, showing some hairy belly between his jeans and his T-shirt. "She knows it's about Mike?"

"I believe she actually used the word provocative when some of the possibilities occurred to her. Boffo was also used." I took another sip. "God, I wish we could do this project independently, our way. Like the old days."

"The old days are gone, Mag," he said. "The way things are now, it's better to let Lana be your bwana-guide through TV Land. Without her? You'd have to fight with the network apes all by yourself. Tough as you think you are, buttercup, you wouldn't last till daybreak among those zombies."

"I know my way around," I said. "I survived as an independent filmmaker for a lot of years."

"Oh, yeah?" He barked a wicked laugh. "I was there, remem-

ber? We were dealing with genteel old PBS and hungry HBO dur-
ing the glory years for documentaries, and still barely surviving.
Times have changed. It's a whole new jungle out there. Answer
me this: You want to be out there making films or do you want to
spend your time navigating uncharted terrain and trying to sell
your soul for funding?"

"Yeah, yeah." Through my single window I saw towers of high-
rise offices and the brown haze of San Fernando Valley smog that
was their backdrop; this ugly sprawl is the center of TV Land. Over
the whir of the building's air-conditioning, the high-pitched buzz
of the security system, and the general hum of people at work,
I could hear the Ventura Freeway, a constant backdrop of white
noise somewhere in the distance. A jungle of glass and steel that
generates its own form of reality and delivers it in mega-pixels.

I flashed Guido a big, stagy smile. "We're going to have a hellu-
va good time on this project, mister. Better than the old days."

"You think so?"

I saw his quick grin. I said, "What?"

He began to hum, "Back in the saddle again."

— 5 —

HARRY'S DIRECTIONS to Central Station included "Keep your doors locked and the windows up. Don't stop for anyone or anything." But the scene I passed was irresistible, so I rolled down my window, held a little palm-sized digital video recorder to the opening, and let it roll as I drove, making a crude video record for later reference.

Changes are underway in downtown LA—lots of gentrification, new shops, and many expensive loft and condo conversions—but there are still two downtowns, one by day, another by night. By six P.M. the day shift, the gray suits who staff city hall, police head-quarters, federal, state and local courts, the jewelry and financial districts, for the most part has evacuated downtown and headed for the suburbs. As they leave, a ragged second shift takes over the sidewalks and parking lots: derelicts, hypes, whores, users looking to score crack or blow or H, or people who simply have no other place than the streets to lay down their heads.

After nine P.M. the city briefly turns its back on the health codes and lets the homeless erect shelters on the sidewalks of a designat-ed few streets on the industrial edges of the city center, the biggest Skid Row in the nation. As I drove through, street people were still diving into Dumpsters to gather the building materials for their overnight shelters.

With only the street lights overhead for illumination, I filmed people lumbering along the sidewalks with flattened cardboard cartons on their backs, trailing discarded plastic sheeting and whatever else they had scavenged. Through the little monitor on my camera they looked like strange insects with asymmetrical wings. Or broken wings. Didn't matter, they weren't flying any-where.

Every dawn, city street crews come through and level the remnants of the shelters, hose down everything in preparation for the brigade of crisp gray suits pouring in off the freeway ramps again, so that the only sign that the shelters had existed is the faint smell of urine, and here and there the toffee-brown resinous residue that is a byproduct of burning crack cocaine. And every night, like the mythic Sisyphus, street people go through the building process all over again.

As I watched the crowd, I had to admit to a certain admiration for their courage to soldier on. Few of them had prospects for anything better, but every day they decided, anew, to begin again.

I turned off the camera, rolled up my window, and continued on to Central Division's station.

Locals call LAPD's Central Station the Fort because it has no windows in its stone and mosaic façade; post–Watts Riots design. Located in the middle of Skid Row, Central's jurisdiction covers most of downtown, ironically an area that includes police headquarters, Parker Center.

When I arrived, Harry Young was schmoozing with the guard on duty at the entrance to the station's parking garage. He said he was watching for me. I knew he was outside sneaking a cigarette. Harry is an old-timer who never bought into the physical culture of the New Cop. His uniform always seems to need pressing or tucking in, his hair, what little remains, apparently cannot be disciplined. This exterior shambles belies the sharp, intuitive cop inside.

Harry leaned in my car window, cigarette hanging from one side of his mouth like a B-movie tough guy. "Say, sweetheart, you ready for a good time?"

"Whenever you are, Harry," I said. "Whenever you are."

"Park it anywhere. Go sign in with the duty sarge. I'll meet you in the roll call room."

Central Station was old and overused, too many officers working out of too little space. But the paint inside was fresh. And while the furniture was well-worn institutional wood and steel and hardly comfortable, there were enough personal touches to rescue the place from bleakness: snapshots on a bulletin board from a reunion steak-fry at the Harbor shooting range, trophies and

banners from a couple of the annual Baker-to-Las Vegas law en-
forcement relay runs and from the division softball team, a bright
philodendron trailing over the door to the coffee room. There was
an ATM in the lobby, a neighborhood service.

The place might be superannuated, but the people who worked
there were generally young, hard-bodied, sharp and eager, rep-
resentatives of the New LAPD diversity created under a federal
force decree after the Rodney King riots. Walking among them, I
felt I needed to tuck in my shirt and stand up straight.

The dress code at the TV studio is essentially nonexistent ex-
cept for the parts of people that show on camera; you don't want
to know what the talking heads wear, or don't wear, below the
desks they sit behind. As long as you aren't naked or a hazard to
yourself or others, no one much cares what you wear. There are
some genuine slobs, but most people dress with a sort of studied
nonchalance. Very different from the crispness of the police, with
maybe the exception of Harry.

Before I could go out on patrol with Harry I had to prove my
identity, state my intentions, and sign a general release absolving
the LAPD in case I got caught in some crossfire. On the line that
asked the purpose of my ride-along, I wrote research, as instruct-
ed by Harry.

The duty sergeant, whose nameplate identified him as L. Banks,
was a big, fine specimen of LAPD's culture of physical fitness. Af-
ter his first glance at the release form, his head snapped up; he
gave me a very pointed looking over.

"Damn shame about Mike Flint," Sgt. Banks said. "Don't know
what I'd do in his situation."

I said, "Yes," because I couldn't think of anything else to say. I
had never seen this man before, but he seemed to think he knew a
lot about Mike's business, and maybe my own.

"How are you doing?" he asked, holding his pen poised over the
signature line on my release.

"I'm fine, thank you." What was there to say?

"Mike and I go back a long way," he said. "He may have men-
tioned me, Lewis Banks. I was a rookie at Seventy-seventh Street
Division when he made detectives."

But his name rang no bells for me. It seemed to be important to
Banks that I know he had known Mike well, or could call himself a
friend, or had wanted to. When Mike worked out of Seventy-sev-
enth Street he was one of a legendary group the others called the
Four Horsemen, or Whoresmen, because of their exploits. Of the
original Four Horsemen, there was now only one survivor, a retired
K-9 officer named Doug Senecal. After Mike made detectives, he
was transferred out of Seventy-seventh over his objections, and
the group broke up as a patrol force, but remained friends.

I didn't want to hurt Banks's feelings and tell him Mike had
never mentioned him. So I said, "When did you start working
Central?"

"First time? Eleven or a dozen years ago. I rotated out, the way
we do, worked all over the city. Came back here a couple years ago
when I made sergeant."

"Were you here in 'ninety-eight and 'ninety-nine?" I asked.

"Sure was," Banks said. "Working gang detail."

"You worked with Boni Erquiaga," I said.

"Don't remind me." He screwed up his face to show his distaste
for his former colleague. And he flushed a furious red.

"I'd really like to talk to you about some things that happened
back then," I said.

"Anytime. You know where to find me." Banks signed my re-
lease form and laid it on his desk. Then he straightened his collar
and extended his hand toward the door, indicating the way out.
"It's time for roll call. You ready?"

Harry saved me a seat next him in the roll call room. I was
greeted by several of his colleagues and given various versions of
thumbs-up and shoulder pats as officers filed in past us: as Mike
Flint's wife, his survivor, I was a notable presence that night.

During roll call, Lewis Banks dispensed with most of the usual
routine bulletins to save time for a refresher on off-duty safety.

"I'm reminding you that when you drive out of here at end of
watch, look around, make sure no one's following you," he scolded.
"If you haven't done it already, make sure the tags on your personal
vehicle lead back to a blind so that no one can tap into DMV files
and get your home address. Keep your eyes open, be aware going

home and driving in. And never, never, never, leave the garage at end of watch with any part of your uniform or department insignia visible."

Banks picked up a clipboard and turned over the top page. "Some of you have already heard, but just so everyone is aware: Jock Mikulski, works P.M. gang detail, got followed home by a couple of gangbangers who have a special sort of appreciation for Jock's dedication to the job. Looks like they lay in wait, then followed his wife to her place of business."

There was a good deal of outraged utterance. "She okay?"

"More scared than anything. They roughed her up some. She's a cop's wife, she'll be fine."

"Catch 'em?" And variations.

"Not yet. Mikulski has been putting pressure on a particular set affiliated with Thirteenth Street Bloods clique. If there's a connection between them and what happened, we'll find it. Parker Center is giving us every resource. The message we're putting out is that the department has zero tolerance for any kind of threats or actions aimed at any officer's family."

Banks leaned forward, narrowed his eyes as he scanned the men and women in the room. "The thing you gotta think about is this: Mikulski lives way out in eastern Orange County. If they'll follow him home, they'll follow you, too."

After a few more questions that had no answers but which expressed the general outrage that an officer's family had been touched by street scum—further proof that "out there" it was us-against-them—Banks dismissed the squad.

As I filed out past him, Banks said, "Watch six out there, Miss MacGowen."

"Don't need to," I said, responding to his caution to watch my back, the six o'clock position on a target. "I have Harry."

"Uh-huh." He looked toward Harry, studied him, frowned. He said, "Like I said, Watch six."

Harry led me out to his car, lugging a black duffel full of gear.

"You worried?" I asked.

He glanced back at me. "About?"

"Being followed home."

"Nah." He sneered at the suggestion as he lit another cigarette. "Not me."

I nudged his shoulder. "Tough guy."

"The whole thing's bullshit, Maggie." He dumped his duffel into the trunk of his black-and-white patrol car, then leaned against the back fender to finish his smoke. "Jock Mikulski is too good a cop to let some pissant gangbangers tail him all the way home behind the Orange Curtain. Nope. Didn't happen that way."

He flicked the butt away. It landed on a collection of butts of the same brand directly under a NO SMOKING sign.

"Half the brass in the city is over at Jock's house right now," Harry said, "talking about going to the mattresses. My money says the problem will be inside the house, not outside. Jock has a little asshole of a teenage stepson. They want an answer, they should find out who the kid has ticked off."

"Maybe you should say something to the brass," I said.

"I don't tell assistant chiefs nothing." Harry shot me a smart-alecky grin. "Anyway, by the time we check back into the station at mid-watch, they'll have it figured out for themselves. Why spoil their fun?"

He slammed the trunk shut. "Ready to roll?"

Uniformed street patrol is a young man's job. At fifty-five, Harry had outlasted most of his Police Academy classmates. After thirty years on the job, he had no desire either to retire or to join the suits in the detective squads. He was a street cop, period. And he was old school, inclined to kick butts now and take names later.

Among his colleagues, Harry's a legend. They brag that he has a sixth sense about crimes in progress. A car parked hinky in a driveway says break-in to him when it says nothing to his partners. An out-of-state license plate on a nice car always needs a second look: what would Iowa or a new Beemer be doing on Skid Row at midnight?

I asked him, "Where is this woman who's going to tell us about Nelda Ruiz?"

"Working." He drove up out of the garage and turned east onto Sixth Street. "It's too early to talk to her. Let me take care of some business—I got three probationers in the field tonight. When

everything is nice and quiet, we'll go on over and visit Ms Lisa Peñaloza at her place of employment and see what she has to say. And before that, as soon as I get the call, we're going to also go see Jesús' little girlfriend, Teresa Galba."

"You found her?" I was surprised, delighted. "I thought she left the country."

"She did. Now she's back at home with the kids, and so is hubby," Harry said. "We need some backup before we go in. When that's in place, we'll roll."

"Backup, because?"

"Hubby, though I doubt they're actually married, is a real problem child. Not that she's a prize." He checked his rear view. "You'll see the kind of adulthood Jesús Ramón missed out on."

"You've put together a full dance card for me, Harry," I said. "I'm grateful."

"You might want to wait until end of watch before you commit yourself to gratitude," he said, grinning. "Get yourself comfy, it's going to be a long night."

Harry could have asked me to join him later in the shift, but I got the feeling that Harry liked having company in the car, an audience for his stories. Sergeants usually ride around alone. Every time one of the patrol officers makes a stop, the sergeant drives over and takes a look at what's happening to make sure that no unfixable mistakes are made, and to call in for any needed support. For the most part, it can be a lonely evening.

For an old hunter like Harry the fun was being on the scent, making the collar. Riding up after the fact held few charms for him. He told me the only reason he took the sergeant's exam was to raise his salary base before he pensioned out. Otherwise, he'd still have been in a patrol unit.

We rode Harry's route, circling through empty parking lots looking for stolen cars, coursing down alleys behind the vast, dark warehouses of the produce district watching for anything that seemed out of place to him. And then up San Pedro Street making sure the hookers behaved. As long as the working girls kept walking, Harry did no more than wave as we passed.

The footage I captured, accompanied by Harry's running narra-

tive, was priceless. The quality of my video was crude, but I knew I had something that Guido could use, if only to get Lana onto her plane Thursday night.

All the time he drove, Harry was on the radio to units in the field, black-and-white cars with two uniforms in each. An hour into the shift, they were all complaining that it was a quiet night. Next door, in the Rampart Division, there was a bank alarm and a four-car collision. But in Central, there was nothing except the occasional fistfight between drunks and a fender bender near a freeway onramp.

About eleven o'clock, Harry got the call he had been waiting for.

"Backup's in place," he told me, making a midblock U-turn. With his gumball lights flashing, but without a siren, he sped over to the Main Street address where he said Teresa Galba was living. When we arrived, there were already four patrol units parked on the street and a plain city car. Two more black-and-whites pulled up behind us.

"Why is all of this necessary, Harry?" I asked, watching uniformed men and women emerge from their cars and strap on their gear: Kevlar vests, nightsticks, side arms, flashlights, cuffs, and a battering ram.

"*All* of this isn't necessary." Harry reached for his own nightstick. "It's a quiet night, so we can give the troops a good training exercise."

"And I thought this show was for me."

"Sure," he chuckled. "We're hoping to bag two birds with one visit tonight. The guy Teresa lives with, Xochimil Guerrero, is a capo in the prison mafia. He's recently out of the slam, on parole. Word is, he's working his old connections and getting back into the action. Parole officer has been planning an unscheduled visit, so we'll back her up."

"You have a warrant?" I asked while he called in his location and his intention to go inside the address.

"Don't need it," he said. "Not with the parole officer there. She'll talk to Xochi, you can talk to Teresa. And while we're in there, we'll see what we see. You never know until you go in."

"And the reason Teresa will talk to me when she has never talked to anyone else is, what?"

"The stakes have never been this high for her before. She has a couple of kids now, and a bun in the oven."

We joined the huddle that had formed in front of the building next door. There were eight officers, four of them wearing midnight blue jumpsuits and boots, and an attractive woman about my age, wearing a polo shirt and khakis with a Luger on her hip. Harry introduced her to me, Patricia Goodson, the parole officer.

Goodson asked the first question. "What's the plan, Harry?"

"We're going in, apartment two-ten." Harry sorted the officers, jabbing the air with two fingers as he defined squads and assignments. "Two, two, and two. You two, outside, all exits, front and back. You two, in position up the stairs just past the second landing, you two, downstairs hall. Be ready if we need backup or someone comes running out." To the remaining pair, both in jumpsuits, he said, "Flank the apartment door. I'll knock, Goodson will call out. If there's no quick response, I'll signal you to boot the door. Maggie and Goodson will stay in the hall until the place is secure. Got it?"

They all said, "Roger that," but I held up my hand.

Harry turned to me. "Concerns?"

"There are kids inside," I said.

"Kids should be in bed at this time of night," Goodson said, eager to go in. "If they aren't, we'll add a neglect charge to anything else we find."

My face must have shown my reluctance.

"Trust me on this, Maggie," Harry said. "Because of the way these folks choose to live their lives, midnight raids are just a fact of life. You're going to be a whole lot more traumatized by what you see in there than they will be about finding us at their door."

"Whatever you say, Harry." I held up my little video recorder. "But camera's running."

"Good idea," he said.

One of the jumpsuited officers, a big, well-built man with Skruggs on his nameplate, straightened his collar and ran a hand

over his short hair. "Try to get me from the left," he said. "I film better on the left."

There was some nervous chuckling and nudging.

"When we go inside," Harry said, "we'll send Teresa out into the hall for a conversation with Maggie. You guys out there, keep a close eye on things. Teresa is a hard case."

"Where will you be, Harry?" I asked.

"Inside with Goodson, tossing the apartment, chaperoning a piss test." He swung his arm in a broad forward arc, doing John Wayne proud. "Let's roll."

Officers quickly and quietly moved into position. I walked up the flight of stairs, hugging the wall like the others, following Goodson, the parole officer. On the opposite side of the door Skruggs, the jumpsuit with the photogenic left side, held the battering ram ready to boot the door. When Harry saw that everyone was in place, he gestured for Goodson to move closer beside him, and then, with the barrel of his pearl-handled Smith and Wesson .45—he was an old cowboy at heart—he knocked on the apartment door.

"Parole Office," Goodson called out. "Open up, Xochi."

From inside, silence, and then some rustling. The battering ram came up, but Harry raised a hand to stay it and to keep everyone in position when locks turned, one, two, then there was a thump on the far side of the door as if someone kicked it or jumped against it, and then the sound of a chain hitting the door jamb. The knob turned, the door began to open.

Harry, poised to drop his hand as the signal to rush the door, froze, waved everyone back as he dropped to one knee, face now level with a pair of wide dark eyes in a frightened little face. Cautiously, Harry pushed the door open. Standing there, in a living room lighted only by a television set was a very little boy, no more than three years old, wearing action-figure jockey shorts.

Harry raised a finger to his lips as he looked into the boy's face. "Shh. *Cálmate, mijito.*" Be calm. "*¿Tu madre está en casa?*"

The little boy nodded and pointed toward a closed inner door. Behind the door we could hear the unmistakable sounds of lovemaking. I brushed past Harry, took the little boy by the hand, and

walked him out into the hall, out of the traffic lanes. Holding the boy to the side, I knelt beside the open door to see what was happening inside, camera running.

Silent in their rubber-soled boots, the jumpsuits slipped inside. The apartment was tiny, a galley-sized kitchen off the living room, and, apparently, a single bedroom at the end of a short hall; doors on either side led to a bathroom and a closet. It didn't take long to check over the entire place. When it was clear there was no one hiding, Skruggs, Goodson and Harry went to the bedroom door, flanked it, and, over the squeal of old bedsprings and the lovers who were making them sing, did their routine again. A loud knock and a shout: "Parole Office, Xochi. You need to come out. Now."

There was a confusion of whispering inside, some rustling, feet hit the floor, and the door opened.

A youngish man, maybe early thirties, with prison-gang tattoos all over his face, his arms and hands, his neck and his bare chest—tribal insignia illuminating his criminal history and his membership in the Sleepy Lagoon gang set, as if his compact body were a living totem pole—stood there, naked except for white jockey shorts that he had pulled on inside out. He was surprised to the point of tearfulness when he saw the wall of midnight blue facing him, as well as his parole officer, Patricia Goodson, all with hands on gun butts, more officers visible out in the hallway. The man assumed the position before he was asked to, hands locked behind his neck, legs spread.

Next the woman appeared, pulling a bathrobe around her thin body. Like her husband, she had elaborate gang tattoos on her neck, her chest, and her hands. Her front teeth were silver-foiled. She appeared to be pregnant, and seemed to be more angry than frightened.

"Paco," she called out as she scanned the room for her son.

"*¡Mami!*" The child slipped past me and ran to her. She more or less scooped him into the bedroom, whispered a firm caution, and then shut the door behind him.

"Maggie." Harry turned to me. "You want to get her out of here?"

"You're Teresa?" I asked her, looking at her closely, the gang tattoos, silver front teeth, old needle tracks on her arms, her toughness, her anger. This was not the Teresa of my imagination, not the pretty young innocent whose teenage boyfriend, young Jesús, had fallen prey to the street and disappeared. She *was* the street, a hardcore gangster, as she probably was on that particular January day. As Harry suggested, if Jesús had lived he likely would have grown up to be some version of the man in the inside-out underwear now lying spread-eagled on the threadbare carpet in front of his family.

"Come with me, please," I said and escorted her out to the hall.

When Teresa saw the officers watching us from their positions on the stairs and down the hall, she modestly pulled her robe tighter and crossed her arms over her breasts.

"You from the County?" she asked.

"Awfully late for a little boy to be up watching television alone," I said. Through all of this I held my camera in my left hand, about shoulder high. If I turned my head I could see what I was getting in the tiny monitor on the side so that I could make adjustments. Teresa said nothing about the camera.

I said, "Your son opened the door to strangers in the middle of the night."

"Xochi wanted…" She gazed toward the apartment door just as someone closed it.

"Sex," I said.

She nodded. "I don't like to do it with my little boy in the same room."

"How long has Xochi been out of prison this time?" I asked.

Her hand dropped to the round ball of her pregnant belly. "Five months, six almost."

I took her arm and turned it over, showing the blackened track scars. "Are you using?"

With her hand still limply in mine, she shook her head. "Not now."

"Teresa, I want to talk to you about a boy you knew a long time ago. Jesús Ramón."

"Jesús." She shook her head. "I don't want to talk about Jesús no

more. Everything I know about that boy, I told it a long time ago. I want to forget that boy."

"The day after he went missing, you left the country," I said.

She nodded. "I went to stay with my grandmother in Mexico for a while."

"Tell me about Jesús," I said. "His mother thinks he was an angel, the police think he was a little devil. Which was it?"

"Both," she said firmly. "He was just a boy, like all the rest of them."

"You were in a gang."

"That's how you stay alive where I come from."

"How was Jesús doing in school?"

"He already dropped out." She seemed to be studying the floor, bored or defiant, or I didn't know what, but she wasn't looking at me.

"Were you in school?"

"I quit in eighth grade. Didn't need it."

"You were with Jesús the day he went missing," I said. "You saw him get into a car with Detective Mike Flint. Tell me what you remember."

"*Nada.*" She shook her head. "Nothing. Don't remember nothing."

"What did Detective Flint say to you and Jesús?"

Again she shook her head.

I said, "And what do you remember about Boni Erquiaga that day?"

Boni's name got her attention. Her head snapped up and she looked at me with heat flashing in her dark eyes. "Is he still in prison?"

I nodded. "I visited him there a few days ago."

"Did that lying bastard say anything about me?"

"Like what?"

"Like I know who killed Jesús and where his body is."

"Do you?"

"No," she said with enough force that the officer down the hall moved a few steps closer. "I don't know nothing about nothing that happened after I saw Jesús go away in the officer's car. He was just gone, all right?"

"Did Detective Flint seem angry with Jesús, or was he rough with him? Did Jesús resist him?"

"None of those things. Jesús put back his hands, the officer cuffed him, and Jesús got in the car. They drove away. That was all."

"Where was Nelda Ruiz when that was happening?"

"That *puta* was right there by the car with Boni. She'd been doing him for a while. She told me he was always after her, you know. She told me he threatened her what he'd do if she wouldn't give it to him."

"Did you believe her?"

Teresa, with exaggerated ennui, said, "I didn't care."

"That day wasn't the first time you saw Jesús get arrested, was it?"

"No. Cops, they're all over us all the time. Like now." She locked eyes with the closest uniformed officer. "Pigs."

"So it wasn't a big deal when Jesús got picked up that day."

"No."

"But on that day, you ran all the way over to Mrs. Ramón's *bodega*, crying. You got her to go over to the police station to bail out her son," I said. "Why were you so upset that day?"

"That day was a long time ago," she said. "I don't remember."

Then I remembered that Harry had said there were kids, plural, in the apartment. So I asked, "How many babies is this for you?"

"Three."

"Where's the other one?"

"In Mexico with my grandmother," she said. "Xochi isn't her father."

Harry opened the apartment door. "You need us to get the boy's clothes together, Maggie?"

"No, Harry, I don't," I said, understanding that he was making a threat to the woman, and I didn't like it. "We're finished. Teresa is having some serious memory problems."

"I understand pregnancy does that to a woman." He turned back into the apartment. "We're done here. Let's go, let the kid get to bed."

Officers filed out. Patricia Goodson lingered to offer a few

words of advice and caution for Xochi, but let Harry have the last word. Xochi still seemed a bit dazed after having his domestic peace invaded in the middle of the night.

"You two," Harry said. As he lectured both parents, he pulled one of his cards out of his breast pocket, wrote a number on it, and handed it to Xochi. "You have a smart little boy in there. You need to do a better job taking care of him. Time you both start acting like the grownups, set an example for him. This number is for a friend of mine, a plastic surgeon. He'll laser off those tats for you, won't charge you anything if you tell him I sent you. It'll hurt like hell, but you need to do it. For the boy."

His parting words were, "Don't make me come back here."

Then we followed the others down the stairs and out. There was no curbside debriefing. Without fanfare, everyone got back into their cars and fanned out to patrol the streets.

"Get what you wanted?" Harry asked me. He made a midblock U-turn and radioed that he was back on patrol.

"I'm not sure yet. Did you?"

"Yeah, pretty much. We want them to know we're keeping an eye on them. Xochi peed in a cup and came up dirty. Goodson gave him a warning in exchange for his drug source. Says he just goes down on the street and looks for a crowd by a fence."

"Do you believe him?"

"Maybe. He says Teresa won't let him bring it in the house, and that's good."

"Do you think she's clean?"

"Lord, I hope so."

Harry drove us up Broadway, then crosstown on Sixth Street. Downtown was beautiful—towering high-rises lighted for the night, palm trees swaying in a warm, gentle breeze—as long as I looked up. At street level, even though the streets were clean and the buildings were generally in good repair—many indeed were elegant—on random blocks the scene was like driving through a circus from hell. Inside the gated entry of a once famous hotel, a wizened old woman with a kerchief on her head, a *babushka*, sold little plastic bags of something to the human ruins who reached hands through her iron bars.

"This endless all-night shuffle." I looked at Harry's profile. "Does it ever get to you?"

"Only when it's kids."

"Like that little boy tonight?"

"That kid? No. He's just fine. Bright little guy, look at what he did, figuring out how to unbolt the door. Right now he has two parents and a roof over his head and no one's hurting him. What else does a kid need?"

"A future."

He smiled. "I can't play God."

"Mike would see that little kid as a gangbanger in training."

"Maybe that's the difference between Mike and me. He was a good cop and all. One of the best." He eased across a deserted intersection against the light. "But he did tend to look on the dark side of things."

"True," I said.

Harry turned to me. "Soon as I met you, I knew you were the one who was going to make the difference for Mike. Out here, it isn't easy staying straight all the time, doing the right thing instead of the easy one. Because of you, Mike made some good choices he might not have made if his life had been different."

"He did the same for me," I said. I turned to look out the side window. Mike the tough guy, the softy. And the nag. Tough to argue with someone who sees the world in black-and-white when your own realm is mostly shades of gray. Noisy sometimes, but it worked. For us it worked.

After a few blocks, Harry reached across and patted the seat beside me. "It's none of my business, but you okay?"

"Sure," I said. "I'm just fine."

"You have to give it time. You'll miss Mike…"

"Harry," I said before he could get any further into that particular riff; how many people had given me some version of the same advice over the last couple of days?

"Don't mean to pry, just want you to know I'm here," he said.

"Thank you," I said. "I appreciate the concern."

"You're very welcome," he said. "As long as we're over this way, we might as well go check on Lisa Peñaloza.."

— . —

Club Las Palmas was a taxi-dance place that had been doing business on Broadway since World War II when the sailors were in town. There was a new clientele and a new décor, a Mexican fiesta theme, and the price for ten minutes in the arms of a dance hostess had risen from a dime to five dollars. But the general idea remained unchanged over sixty years, and was best expressed by the flashing neon sign over the door: GIRLS, GIRLS, GIRLS.

The men taking some air on the sidewalk in front of the club looked like *compañeros*, country boys from Mexico, all slicked up for romance. There were a few in jackets and ties, but most wore a variation on a starched, tight-fitting, western-style shirt, tight, pressed jeans, and hand-tooled boots, the ensemble topped off with a stiff, white straw cowboy hat.

"Girls, girls, girls?" I said as we passed under the neon. "You take me to the nicest places, Harry."

"It's okay here." He held the door for me. "Most of these guys are a long way from home, can't afford a wife, or the wife is back in the village hoping he doesn't get into trouble. These boys work hard for their money. They get a little coin in their pockets, they come here, dance a little, get a little hard-on, have a good time. No liquor, no hands below the waist. Who's hurt?"

We strolled in past the security desk with no more than a nod. A mirror ball spun above the dance floor. Couples on timers sat at tables around the dance floor, or they danced close. A snack bar at the near end sold supermarket-brand soda for three dollars a can.

The music was *Banda*, the language of love was Spanish, and the hostesses were, every one of them, Latina. Their party dresses were cheap and bright and shiny, but over all they were attractive and wholesome-looking. Some of them would have passed muster at any senior prom on the city's east side.

I looked around. "All they do here is dance?"

"Downstairs that's all. For a little extra, you can take a girl upstairs for 'conversation.' There's no sex allowed, but who cares if you cop a little feel when no one's watching?"

Harry was on patrol, as Harry always is, looking around, making some of the paying guests uncomfortable. We weren't

Immigration, but anyone in uniform probably made a good portion of the clientele nervous.

The manager intercepted us as we walked toward the dance floor. He grinned big, showing a gold tooth, showing his apprehension as well.

"Can I help you?" he asked, actually wringing his hands.

"I'm looking for someone." Harry kept eyeing the room. "One of your hostesses, Lisa Peñaloza."

"Sorry." The manager shrugged, held up his palms. "*No la conozco*. No Lisa Peñaloza works here."

"Maybe she uses a different name." Harry reached into his breast pocket and took out a mug shot, a woman with dark hair and a black eye, and handed it to the manager. With barely a glance at the picture, the manager shook his head and handed it back.

"As I recall the state statutes covering dancing establishments," Harry said, the mug shot held up in front of him, "you have to run a background check on all the hostesses you hire. If anyone comes back with a history of solicitation, you can't hire her. Now, see the woman in this picture? She is a convicted prostitute. I have good information that she is in your establishment tonight. I intend to find her."

"I go by the rules. Strictly by the rules. There are no whores working in my place. I run an honest business. Chamber of Commerce all the way."

"Listen to me, Jorge."

"Fredo," the manager corrected.

"Fredo. There are a couple ways we can proceed. I can spend the rest of the night going through your place, one *chica* at a time." Harry paused to give Fredo time to think over the implications; some of the paying guests were already slipping out the front door. One deserted his partner in the middle of the dance floor and made a quick exit. "Then again, maybe this girl lied to you, gave you the wrong name so she would came up clean. How could it be your fault?"

"Oh-h-h." Fredo hit his head, eyes wide as if revelation had just flashed by. "*Soy estúpido*. Lisa something. Sure. You say the *puta* lied to me?"

"That must be the way it happened," Harry said. "Now, is she here?"

"I think I saw her go upstairs to the small lounge with a customer."

"Thanks, Fredo." We headed toward the elevator.

Fredo came with us as far as the elevator door. "You tell that *puta* to get out of my place. You tell her that if she ever comes back, I will throw her out on her round little ass."

"Sure, Fredo." Harry waited for another couple to enter the elevator before we followed. "That's exactly what I'll tell her."

Fredo declined to come upstairs with us.

The couple sharing the elevator was young and less than pleased to be confined with Harry. He seemed amused by their discomfort. He asked the woman, "How much can you clear in a night working here?"

She held up her hands and said, "*No hablo inglés.*"

So Harry repeated the question in perfect Spanish. Trapped, embarrassed that her ruse had not worked, probably afraid not to be cooperative, she answered in English.

"Sixty dollars, sir," she said. "We work from six o'clock until one in the morning. On a good night, I can take home maybe sixty dollars."

"Counting tips?"

She nodded her head.

"Sixty dollars is barely minimum wage," I said.

She shrugged, then the doors opened and the couple got out.

I said to Harry, "What do you think she really earns?"

"Couple hundred, most of it under the table. All cash. Plus whatever services she negotiates to deliver after hours."

The upstairs lounge had sofas arranged for privacy. There was another snack bar, and a security man, but no one seemed to be paying attention or checking to see whether a little hand-holding here and there bloomed into heavy petting. It was dark enough that you'd have to look very hard to see what your neighbors might be doing, if you cared to.

I spotted Lisa first, sitting with an older man off to one side. They were angled facing each other, heads touching; he had an

arm on the back of the sofa behind her. Her hands were busy down toward their laps.

I peered through the gloom, expecting to see Lisa working in the area of her customer's fly. Instead, I saw her surreptitiously unscrew the cap of a half-pint bottle of Bacardi and pour some into the open cola can the man held with his free hand, mixing a Cuba Libre. She recapped the bottle and slipped it between the sofa cushions. The customer raised the can and drank, and then he offered it to her.

Harry walked over and sat down close beside Lisa on the sofa, crowding her. I sat on the little cocktail table in front of her, our knees nearly touching.

"Hello, Lisa," Harry said.

Lisa looked at Harry, eyes stopping on his shiny badge. "I didn't do nothing, Officer," she said, defensive. "Anybody says I did, they lied."

"Just want to talk to you," he said quietly.

"Another time." She put her hand on her customer's thigh and turned away from Harry. "I'm working right now."

"How you been doing since you got out of Frontera?"

"Frontera?" She flipped her hair over her shoulder, a disdainful gesture. "Never heard of that place."

"I understand you got pretty close to your cellmate, Nelda Ruiz, when you were at Frontera," Harry said. "When was the last time you talked to her?"

"I told you already, I don't know what you're talking about." She seemed awfully huffy.

The date started to speak, but Harry stopped him with a glance. "You want to excuse us, pal?"

The date seemed happy to be excused, but Lisa grabbed him by the belt before he could get away. All she did was glance at her watch, and the man handed her a string of tickets. She looked at the tickets, then up at the date, and he gave her three more before he went away, taking his drink can with him.

She stuffed the tickets into her little sequined evening bag. All pouty, she shouldered Harry. "You screwed me out of a good tip."

"Lisa," Harry chuckled. "I just screwed you out of your job. But

before you leave this place tonight, you're going to tell me what I want to know about your bunkmate Nelda Ruiz or I'm going to screw your ass into jail."

"On what charge?" She had a whole lot of attitude.

"Violation of parole; you haven't registered your current address with your parole officer. And if I take you in and the matron finds any evidence of a certain testosterone-rich joy juice in your underwear or behind your teeth, I'll book you for lewd behavior in a public place, too."

Uncowed, Lisa muttered, *"Chíngate."*

"I would if I could," Harry laughed. "But I'm not that well built. Now, if you cooperate a little, I'll forget where I found you, and you can finish your shift and cash in your tickets. Just don't be here next time I drop by."

I said, "Where can we find Nelda Ruiz?"

Lisa looked directly at me for the first time. Her question was a challenge. "Who are you?"

"My name is Maggie MacGowen. I want to talk to Nelda."

She evaluated me through narrowed eyes. "I know you. You're the lady on the TV, aren't you? I saw you."

"Yes," I said. "I work in television."

"You make a lot of money from the TV?"

"Not as much as people seem to think."

"I hear if you know something about somebody famous, or you have a picture of somebody famous, you can get big money for it."

"I don't buy information," I said.

She put up her hand between us, the hand wall. "That's fine with me, 'cuz I got nothing to sell. And I haven't seen Nelda, neither, because talking to her would violate my parole."

"I thought I made myself clear," Harry said.

"Yeah, yeah." She waved him off. "You take me in, I'm out tomorrow and you still don't have what you came for."

In the old days, this is where the cop would have slapped her face, the bitch slap. Since Harry was adhering to the kinder, gentler school of policing, at least in public, I considered doing the deed for him. Instead I leaned in close to her and pulled the Bacardi out from under the cushion. I opened the bottle and of-

fered it to her. First she glanced toward the security man, saw he was talking to the snack counter clerk. Then she looked at Harry, her shield if security should become interested, and gave herself a big shot of dark rum.

"Harry has to play by the book," I said, holding up her mug shot with the black eye. "I don't."

She froze with the bottle halfway back to her lips for her second drag when she realized it was herself in the picture.

"You don't look so good all beat up," I said. "Hard to get paying dates when your face is trashed."

"You threatening me?" Unsure of herself finally, she turned to Harry. "She threatening me?" Harry just shrugged.

I put my hand in my jacket pocket and came up with a twenty. I held it out to her. "Twenty bucks buys forty minutes of your time. How long do you think it'll take you to tell us what you know about Nelda?"

Lisa took another long swallow of rum, let it do its work while she considered her options, I thought. Then she snatched the twenty and made it disappear.

"Nelda is probably working out of the bus station."

"Soliciting?" I asked.

"She ain't no whore. That ain't her thing. Miss Nelda picks up people who come downtown looking to score some crack or some bud. She takes them out into the neighborhood and makes the buy for the customer. It's good money 'cuz she gets paid on both ends: The customer gives her a cut of the score, the dealer gives her a kickback."

"Do you send her customers?" I asked.

She squirmed a little, but she didn't say no.

"How do you get in touch with her?" I asked.

"She calls me on my cell to tell me where she'll be, gives me a password for customers, tells me where she'll leave my cut." Lisa frowned. "But I haven't heard from her for maybe a week."

"What's she driving?" Harry asked.

"Her? Drive?" Lisa laughed, as if the notion that Nelda would use her own car was naive. "They take a taxi from the bus station."

"A taxi?" I glanced at Harry for confirmation.

"It's smart," he said. "If anything doesn't look right, she can get away clean."

He took Lisa's mug shot from me and slipped it back into his pocket. "Where is Nelda's candy store? Where does she take her pigeons?"

"What, you think she'd tell me?"

"I do."

She tried to shake him off. "Most times, some yard down by the bus station."

"I'll check it out, Lisa." Harry rose. "But if I find out you're lying to me, you know I can find you."

"Yeah, yeah," she said, followed by a great big, sad sigh.

When we came out of the elevator downstairs, Lisa's boyfriend was already trying to fall in love with a different girl.

Back in Harry's car, we made another circuit through empty lots, scattering people off the streets. I yawned and asked him if he got bored, or if he found a quiet place to take a nap from time to time. He said no to both questions. I knew this could never have been my job.

At the corner of Sixth and Wall, a block past the Greyhound bus terminal, with his spotlight Harry scattered a little gathering of flowers of the night, five or six not-very-young women, all of them wearing the uniform of their trade: well-stretched spandex and crippling high heels. These women who worked the transient crowd were hardly *Pretty Woman* material: dirty hair and soiled clothing stretched too tight over slack bodies. Some were fat and some were skeletal, none of them had been anywhere near lovely for a long time. A far cry from the women working Club Las Palmas, this neighborhood defined the low end of the love-for-hire trade.

"Strawberries," Harry said. "Look at their teeth, that's how you tell. They work for drug money. Smoking crack and meth fries their gums and their teeth go to hell. Later, just to cheer you up, I'll drive you over and show you the real babes. The most gorgeous hookers in the division."

Harry cruised along beside a chunky blond woman, separating her from the others. She wore tight, midcalf-length sunflower-print leggings and a tiny pink halter top. After one glance to see if we were potential clients, she kept her eyes straight ahead.

Harry rolled down my window, and called out to her.

"Hey, Wanda." He steered with his left hand as he leaned over me to talk to the woman. "When'd you get out?"

"Out of where, sir?" She wouldn't turn her head toward him. "Sir, I do not know what you're talking about. Sir."

I thought Harry was having too much fun. "Just taking an evening stroll, Wanda?"

"Yes, sir, I am. Getting me some fresh air."

He stopped, and she stopped about even with the headlights so that all we could see was her dimpled backside and her midriff roll.

"C'mere, Wanda. Talk to me."

She hesitated, but she backed up a few steps and bent down to put her face at window level. She had no front teeth on either top or bottom, and her skin was hard, as if it had been left outside to dry like beef jerky. More than anything, she looked used-up.

"Who's your dealer?" Harry asked.

"No sir," she said, shaking her head. "I'm clean."

Harry's sleeve brushed my chin as he extended a mug shot of Nelda Ruiz towards her. He said, "You see her tonight?"

"I'm sorry, sir, but I do not believe I have any knowledge of the lady."

"Nelda Ruiz." He flipped one of his cards out of his breast pocket and handed it to her. "If you see this woman, you call me. And if you do, next time you get picked up, have the arresting officer call me. I'll stand up for you."

She was still leaning over, waiting for Harry to say or do something, when Harry rolled up the window and pulled away.

"Cons," he said, head turned away to the left to check for oncoming traffic. "You can always tell a con by the way they talk. Yes, sir. Yes, sir. Yes, sir. You hear her? That's how they have to be in the joint. Totally servile."

"You called her by name," I said. "Do you know this woman?"

"Sure I know her." He laughed. "And her mother, too. I just never met her before."

"So her name's not Wanda?"

"Now it is. Just ask her."

I rolled my window back down a few inches to let in some fresh air. The fetid smell of the woman filled the car. "She needs a bath and a toothbrush."

"Hasn't got many teeth left to brush."

Harry made a sharp right turn at the corner, dropped down to Seventh where a patrol unit had a man against the wall. Harry pulled up behind them and we got out.

"What do you have?" Harry asked the arresting officer, a very buff woman rookie. Her partner, who was her training officer, stood to the side, right hand on the butt of his service revolver as he evaluated how she handled herself.

"D and D. Too much to drink, got in a fight with his buddy."

"Where's the buddy?"

She nodded toward her car where I could see the profile of a man in the backseat. "They're pretty steamed."

"Anyone hurt?"

"No. They both got in their shots, but they're both way too drunk to inflict much damage."

Harry walked over to the car and had a conversation with the man inside. He came back grinning. "Buddy's crying. Take them in, let them sleep it off in lockup."

"Okay." The woman officer handcuffed her charge and using the chain between the cuffs like a handle, she guided him into the backseat of her car next to his friend. I heard her say, "You two behave. And don't throw up in my car or you'll have to clean it up."

Before we left them, Harry asked both officers to keep an eye out for taxis leaving the bus station with a dark-haired woman in the front passenger seat. He showed them Nelda's mug shot.

As he eased away from the curb, Harry said, "I like that rookie. Has a lot of confidence about her. You might even say she has attitude. That's what a female street cop needs to survive out here, a salty attitude."

We were at the edge of an industrial zone. Harry drove down

the side streets: Cyclone fences around salvage and storage yards, the walls of blocky warehouses—all of them dark for the weekend—were the backdrop for what looked like a low-rent Scout camp. Against the fences and windowless walls, street people had erected shelters for the night.

By one-thirty, when we turned down Kohler Street, the sidewalks were solid with the assemblage of junk the homeless use for building materials. Harry drove slowly with his headlights out. The fence around one particular salvage yard seemed to be a gathering place, a club *al fresco*, as it were. As we approached, the denizens of the block scurried out of the open to slip into their shelters, out of sight.

Harry turned on his spotlight and aimed the beam through the fence. A dog barked somewhere inside, but all I could see were dark mounds that looked like the carcasses of broken machinery.

"Dealers hang out inside these fenced-in yards, a different location every night," Harry said, following the beam of his spot. "They sell through the fence. Anyone goes after them or tries to rip them off, they just disappear into the junk."

"You'd think the property owners would put up lights."

"Waste of money." Harry shrugged. "The crackheads would only knock them out. For the good citizens camped out here on the sidewalk, it's like living next door to the candy store. Anything they want, they just go to the fence and order it. If they go back into their hovels to smoke or shoot up, we can't go in after them unless we see the buy go down or we get a warrant; court says 'expectation of privacy.'"

I turned on the camera again and aimed it at the fenced yard, hoping to see something there. The shadows in my monitor were ghostlike; were there human forms inside, or were the apparent movements only tricks of the light?

Harry turned off the spot and accelerated toward the corner. Before he turned the corner, he took a last glance over his shoulder at the street.

"You notice how many people were hanging out right where that Dumpster is? I think we've found where the candy store is tonight. Or one of them." He had a *eureka* grin on his face. "Pretty handy to the bus station.

"The guy behind the fence can be a fairly big player and pretty well connected," he said. "Takes a big stake, or a backer, to buy enough stuff to stock a store. Lot of volume passes through that fence in a night, lot of money to be made if the dealer doesn't smoke up his profits."

"Shall we stake it out and hope that Nelda shows up?"

He shook his head. "Don't worry, we'll get her. Right now, though, we're going to go find the gorgeous hookers I promised you."

He turned down Ceres Street. The area was in transition from residential to commercial use. Small, old apartment houses sat among newer commercial buildings. At the far corner, the bottom floor of an old, narrow, two-story, yellow stucco tenement building was the Club Caribe, a beer and wine bar. Reggae music poured from the open front door. Above the bar, bright red and turquoise curtains billowed from open apartment windows. The place was seedy, but in a tropical way. Exotic. The people hanging around outside were a mixture, white, black, Asian, Hispanic.

Nice cars and hopped-up pickup trucks lined both sides of the street. The club and the apartments above it seemed to be an oasis of gaiety in a desert of squalor. Well-dressed men hung out on the sidewalk with women who were so flamboyantly beautiful they could have been refugees from a Las Vegas floorshow.

Every woman was tall and slender, snaky-hipped and graceful. They still wore hooker high heels, but their clothes were fabulous, like high-budget-film versions of streetwalker apparel.

Harry pulled up to the curb and honked. A tall creature wearing a tight purple Chinese silk sheath toddled over, swinging her shoulders to make her breasts sway. It wasn't until she leaned into Harry's open window that I caught on.

Harry cupped his hands over his own breasts. "Where'd you buy those?"

"Tijuana." Sounded like *Ti-hwhana*, the *J* rolled at the back of the throat. The he-she's baritone voice and five-o'clock shadow gave him away.

"How much?"

"Two thousand, but worth it." The beauty pointed to my chest. "You want a referral? I'll give you a card."

"Lovely, but no thanks," I said.

"How about down there?" Harry asked, pointing to his own lap. "You still have all your goods."

"Good God yes, honey." Our friend reared back and laughed. "I wouldn't let no man with a knife touch my little Petey. Uh-uh. Why you ask me such a personal question? You want to see it?"

"I'll take your word for it," Harry said.

"Speaking of down there." The beauty gestured for Harry to lean in closer. "There's all kinds of implants you can get. You want a nice set of big *cojones*, they run you about a thousand, fifteen-hundred, but, my, they are pretty. Feel good, too, like real."

"Thanks for the information." Harry blushed, looked at me, shrugged, and began to pull away from the curb. "See you."

"Bye-bye, Officer, honey." Playfully, tottering on his ridiculously high heels, the man ran after us for a yard or two, blowing kisses. "Come back, now. I'll be looking for you."

"Thanks, Harry," I said, laughing, as we drove away. "As I said earlier, you do take me to the nicest places."

"Thought you'd enjoy that," he said.

"I'd kill to have that guy's thighs."

"He's a Barbie doll. Everything he has is made of plastic." Harry shook his head. "You'd be surprised how many hetero guys, at least guys who like to believe they're hetero, come down here. Like they think that when they have their hands on a set of silicon boobs, it makes shoving their six inches into a whore's poop chute somehow not gay sex."

After a while, we stopped by the station to stretch, use the rest room and get hot coffee. While we were there Harry set up a strategy with a couple of his patrol units for tracking Nelda. I suggested staking out the bus station, but he said a good stakeout would take too long to arrange. If Nelda spotted a tail she would jackrabbit and we'd have to start all over again.

The plan was to watch any taxi that turned down Kohler Street. The fare would be given time to make a buy before anyone closed in.

While Harry worked out the details, I took advantage of the break to walk down the hall to the ladies' room. When I came back

out, there was a tall, well-built man, late-forties, waiting for me. He wore civilian clothes, an open-neck shirt and Dockers, but, because of his posture and attitude, I knew he was on the job, or had been.

"You're MacGowen," he informed me.

"Guilty," I said.

"You think you're going to go out there tonight and find Jesús Ramón?" He was sarcastic, dismissive. A hard-ass.

"Might take me till morning," I said, looking him square in the face. "I didn't get your name."

"Washington," he said. "Eldon Washington."

"Interesting." I looked him up, I looked him down. If he didn't have eight inches and ninety pounds on me I would have spun him around and checked his backside, too. Here was Eldon Washington who busted Nelda the day Jesús disappeared. Someone I wanted to talk to. I wondered who had called him.

I said, "I heard you retired."

"I put in my twenty-five," he said, as if that gave him some sort of credential to have major attitude. "Doing investigation work for the district attorney now."

"At this time of night?"

"I do what I need to do, when I need to do it."

"Actually," I said, "I'm not looking for Jesús, but for an old friend of yours, Nelda Ruiz."

"So I heard."

"Maybe you're looking for her, too?"

He shook his head. "Not me."

"Glad I ran into you," I said. "Saves me a lot of phone calls. I was hoping for a chance to talk to you about what you remember from that particular day ten years ago. You were there, saw everything."

"I saw the beginning, that's all. After Mike drove away, I know nothing."

"Interesting running into you, here, now," I said. "I would stay and chat, but I need to get back to Harry. When you're feeling a little better, I'd like to sit down with you."

He frowned, puzzled. "Feeling better?"

I nodded toward the men's room door beside him. "I believe I interrupted you on your way to take care of some business." I

flipped him my card before I turned to walk away. "Call me any time."

Harry watched all this from the other end of the hall. I saw him roll his eyes and shake his head.

"Better watch yourself," Harry said when I caught up to him.

"Maybe you'll explain to me what his problem is."

"He's afraid you might actually find Jesús, something he's worked on for ten years and failed to do."

"Maybe if he didn't work so diligently on his hard-ass routine," I said, "he'd get somewhere."

When we were back in the car, I asked Harry, "Did they find the gangbangers who followed that policeman home?"

"Like I told you," Harry said, sounding cocky. "Cops are too smart to get followed home. The guy's step-kid got into a situation with some knuckleheads at school—he owed them money for bud—and they went after his mother as a warning. That's all there was to it."

"You're a genius, Harry," I said.

"I know," he said. "That's what I keep telling my wife."

I laughed; sometimes he reminded me of Mike.

"The thing you got to remember is," he said, "most violent crime is a family affair."

Harry and I made another circuit of the eastern end of the division, up and down dark and quiet streets and through the empty parking lots again. It was well after two o'clock. The bars were closed and the drunks were all down for the night.

"The druggies are pretty much all stoned or broke by now," Harry said. "In another half hour the dealers will close up shop."

With every circuit, we passed the bus station, looking for the right combination of people in every taxi.

At about two-thirty a taxi left the cab stand at the bus station and headed east on Sixth Street. Harry saw it in his rearview mirror and told me not to turn around, so I adjusted my side mirror to get a look. There were two passengers in the back, both of them sitting very low. In the front seat, next to the driver, sat a tall, blond woman.

"That isn't her," I said, disappointed. "Nelda is small and has dark hair."

"We'll see," Harry said.

The taxi turned onto Kohler; we stayed on Sixth, drove on for half a block. Then Harry made a sharp U-turn and stopped about fifty yards from the intersection. He seemed to be counting, as if this were a familiar dance and he was waiting for his cue to cut in. I watched the clock in the dash tick off seconds. At forty-five, Harry's internal alarm must have gone off.

When Harry moved, he moved fast. With the car lights off, he revved the cruiser, floored it, careened around the corner and laid rubber as he braked to a quick stop less than a foot behind the taxi. Somewhere in the dust and noise, he had snapped on all his lights, catching the front seat passenger in motion just as she slipped back into the taxi after making her buy.

I snapped on my camera's flash—a dazzling halogen drilling a hole through the dark—and captured the scene in bright silver artificial light, with Harry's red-and-blue gumballs flashing on the margins. It looked wonderful, unearthly.

The cab driver had to have known what his fares were interested in when he picked them up. He had stopped maybe thirty feet before the salvage yard fence, lengthening by a few seconds the time it would take for the passenger to make her buy, forcing her to cross the street but also leaving himself a cushion for escape if things went sour. He hadn't counted on Harry.

For an old-timer, Harry was quick on his feet. He had his rover radio in one hand, calling for backup, and a Kel-Lite flashlight in the other. In three long strides he was beside the front passenger door shining his Kel-Lite into the faces of the passengers. I was right beside him, my bright light adding to their alarm. I was pumped.

Everyone inside the cab froze; the only movement was nervous shaking, which I suspect was exactly what Harry intended.

"Hands where I can see them," Harry bellowed, and four sets of upraised hands cast shadows in the flickering lights, a puppet show of a sort, a Noh drama. With his flash he picked out the face of the blonde in front and abruptly yanked open her door.

"You, keep your hands where I can see them, and step out."

"What is it, Officer?" The woman stayed in her seat, trembling. "We haven't done anything. We just came in on a bus and we're

lost. I think my cousin gave me the wrong address. Or maybe I wrote it down wrong."

"You're all family, then?" Harry's flashlight played on the two black men in the backseat. "I suppose if I ask your cousin's name, you'll all say the same thing?"

One of the men in the back said, "I don't know what she's talking about."

"Where you from?" Harry asked him. There was some equivocating, but the two passed up their IDs. Harry looked at the IDs and passed them back. The woman said she hadn't brought her purse with her to such a bad neighborhood, so she had no ID. Said her name was Nicky Jones.

"Ma'am, I need you to step out of the vehicle," Harry said. When she still did not move, Harry reached for his handcuffs. The woman hopped out so fast she nearly fell on the broken sidewalk.

"Oh, please don't cuff me, Officer. I've never been arrested before."

"Uh-huh," he said. He pulled her hands behind her and snapped the cuffs on her skinny wrists. "Why don't you go stand over here where Detective MacGowen can keep an eye on you."

I'd been promoted, suddenly. Doing my best to look detectivish, I walked her a few feet away from the car and watched her through my camera lens.

"Don't do that," she pleaded, trying to block her face with her shoulder. "Why d'you have to do that?"

"Just covering our backsides, ma'am," I said, imitating Mike when he retold stories about the street.

The woman who called herself Nicky Jones didn't look much like my image of a crackhead or a dealer. She was plain, and very thin. Not pretty, not a drugged-out hag, either. Her thrift-store duds made her look like a small-town hick, pastel polyester pull-on pants and a striped T-shirt with a collar, pink Keds: old-fashioned, unhip, square, with a big teased hairdo. I thought it could be a costume so that she would blend in with the folks who rode Greyhounds instead of 747s. An ordinary woman from the heartland.

Harry came over to talk to AKA Nicky.

I saw movement behind the fence, a figure too tall and too hu-

man in structure to be a dog. Someone was taking a big risk, staying around to eavesdrop while the police questioned Ms Nicky Jones. As I turned off my camera I wondered what a random flash shot aimed at the dark figure behind the fence would pick up.

Harry was busy with his arrestee.

I took a few steps into the street to get away from the flashing car lights, and saw the figure move again, a head, a shoulder, spikes of hair.

The Dumpster, where we had seen people congregating earlier, was on my side of the fence. It was about five feet high; the fence behind it was eight with a double strand of barbed wire at the top. Someone had thrown a flattened carton over the barbed wire, perhaps so he or she could climb over.

"Be just another minute, Maggie." Harry had his rover radio in his hand. "I'm going to turn the collar over to that female rookie we met, give her the experience of booking in a female prisoner. I don't want to do it because we'd have to drive all the way over to Hollenbeck Station. Central doesn't have holding facilities for women."

I said, "Okay," watching the figure in the dark, so still that after a while I thought that maybe I had fooled myself into seeing something that wasn't there. But it turned as Harry moved, as if watching him, or watching the prisoner. From the angle the chin was pointed, I thought I was outside the person's field of vision.

The backup car turned in off Sixth with a roar of dual carbs. The figure behind the fence grew very still for an instant, and then hunched down and began to slink away, deeper into the darkness. As it moved, fearing that I was about to lose something essential, I feinted right, into shadow, flipped on the flash and camera again, and ran toward the retreating shape, hoping that the camera would capture more than I could see.

"MacGowen!" Harry shone his big light on me. "Bring that camera, come here."

Whoever had been on the other side of the fence was gone. I trotted back across the street.

"Look at this." Harry gestured with the beam of his flash. On the taxi's front passenger seat there was a little pile of shiny, sugary-looking chunks, each one about the size of the nail on my pinkie

finger. If I sat where our suspect had been sitting, the pile would have been between my legs.

"Twenty rocks," Harry counted. "Enough for a party. What did they cost you? About a hundred?"

The backseat talker said, "I gave her a hundred. She went over across the way and made the buy."

I filmed the crack cocaine for Harry.

"Oh, please, Officer." Ms Jones seemed genuinely frightened. Her shakes seemed to start where her feet touched the sidewalk and zap a cold line up through her spine. "I've never been in trouble before. I was just doing a favor for friends. I'm not a user. I can't get arrested. What will happen to my family?"

"You shoulda thought of that before you came down here." Harry scooped the cocaine into a plastic evidence envelope and wrote on it. The end of the bag hung out of his breast pocket while he reached back into the car for the purse sticking out from under the seat.

He held up the purse. "Yours?"

"No. I told you. I didn't bring my purse. I don't have ID. That one must belong to the last person who took the cab."

The cab driver had his head back against the seat and seemed to be praying to the heavens. When Harry showed him the purse and pointed to the woman, the cabbie nodded; the purse and the woman belonged together.

Harry found a wallet inside the bag and went through it while he lectured the backseat passengers about the dangers of fooling around in a neighborhood where they didn't belong, and told them to go home to Covina. And then he sent the cab and its passengers away.

Harry handed me the expired Utah driver's license he found in the purse. She probably wasn't Nicky Jones. No surprise there. But I wasn't certain she was Barbara Adams, as the license named her, either.

Harry pulled out Nelda's mug shot and held it in the light for her to see.

"Friend of yours?" he asked.

I thought there was a flicker of recognition, or maybe something else, like the possibility of a back door out of a bad situation,

a bigger fish to offer up when charges were filed. But she shook her head and said, "Don't think so."

Harry turned her over to the female rookie and stood back to watch how the officer handled a routine search. She patted the prisoner's pant legs, around her waist and shoulders. Then she put both hands into the woman's hair and gave it a tug; long black hair tumbled out as the blond wig came off, and with it a short crack pipe. Suddenly the out-of-town hick was a streetwise con.

The process took a little while. Harry yawned; I was bone-tired. I leaned against the side of Harry's car, flipped the video replay button on my recorder to see what I had captured behind the fence.

Black, indistinct patches against deep charcoal. A sudden bright flash of silver when I turned on the light, and then a human figure began to take form, someone crouched low, head dropped between shoulders, the form furtive, featureless, on the move. Disappointed, I watched this amorphous being retreat, merge back into the black.

And then there was a second light source from the side; Harry's Kel-Lite swept the yard. A vague profile became, for an instant, a full face.

I froze the frame.

"Harry," I said, my hand and voice shaking. All of a sudden I wasn't tired anymore. "Take a look."

He looked into the monitor, a screen smaller than the mug shot in his pocket.

"Huh," he said. "What a surprise. The lady got herself promoted from buyer to dealer. Must have a sugar daddy out there staking her."

"You think?"

He turned the image back to face me. "Maggie MacGowen, meet Nelda Ruiz."

But by then, Nelda was long gone.

— 6 —

"Looks like you had quite a night, Maggie." Guido scanned through the images I'd shot during my ride-along with Harry and sorted them into clusters on his digital editor: the streets, the makeshift shelters, the people, the police, Nelda's face caught raw against the dark, Lisa's mug shot, the he-shes at Club Caribe, the tattoos on the back of a man lying spread-eagled on his apartment floor, his pregnant girlfriend surrounded by uniformed police.

"There are some good images here," he said. "No awards for cinematography—pretty rough—but a lot of great content. Let me show you what my guys brought in while you were napping."

After I left Harry, in the deepest, darkest hour of the night, I called Guido. I intended only to leave a message but he picked up, said he been waiting to hear from me. I told him in brief about the events of the night and that I was dropping off some footage at the studio for him to work with. I left the camera's memory cards, the draft of a narration script, and a shot list on Fergie's desk where he would find them, and then took my turn napping on my office sofa.

Guido came straight in to the studio after I called. The previous evening he had summoned a couple of his graduate film students and, first thing in the morning, sent them off with an experienced union crew, Paul Savoie on camera and Craig Hendricks as sound-man and field producer. They were to record background scenes from Jesús Ramón's neighborhood: the mother's *bodega*, the telephone booth from which Nelda was seen making a drug sale, the downtown alley where Mike said he dropped Jesús, and so on.

One of Guido's film techies had connected his digital camera to his computer so that, using a Wi-Fi Internet connection, he was streaming images from the field to Guido for capture as they were shot. Guido kept an eye on both a monitor displaying the live feed

88

and a monitor displaying old footage called up from the studio's news archives. Somehow, he managed to find ten seconds of an ashen-faced Mike Flint walking away from the grand jury room where he had been called to testify about what he had and had not done on the day that Jesús vanished. The grand jury found there was no evidence of a crime and dropped the inquiry, but Mike was rattled to his core by the grilling he got. And the image showed it.

When Guido wakened me from my nap, he had a rough-cut ready to show me. I walked down to his work area to see what he had. It was good, even with the holes he had left to insert the new footage his crew would send in that afternoon.

"Think what we have is adequate for Lana's purposes?" he asked as I watched over his shoulder. "Hit the highlights, boost the drama, make tantalizing promises."

"We're getting there," I said. "I'm going to leave you to do your magic. I'll be downstairs in the audio booth recording the voice track for you to mix."

He looked up at me from his monitor, brow furrowed. "Don't you want some face-time in this piece?"

"Guido," I said. "Look at this face. I've hardly slept for forty-eight hours. I need a shower, a meal that doesn't come out of a paper bag, and a week at the beach before I'll put this face in front of a camera."

"Actually," he said, smirking, "at the moment that face would lend a gritty—okay, scary—*cinéma vérité* quality to the piece. But suit yourself."

"Later." I walked out clutching a draft copy of the narration script.

"Maggie," he called after me. "Time?"

"First read-through clocked at just under eight minutes. I need to cut it to five or six."

He didn't respond. I know he heard me, but he was already bent over the digital editor, lost in images.

Taping the voice track took less than an hour. Guido listened to the various versions, told me he had all that he needed to cobble together the technical parts, match voices to images, and that I should go home for a while.

We decided that later he would pick up some dinner and bring

it to my house. We'd eat, fine-tune the proposal, keep each other company, and probably drink too much. With some luck we'd have a nice promo package for Lana's review by Thursday, leaving plenty of time for a last edit before her flight left for New York later on Thursday evening.

I loaded my bag with discs, notes, and the thick bundle of sympathy cards that had arrived from all over the globe since I was last in the office. When I arrived, I had started to look through them, but had to wrap them back up in big rubber bands to take home. The variety of outpourings of grief and remembrance was heartening, sad. Daunting. In the bundle were long confessional letters from cons—both current and ex—and little boxes with religious tokens, packets of photographs, mementoes people thought I might appreciate. Every note was touching, and I appreciated every one, but I could only read a few at a time. And I certainly needed to read them at home, privately, just me, a bottle of wine, and a big box of tissues.

When I got home, I dithered around outside for a while with the horses, not quite ready to go into the empty house alone. Early Drummond had, as he told me, fed and watered the horses that morning. They had what they needed, but all three of them were antsy, begging for attention. Every day, no matter how sick he felt, Mike had always managed to come down and spend some time with them, even if it was just to lean on the rail of their enclosure and scratch whoever nuzzled up to him. Horses are dumb creatures, but they're very intuitive. They knew something had tipped their universe. They didn't want explanations, they wanted comforting.

I gave Rover a last pat and walked up the front walk. Feeling shaky, I opened the front door and went inside. Everything looked the same as it had when I left on Sunday night, all of our things undisturbed, familiar. But I felt like a stranger among them. I turned on music, loud, and went into my workroom where I had left Mike's files.

My workroom was intended by the architect who designed the house to be a formal dining room, but the way Mike and I lived anything labeled "formal" wouldn't see much use. So, I had commandeered it. The space suited me. It was big and well-lit—the

crystal chandelier was now somewhere in the garage, replaced by functional track lights—with tall French doors that opened onto the patio. We built a counter along one wall for my computers and monitors and other plug-ins. The wall opposite was floor-to-ceiling shelves and cabinets full of filmmaker detritus: cameras, cords, lights, discs, tripods, reflectors, gels, digital this and analog that, and so on. Looked like shelves in a junk store.

I made space on the counter for Mike's files and sat down to go through them more methodically than I had before. Actually, so far, I had only carefully studied the original police summaries. One by one, I pored over the notes, reports, maps, and clippings that Mike had collected over the last decade.

In a folder labeled EVERGREEN, I found a sheet with a series of abbreviations and numbers that I recognized as the coroner's code for John Does. For instance, "JD 99–235, 25–35, 130, 5'10–6', OD?, Evergreen 03/01," meant that in 1999 the 235th unidentified male the coroner examined was twenty-five to thirty-five years old, weighed one-hundred thirty pounds, was five-ten to six feet tall, and died of a possible or probable overdose. There were about two hundred John Does listed, each followed by "Evergreen" and a date some years after the body was discovered. I didn't know what Evergreen meant, or the dates after.

I called Mike's former partner, Nick Pietro. After we reassured each other that we were hanging in, I asked him, "What does 'Evergreen' mean to you?"

"Evergreen?" he repeated. "In reference to what?"

"John Does and Evergreen."

"Ah, sure. Evergreen is a cemetery. Could be the oldest cemetery in the city; east of downtown, Boyle Heights. A lot of the founding fathers are buried there, like the Van Nuys and Lankershim and Chapman families; headstones read like street names.

"At the southeast corner there's a potter's field for the indigent and the unclaimed. The county holds on to unclaimed and unidentified bodies for a while. The coroner looks for relatives, but after a while if no one claims the body, it gets cremated and put into a plastic box. Every once in a while there's a little ceremony and all the unclaimed remains get buried together in a trench in potter's field. County's been doing that for over a hundred years."

"John Does can be missing persons," I said.

"Can be. Why?"

"Mike kept a file of John Does, apparently buried in Evergreen."

"Part of the Jesús Ramón files, I'm guessing."

"Yes."

"What you might do is call the county morgue. There's a tech works there that Mike was real tight with. Name is," he paused, apparently thinking, "Phil. Phil Rascon. He could probably tell you more about exactly what Mike was looking for than I can." He paused again. "Mike caught the Jesús case a long time before we partnered up. I never worked that one."

"You've been a real help," I said.

After good-byes and promises to get together soon, I pulled out the printout of Mike's contacts that I had taken from his computer. I found Phil Rascon and called his work number, hoping to catch him in.

When I identified myself to Mr. Rascon, he became very emotional. I listened to his spill of anguish, heard about his long history with Mike. When I told him what I was looking for and why, he was quick to set up an appointment to show me information that he began compiling, at Mike's request, in January of 1999.

Day after tomorrow, at the county morgue, one o'clock.

I had moved Mike's computer into my workroom the week before. I booted it and copied his Word files on a thumb drive that I slipped into my laptop case, in case I needed something from it when I wasn't at home, and went back to the hard-copy files on the counter.

The file folder labeled OBITS AND PALLBEARERS sounded intriguing. The contents were at least that. Mike had gathered information—coroner's reports, police investigation reports, newspaper clippings—relating to the off-duty deaths of three LAPD patrolmen. Relatively few LAPD officers live within the limits of the city they protect and serve, choosing instead to commute in from any one of well over a hundred outlying suburban towns in Los Angeles, Orange, and Ventura Counties. The clippings Mike collected had been gathered from newspapers all over the southern part of the state.

There were three accidents. I read through each set of information carefully, looking for the connective thread, other than the fact that three officers died.

Chronologically, Rod Pearson was the first. On the job for less than four years, the father of three, worked Devonshire Division in the North Valley, fell off a sixteen-foot ladder at home while stringing Christmas lights in late 1998.

The second officer, Art Collings, on the job eight years, divorced, father of a daughter, worked Hollenbeck east of downtown, died in the early moments of January 1, 1999 of that peculiarity called a New Year's Eve lobotomy. Apparently, a holiday reveler randomly shot his handgun into the air, and when the bullet fell back toward Earth it cleaved the skull of Officer Art Collings while he stood in his backyard perhaps a mile away. A fluke.

The third and last officer, Tom Medina, on the job twenty years, married father of five, worked out of Harbor Division. Medina's was the most recent incident. In March of 2003, Medina stopped at a 7-Eleven store on his way home from his mid-watch shift. It was almost four A.M.; he was dressed in civvies. As he approached the store's front door he spotted a man, dressed in black and brandishing a firearm, who was apparently intent on robbing the store. Officer Medina drew his service revolver, identified himself as a police officer, told the man to drop his weapon, and was shot dead. His community established a scholarship fund for his children. The would-be robber got away.

There were grainy funeral photos in each bundle of clippings, tiny faces, difficult to differentiate. The file was labeled OBITS AND PALLBEARERS for a reason. I put the clippings into my scanner and enlarged the photos, fooled with Photoshop to fill the gaps between the pixels, and managed to create images with recognizable, and sometimes familiar, faces: Boni Erquiaga was a pallbearer for Rod Pearson, Tom Medina helped carry Art Collings, and Harry Young and Lewis Banks did like service for Tom Medina.

I printed the enhanced photos and put them into the file, and made a note to call Harry.

The next file I picked up, labeled DESERTS, was thicker, and was almost entirely clippings. After drug kingpin Rogelio Higgins was killed in December of 1998, there was a string of robberies,

fires, and killings across the three contiguous counties that all get lumped together as "Elay": Orange, Los Angeles, and Ventura. All of these events involved the homes, warehouses, vehicles, and carcasses of known or suspected drug dealers. And, none of them occurred within the jurisdiction of the LAPD or the LA County Sheriff, and none garnered much interest beyond a very narrow compass.

The LA *Times* gave three paragraphs near the back of the Metro section to a fire in a Torrance house caused by an explosion set off by a batch of crystal meth the tenants were cooking up on the family stove. Two children who lived in the house were taken into protective custody. The small-circulation *South Bay Pilot* gave the incident more in-depth reportage and ran two editorials about the noble efforts of the local police department to prevent the scourge of drugs and drug dealers from gaining a toehold among the stucco canyons of suburbia.

It was suggested in a few editorials or reports that there was a gang turf war underway, or several gang turf wars because the crimes occurred across a broad geography, which was seen as evidence of many local problems rather than a single shared problem.

There were some arrests, the usual suspects taken in, some convictions among dealers and drug manufacturers, but no concrete association among the crimes in various places was made or apparently even considered. Downtown gangbangers were sometimes credited with beginning a suburban infiltration, evidence that a town needed to crack down on—choose any—curfew violators, gang attire, non-English speakers, overcrowding in rental units, single motherhood, and graffiti.

I got the impression that each event was downplayed by the locals and generally credited to outsiders. Better to keep an isolated violent event quiet than to risk ruining property values. Maybe the local police and their communities thought that the dealers who were beaten or killed, whose homes were torched and meth labs blown up, got their just deserts, ergo Mike's label, perhaps. I wondered how many drug dealer robberies went unreported either to the police or to the community.

Mike also clipped reports of four police officer–involved shoot-

ings in various Los Angeles suburbs during the same time period, some fatal, all found to be justified, and all of them, again, receiving bare mention by the *Times*. Local, smaller-circulation newspapers like the Long Beach Shore community's *Grunion Gazette* and the Santa Monica *Daily Breeze* showed more interest when the incidents happened in their well-mown backyards, but even then the coverage was tucked among reports about high school sports, immediate district political issues, school events, holiday parades, and ads for homes for sale.

As long as the incidents involved police cleaning out drug dealers or dealers killing each other, no one seemed overly concerned.

In my head, I had been keeping a timeline of events. I set aside the files and began to write down the sequence, beginning with the shooting of Rogelio Higgins in December of 1998 and ending with the trial and incarceration of Nelda Ruiz and Boni Erquiaga some years later. I still did not understand how one event related to another, but there was clearly an escalation of events around the time that Jesús disappeared, and there was a cast of recurring players.

After two hours I had a stack of to-do notes, a fierce headache, and only the faintest glimmering of an idea why Mike was interested in the apparently random deaths of those three policemen, and a series of suburban drug-related incidents. I had a whole new set of questions that needed to be asked, and a new understanding that asking the right question of the wrong person could be very dangerous.

Mike warned me, Watch six. It was good advice.

About an hour before I expected Guido, I took a long, cool shower—the day had turned out to be very warm—dressed in clean jeans, sandals, and a favorite shirt. Downstairs again, I uncorked the bottle of very good pinot noir that Mike had opened on his last day, poured some into a broad-bowled, long-stemmed glass, and carried it out onto the front deck.

The heat of the day had begun to soften. Brisk afternoon breezes swept through the canyons. *Dos vientos*, the locals call the afternoon breezes, two winds, cool moist ocean air blowing in from both Malibu to the south and Ventura to the west.

Breathing in fresh mountain air tinged by the sea, I leaned my

elbows against the deck rail and looked out across the canyon be-
fore me. A red-tailed hawk soared on thermals, spiraling higher
and higher until it was a dark speck in the blue. Then, suddenly,
it dove straight toward the earth as if it were shot from the sky.
When I saw it again, dinner hung from its talons, maybe one of the
abundant cottontails or ground squirrels that were local garden
pests.

I was marveling at this rugged mountain wilderness into which
we had managed to interject ourselves, when I heard footsteps
coming up my wooden front stairs. I looked over the rail, saw that
it was Early.

"Hey, neighbor," he said. "Saw you were back. How you doing?"

"Hanging in," I said.

"All fixed." He held out the remote garage-door opener he had
taken home to fix the week before. "The clicker's fine. Looks like
the real problem was a critter nested inside the motor in the garage.
I replaced the motor. Works fine, now. I left you a message...."

"Thanks, Early," I said, accepting the opener from him. "Sorry I
didn't get back to you."

"Didn't expect you to." He leaned his elbows on the rail beside
me and looked out over the canyon.

"Thanks for helping out last week. Couldn't have handled all
those people without you."

"You'd do the same for me," he said.

"The horses are still squirrely," I said.

"Horses are notional. They'll settle down." He didn't take his
eyes from the canyon.

I'd worked with Early a couple of times, borrowing him from
the news division when I needed his expertise. He's one of those
people who is indispensable to a big institution: versatile, re-
sourceful, knows the back doors, a go-to guy when you don't know
who else to ask, or when you need to learn how to do just about
anything related to television production.

Early was a somewhat laconic Midwesterner, closer to Mike's
age than mine, with a slow, dry sense of humor. Early rarely seemed
to be in a hurry, generally paused to think before he spoke. In the
zippity-do-da, rigid timeline-driven environment we worked in,
he sometimes seemed to function in slow motion when everyone

around him was in fast-forward. Might drive the hyper sorts a bit crazy to be around him, except that what he had to say was generally worth waiting for, and when he did something it never had to be undone or redone. And polite to the point I would call him courtly. Add bowed legs and an extravagant handlebar mustache, he could easily be cast as a cowpoke in any western movie.

He's a good co-worker, and an easy neighbor.

"Can I get you a glass of wine?" I asked. "Maybe a beer?"

"Wouldn't mind a glass of wine at all," he said. He followed me into the kitchen. "Guido told me he's coming over to work on your project proposal later. I wondered if your digital editor was still giving you problems. Want me to take a look at it?"

"I'd appreciate it," I said, handing him a glass of wine. He picked up the bottle, looked at the label, and whistled in appreciation.

"Mike opened it," I said.

He nodded, raised his glass to tap mine. "To Mike."

"To Mike."

I led him into my workroom.

"I was thinking," Early said, "that the problem with your editor might be in the hardware and not with the software."

"Another squirrel in the motor?" I asked.

"About like that." He found a grounded screwdriver he liked from the bucket on the counter, sat down in front of the computer that held the editing program, and set to work with a happy gleam in his eye.

I was happy to have some congenial company while I did work of my own. I put away Mike's files in the cupboard and started writing thank-you notes to the people who had sent flowers or food or performed any number of other kindnesses over the last week and a half. The list was huge. Time would have to be set aside every day until everyone on the list had been contacted.

"Hardware problem, as I thought," Early said. "Faulty core processor."

He went over to the cupboard and found a CPU that wasn't attached to anything.

"Mind if I cannibalize this?" he asked.

I said, "Go ahead."

"I'll bring home a replacement part tomorrow."

Twenty minutes later the transplant was complete, and successful. The editor was working.

"I'm beholden," I said.

He bowed, grinning.

"Interesting name, Early," I said, sticking postage stamps onto the day's finished notes; it was dark outside.

"Earl Edward," he said. "My dad was Earl Thomas. Folks called us Earl E. and Earl T."

"Family nicknames." I chuckled. "My real name is Margot, but my older sister and brother always called me Maggot. I was happy when that morphed into Maggie."

Outside there was a terrific racket of horses whinnying and neighing. Duke, Mike's big gelding, was as good as a sentry dog. When anyone approached, he set off the other two horses before they knew why. Duke liked to stand in the front corner of the corral, right where the headlights of cars coming around the last hairpin curve of the road would hit him square in the eyes. Long ago, I learned to snap off my lights before rounding that turn to spare Duke's sensibilities and to maintain peace in the neighborhood.

"Guido's here," I said, glancing at my watch. It suddenly occurred to me that I was really very hungry. "He's supposed to be bringing food. You'll join us."

It wasn't a question and he didn't bother with a demurrer.

Guido came in laden with buckets of barbecued tri-tip, ribs and chicken, and various side dishes from the Wood Ranch Grill down by the freeway. Enough food for the rest of the week.

During the evening the promo film got polished. I thought that it played very well, had an interesting look, good color and texture, crisp narrative with some attitude, some pathos, even hints of menace. I had no hesitation about handing it over to Lana for her review.

When we were finished, I was very tired, but I didn't want the evening to end. We'd had fun. Just easy, relaxed fun among friends, colleagues. I gathered together the remnants of our meal, excused myself, went into the kitchen and wept.

— · —

After Guido and Early left, I didn't bother to go upstairs and climb into bed. I locked the door behind them, curled up on the living room sofa under an afghan, and went right to sleep.

Mike was a terrible sleeper. Often, when I worked late, I would sleep on the sofa so that I wouldn't wake him by coming upstairs and fumbling around. He'd never get back to sleep if I did, and then we'd both be up half the night. So, from time to time I slept on the sofa.

Sometime during the night I rose far enough out of a heavy, wine-assisted sleep to hear Mike moving around, a normal enough household sound. I felt Mike standing over me, checking on me, which he did sometimes when he wakened and I wasn't in bed. I was very sleepy, so I just snuggled down into the cushions and waited to fall back into the depths of sound sleep. A cool evening breeze, full of the scent of flowers, wafted across the room. Very pleasant.

I sat bolt upright, suddenly fully awake, and peered into a room full of dark and shadows: If anyone was walking around the house that night, it certainly wasn't Mike Flint.

— 7 —

KENNY NOBLE showed up at my house early the next morning. The Los Angeles County Sheriff's Scientific Services Bureau team had already been there for a couple of hours, dusting for prints and looking for anything the intruder might have left behind. I had called Early immediately after talking to the 911 dispatcher and he had come over on the run. He was in the kitchen making coffee when the first deputy sheriffs arrived from the Malibu substation, lights and sirens, fifteen minutes later.

The intruder had spent some time in Mike's office going through his desk and file cabinets. Messy but methodical, and very quiet. Papers and office supplies, drawers taken out and turned upside down covered Mike's office floor. There was such a mess that I couldn't tell if anything was missing. The rest of the house was untouched.

An opportunist, a cat burglar, the first deputies on the scene said. A sneak thief. The burglar had probably cased the house for a few nights and thought no one was home or that everyone was upstairs, asleep. They said that when the guy realized I was downstairs on the sofa, I probably scared him more than he scared me, and he took off. I doubted that part about me scaring him more, but the rest sounded reasonable.

"Those guys, last thing they want is for anyone to see them," I was told.

"Well, he certainly was stealthy, because the horses didn't see or hear him," I said. "If they had, they would have wakened both me and Early."

"Probably a local kid, I'd guess a junkie, knows the neighborhood, came over the mountain from the backside, looking for anything he could sell."

I was quietly working on Mike's files in my workroom, waiting for the S.S.B. crew to finish, when Kenny strode in.

"You should have called me right off last night," Kenny said as greeting. It was a reprimand of the sort an underling or a child might receive for dereliction. I was offended; I had properly notified the law. Someone in the sheriff's office must have sent a courtesy message to LAPD. I looked Kenny straight in the face until he had finished his lecture with a second, "Why didn't you call me?"

"I've had an eventful couple of weeks, Kenny," I said. "On a scale of one to suicide, I would rate this break-in as maybe a traffic infraction. You tell me who did it and what's missing and then I'll hyperventilate for you. Maybe, next time, if I haven't had six other dustups in the meantime to deal with, I'll think to call you first so you can speed over, lights and sirens, all the way from your house in Corona. After you did get the call, how long did it take you to drive over?" I looked at my watch. "Two and a half hours?"

I took a breath and brought my tone down a notch. I knew he was only showing concern, but I was still a bit steamed about his patronizing tone. And I was very surprised by my quick eruption of anger. I still had a little wine buzz, but that wasn't an excuse.

"Sorry," I said. "Didn't mean to snap at you."

"Me, too." He hung his head for a moment, took a deep breath. "Anything other than Mike's computer taken?" he asked.

I reached out and put my hand on Mike's computer, right on the counter next to me where I had moved it the previous week. "He didn't take Mike's computer. Mike didn't keep anything of value in his office. Other than the computer, that's right here, there was nothing saleable other than the TV, and he didn't take the TV."

I didn't add that Mike had already distributed his treasured possessions and, as a courtesy to me, disposed of junk and clutter. I looked around my workroom.

"There are plenty of toys in here he could sell, but he didn't touch anything." I shrugged and repeated what the deputy had said. "He was just a sneak thief and I probably scared him off before he got any further."

"What if he wasn't?" Kenny wrapped his beefy arms around me

and pulled me against his chest and hugged me tight. His heart was pounding, he was sweating. He was frightened for me.

Patting my back he said, "I love you, Maggie, like an old papa. Getting the call about this put the fear in me like hearing a fire alarm go off in the night. You're way up here in the middle of nowhere. Damn, Maggie, what if—"

"I'm not alone. Early is next door, there are five other houses nearby," I said, face smooshed against the starched front of his dress shirt. Even if I didn't like his patronizing tone, getting the hug was okay. "Don't forget, there are watch horses looking after me, though they weren't any help last night."

I felt his breath catch. The breach of my house, a cop's house, had hit Kenny harder than I could have expected. Loyalty to Mike, genuine concern for me, whatever it was, I was touched.

"Hey Kenny," I said, pulling away from his grasp. "I was going to call you today to talk about my conversation with Boni Erquiaga. And did you hear? I ran into Nelda Ruiz Monday night, and had a little tête-à-tête with Teresa Galba. Ah, and Eldon Washington tried to intimidate me. Overall, I've been having quite a picnic with Mike's files."

He smiled. "Mike always said you're a pistol."

"He meant that in the nicest way, right?"

"He meant, he wasn't always sure he could keep up."

I laughed; that's exactly what Mike would have said if he had been standing where Kenny was, with this funny look on his face that can only be described as terror.

— 8 —

YOU CAPTURED it," Lana said after the final image faded to black. When I arrived at her house in Brentwood with the promo disc that Thursday morning, she was still in her baggy pajamas, spending her day working from home until it was time to catch her flight to New York. "The programming boys will buy it."

"No changes?" I asked.

"Not now."

"You can carry that disc with you for backup," I said. "But the news division will transmit it to New York this afternoon when they have the satellite up for the East Coast evening news feed. The tape desk in New York will copy it for you and get it set up in the conference room for your meeting tomorrow."

"I'm impressed by your access to the news shop." Lana walked me to her front door and followed me down the front steps, her too-big felt slippers slapping on the bricks. "Rare generosity from News. How'd you pull it off?"

"It's who you know," I said.

At the car we exchanged perfunctory kisses and hugs.

"Maggie, it's not too late to change your mind about this project, you know. I love it. The programming boys will give their blessing. But my concern is for you. You've been through a lot lately, darling. You ready for whatever this investigation throws at you?"

"Me? Bulletproof."

"Bullshit."

"Absolutely." I opened my car door. "I'm more afraid of Pete and his gang in New York."

"That bunch of neckties doesn't scare me," she said.

"Bullshit," I said.

It wasn't yet noon when I left Lana's.

— • —

While Mike and I have a sort of quasi-romantic history attached to the Los Angeles County Morgue, it is not one of my favorite places to visit. First time I went, Mike took me there to identify a body. That's how we met, at least that's the short version.

There was a shooting, very high-profile, lots of media attention and hype. Through all the fuss, Mike kept his focus on the victim and what happened to her, and paid not one whit of attention to anything except the investigation and the needs of the victim's family. I never once saw Mike Flint preen for television cameras or kiss the midnight blue butts of his superiors.

My first impression of Mike was that he was the very epitome of a hard-headed reactionary cop. As I came to know him, his kindness to me, to the parents who had lost their child, his genuine concern for people, made me feel ashamed that I had judged him so quickly, expected him to fit my ill-informed stereotype of cops. The tough-guy veneer he presented upon meeting was an occupational necessity for Mike, but it was a veneer only.

On the drive across town to the coroner's offices in Boyle Heights, I kept reminding myself of all that kindness.

I was walking across the parking lot of the morgue corner of the campus of L.A. County General Hospital, maybe ten yards from the body-intake bay, when I got the first whiff of the place. That first day I went there, with Mike, as we walked up to the coroner's back entrance, Mike told me to take a deep breath first thing when we got inside, to get used to the smell quickly.

There is nothing on earth quite like the smell of human decay. All the Mentholatum and Vicks in the world smeared around the nostrils won't cover up that smell. It seeps into the lungs and settles there, to be breathed back up for hours after. It lies damp and heavy on your clothes, leaves a residue on your skin and a film on your shoes, stays in your hair the way cigarette smoke from a rancid bar used to. After a while the coroner's staff seems inured. But they must carry that smell home with them to their families, must be identified by that scent to the people who embrace them.

I entered through the receiving bay doors and identified myself to the clerk on duty. He placed a call to Phil Rascon, the coroner's technician I had spoken with Tuesday afternoon.

Rascon had told me that his office was upstairs next to the evidence storage rooms. Part of his job was keeping track of rape kits and tissue samples and boxes of physical evidence for pending homicide cases filed there. I was dreading the long walk down the central hall between the autopsy suites and the cadaver cooler to reach the elevator up. The big cooler was designed to hold three hundred cadavers, max, but the morgue has, from time to time, an overflow of maybe a hundred more. During the work day they get stacked, naked, along the sides of the hall to await a turn on the autopsy trays. Walking down that long hall is like a descent into the depths of Purgatory, a sampler of the worst behavior of the human species: gunshots, knife wounds, drugs, neglect.

To my relief, Rascon came downstairs to meet me and, instead of going up to his office through the Valley of Death, took me to the administration building next door. We settled into a small conference room that was intended for families who come to view the remains of their loved ones. I wondered why we were meeting there instead of in his office, but I was grateful for both the privacy and for being spared another exposure to the halls next door.

Rascon placed a file folder on the table that took up the center of the small room. With a courtly bow, he pulled out a chair for me and took one opposite.

"I was glad to hear from you, Miss MacGowen," he said as he sat down. "We're all pretty shocked around here about Mike Flint's passing. Damn shame."

"Yes," I said. "A damn shame."

He was intense, a serious man by nature. But he seemed inordinately worried, I thought. Or maybe wary was the word.

Rascon opened the folder he'd brought with him and took out a copy of a Thomas Guide map page showing downtown Los Angeles. On the map someone had inscribed a circle around the eastern part of downtown in red pen.

"Mike gave this to me some years ago," he said. "He asked me to identify all the John Does we brought in from this defined area from 1999 to the present, or could have been transported from that area."

"To the present?" I asked.

"Sometimes we bring in remains that we can't really get date-specific about," he said. "Just last week a city crew power-washing the underside of the First Street Bridge dislodged a skull. Mike wanted to hear about that sort of remains."

"Just a skull?" I asked.

"Lot of the time, we don't even get that much," he said. "Maintenance crews wash down all sorts of debris the homeless people and the dopers take up into the bridge supports with them. Most of it's bedding and clothing and trash and drug paraphernalia, but last week, there was that top of a skull.

"People, they find any kind of crack or nook that's big enough to crawl into, they climb in to shoot up or to look for shelter. Sometimes they die in there, and no one finds them. Not ever."

"Were there more bones from the same person, more than the skull?" I asked. "Other remains?"

"Not so far. Can't be sure exactly where on the bridge the skull fell out of, it was just washed down and swept into a pile with everything else. Now the Scientific Bureau technicians have to go through all the junk that came down that day and try to associate anything they can with the skull, try to determine cause and time of death, and identity. Takes time. Takes man-hours."

"That's the sort of discovery Mike would have been interested in?" I asked.

He nodded as he opened the folder and sorted through the papers and notes he had collected. I noticed that the folder tab said only MIKE. He selected several color photographs and arranged them facing me; bones, hair, teeth, random body parts.

"We don't always get a whole, pretty corpse we can take a portrait of and fingerprint. If the remains aren't found real quick by people, the animals find them and do their thing. You know, dinner."

Rascon pulled up another set of pictures. Some were mostly unidentifiable masses of gray with the occasional recognizable human feature.

"You can't imagine what happens to a cadaver that gets washed down the Los Angeles River in a rainstorm with all the debris that comes down the Arroyo, the rocks and trees and things out of the

mountains and backyards, all kinds of city trash. Everything ends up pulverized, like in a blender. Some remains we fish out of the water, some, usually just parts, get deposited when the water recedes again, or they get washed out to sea and end hung up in Long Beach on the oil drilling islands or against the breakwater in the harbor."

"Mike wanted to know about all of them?" I asked.

"Not all," Rascon said. "He gave me pretty specific parameters. He was looking for someone who died in January of 1999, or could have died then, male adolescent, Hispanic, small. I wouldn't send him an old lady died a week ago, or anyone positively ID'd by prints or DNA match."

"Is DNA analysis routine?"

"Too expensive. Backlog's too big," he said, shaking his head. "Not unless there is evidence of a crime or some indication that the remains are associated with a missing person case or an ongoing police investigation and the D.A. or some P.D. requests it. Sometimes a family will make a good argument for further identification, and it gets done. Just depends. Anyway, some of the stuff we get is so degraded there's no retrievable DNA. But everything gets a file number, a record of where it was found and what it is. We take a tissue sample if we can, and photos."

"Not much to go on, is it?" I asked.

"We do our best to identify remains and inform family members, but our resources are limited, like I said. And sometimes when we contact families they just don't have the money for a funeral, or they don't care enough to retrieve the remains for burial."

With a slow, sad shake of his head, he said, "Working here, you meet all kinds."

"I'm sure you do," I said. "What do you do with the remains that don't get claimed?"

"Everyone who hasn't been reclaimed after three years gets transported over to the crematorium here behind the county hospital and comes back to us in a plastic box, and we keep them a while longer. A few times a year all the unclaimed remains go over to Evergreen Cemetery. The county holds a nice service, and then

they all go into a mass grave in potter's field over in a far corner, down by First Street."

"If you found, say, the skull of Jesús Ramón," I said, "could you identify it?"

"We'd have a pretty good shot at it," Rascon said, shuffling through his folder. He found two pages and put them in front of me. "We have his dental records and his mother's DNA profile. If we found enough to get a sample, we could say with some certainty we had found Jesús."

"That skull you found last week?"

He shook his head. "African American woman over fifty. Skull formation, tooth wear; not Jesús."

"Have you found any good candidates?"

"None conclusive." He cocked his head, looked at me. "I'm still hopeful. But another thing, there are people who die and no one ever discovers them. Finding that skull in the bridge was pretty much an accident."

"When did you start keeping this file for Mike?" I asked.

"Long time ago. When that kid went missing and people started climbing up Mike's back."

"This is ten years of John Does who might fit?" I asked, touching the file.

He nodded. "Yes, it is."

"That long ago, Mike believed that Jesús Ramón was dead?"

"He thought it was a possibility, yes, ma'am."

"Did you go to the grand jury with this file when they convened?"

"Not with the file, no. But I talked to the D.A. about John Does. They told me to forget it. Junk, they said."

"The district attorney said that?"

Phil nodded. "One of the assistant D.A.s, yeah. Someone named Tiffany didn't think a coroner's tech had anything to add to what they already knew, or thought they knew. I grew up in the neighborhoods of this city, Miss MacGowen. I know that attitude. I'm not the person they wanted to hear from, and I wasn't going to argue with her."

"Your information was dismissed," I said.

"*I* was dismissed, yeah." He shrugged. "I asked Mike what he wanted me to do and he said to forget it. Unless I had a positive ID, speaking out might just come back and bite me. My office doesn't know about this file, and he thought we should keep it that way because there was a second part to this that could be tricky. If the right person wanted me to stop collecting data, I'd have to stop."

"Now that Mike is gone," I said, "will you keep looking?"

"As long as I'm working here I'll keep looking for Jesús," he said, eyes misty. "I worked with Mike Flint for twenty years, ever since I hired on. He always treated me with respect, like I was a pro, which is more than I can say for some of his colleagues. Mike was a good man. Because of my respect for him, I went the extra mile for him. He did the same for me."

"Mike had so many good friends," I said. "Thank you, Phil."

"Friends do things for friends," he said with a shy shrug.

"You said there was a second part to all this."

He folded his hands over the folder the way doctors do when they have bad lab results to read to you. "Actually, you could say that Jesús was the second part. At the time the boy went missing, we were already looking into the murder of a big-time drug dealer."

"Rogelio Higgins?" I asked. I knew the name from Mike's files.

He nodded. "Mike was really smart, you know? He saw how little things fit into a big picture damn quick. LA County is a big place, bigger than some states are. And it's fragmented into about a hundred and twenty incorporated cities, most of them pretty small. Some of them contract with the county sheriff for police, but a lot of them have their own little departments. Those small departments don't always share information very well, and they don't always pay very good attention to bulletins that come in from other departments. They get territorial, you know? And sloppy."

The look on his face revealed his attitude toward this territoriality. "A John Doe was found in Downey, and at the same time next-door Huntington Park had a missing teenager whose parents were looking all over for him. Someone should have put the two pieces together, but they didn't. Not for five years. By then,

the boy's remains were already in Evergreen. A little cooperation would have saved that family a lot of unnecessary grief."

"Mike was often frustrated when he had to work with, or around, some little-town police department that never learned to share and didn't have resources for a proper investigation," I said. "Or proper officer training."

"The thing is," Rascon said, nodding knowingly, "just like the freeway system, crime doesn't respect city lines. You can pull a job in one town tonight, and another somewhere else tomorrow, and so on. As long as you keep moving, and, as long as you keep your stuff small and local, you can skate for a long time.

"There's one exception." He tapped the top of the folder, as if promising good things to come. "Los Angeles County has ultimate jurisdiction over every murder, no matter where it's committed. There is only one coroner, one morgue, and one district attorney for the entire county. Bigger cities like LA and Long Beach run their own murder investigations, but the county sheriff takes over the violent and questionable death investigations for most of those little city departments. And no matter who is investigating, all the corpses come here. To me."

"Was Mike looking for a particular sort of crime, or pattern of crime?" I asked.

"Drug deals gone bad, dead dealers found in car trunks. Accidents in meth cookers. Drug busts gone bad, especially if they were cop-related."

I thought about Mike's collection of clippings, stories about dead drug dealers found in car trunks or down canyons, fires in home meth labs—cookers, Rascon called them—drug house raids that ended in deadly shootouts between dealers and police. Altogether, they were stories about the drug purveyors who met violent ends. And the police.

I asked, "Was anyone ever charged with the Rogelio Higgins murder?"

He shook his head. "Too many possibilities."

"Did Mike think that Rogelio Higgins was killed by a cop?"

He looked around to see if anyone was looking in. And then he leaned in close. "It was a possibility."

"And Jesús?"

"Interesting thought, Miss MacGowen." Rascon began turning pages in the file as if refreshing his memory, or glancing fondly through a family album.

"Two potential motives: altruism and greed," he said. "Mike was looking at one cop who wanted to take over Higgins's client list. And another he thought might have done what he thought was vector control, killed a source of blight in the community."

"Boni Erquiaga was the greed-motive suspect?"

He shrugged. "He was the one who got caught. Took a few years, but he got caught. I don't think he was in it alone."

"Who was the altruist?"

"Never found him, or them, if he existed."

"Ah," I said. "It is a puzzle."

Rascon grinned at me as he closed the file folder.

"May I have a copy of the file?" I asked.

"It's yours," he said, sliding it across the table. "You're Mike's executor, I found out. Consider this part of his estate."

"You're a good friend, Phil." It felt like Christmas. "Thank you."

"Like I said, Mike and I go back a long ways." He smiled as if he had heard a private joke. "We had a lot of good talks over lunch, you know. Best way to get the stench of this place out of you? Big bowl of hot salsa and chips, two chile rellenos and three beers at Barragan's. We used to do that fairly regular."

I knew the place, I'd been there with Mike many times, up on Sunset before Silver Lake. The first time he took me there was immediately after our first visit to the morgue.

"Can I take you to lunch, Phil?" I asked.

"Rain check," he said. "I'm swamped today. But another time, that would be good."

"Another time," I said, looking down at the file. I must have looked like I was ready to come apart. He smiled, tapped the table in front of me, bringing my head up.

"You're going to be okay, Maggie," he said. "Mike always bragged about how resourceful you are. You'll get through this."

"You think so?"

"I do."

As he walked me back to the parking lot, I ran through a list of old-timers from Central Division besides Boni Erquiaga that I had run into: Eldon Washington, Lewis Banks, Harry Young. The three of them would be a good place to start a conversation about a missing kid, dead drug dealers, and cops on a mission.

I asked Phil, "Do you know an investigator for the D.A. named Eldon Washington?"

He grimaced. "I knew him when he was a cop on gang detail; he observed a whole lot of autopsies on that assignment. And I know him from the D.A.'s office now."

"Did you ever talk to him about this file or about what Mike was working on?"

"No, ma'am," Phil said. "That man, I only tell him what he asks me for specifically. There have only been two people who ever knew about this file, me and Mike, and now me and you."

"Can we keep it that way?" I asked.

"I was going to ask you the very same question."

"Thank you," I said again, tidying the edges of the file.

"Don't mention it." He offered me his hand. "And I mean, don't mention it."

In the car, before I drove away from the coroner's office, I placed a call to the district attorney's offices.

"May I speak with Investigator Eldon Washington?" I said after I had made my way through the telephone menu to a living being. Washington was in and picked up the phone.

"Washington," he said.

"Eldon," I said. "This is Maggie MacGowen. I think we may have gotten off on the wrong foot the other night. I wonder if we might meet, start over again."

"What's on your mind?"

"Nelda Ruiz. Jesús Ramón. Mike. The usual."

"I'll transfer you back to appointments. Maybe the girl can find an available time for you. I know I'm booked through the next couple of weeks."

Before I could say anything, I heard several clicks on the line and then that blankness that means the line is dead.

I drove straight over to the Criminal Courts Building at Temple

between Hill and Grand where the D.A.'s offices are and parked in the public lot behind. Before I went inside I stopped at a vendor kiosk out front and bought a warm chocolate chip cookie that was about the size of a dinner plate, a staple for courthouse workers and jurors. The cookies are okay when they're warm, but they get really hard when they cool. Fortunately, there was no line at Security and the cookie still felt warm through its waxed paper sleeve when I retrieved it, along with my bag, from the X-ray conveyer belt.

I showed my press pass to Los Angeles County Sheriff's Deputy Frances Nelson, who was standing guard in the D.A.'s marble atrium.

"I know you," she said, handing back my credential. "Sorry about Mike. He was always a gentleman to me."

"And to me," I said. "Is Eldon Washington in his office?"

"In his rat hole, you mean?" Rancor and disdain were rife in her tone. "Why you want to see that one I don't know, but he's in. Down the corridor at the end, last door before the fire escape. He ever goes too far and misses his door—next stop, Temple Street, thirteen stories straight down. I wish."

"Thank you, Deputy," I said, and headed off in the direction she indicated.

"He gives you trouble, you just call out," she said, patting her side arm. Ha, I thought as I walked away, history there.

I found Eldon at his gray metal government-issue desk working the morning crossword puzzle. There were some files on his desk, but his office did not have the stacks and boxes of case files that all the other staff in the D.A.'s cramped precincts had piled ceilingward on every flat surface in their office spaces. Without fanfare, I put the warm cookie on top of his puzzle.

"What the...?" He looked from the cookie to me and had the grace to blanch.

"Peace offering," I said. "The 'girl' in appointments said you were free right now. Said you are a piece of work, but you're available for a meeting. Lucky me. She wants you to stop sending calls her way, says you keep your own appointment book."

He grinned in an almost disarming way, almost pleasant. He

slid an end of the cookie out of its waxed paper and took a bite. In his bare little cubbyhole, cookie held in both hands, Eldon didn't seem either as large or as fierce as he had tried to be when he way-laid me outside the ladies' room at Central Station two nights be-fore. He was a middle-aged man with good shoulders, a softening midsection, and a losing battle with a receding hairline. I wanted to tell him that a comb-over never fools anyone, that bald looks better, but declined.

"These things are good when they're warm," he said after his first swallow. "But when they get cold you could fill potholes with them. Want a bite?"

"Thanks just the same." I pulled up his visitor's chair and sat down facing him, elbows on his desk.

"I heard you retired and went up to Idaho or something," I said. "Why'd you come back?"

"I got bored," he said, shifting a bite to his cheek so he could talk.

"That happens to a lot of cops," I said. "They go off into hunter's paradise and can't take the quiet."

He nodded. He was not being confrontational, and seemed genuinely sincere when he said, "I'm real sorry about Mike."

"A lot of people are telling me how much they'll miss him."

He nodded, the lower half of his face buried behind that mas-sive cookie.

"Okay," I said, "can I have a bite?"

He ripped off a goodly chunk and extended it toward me. I pinched some off, ate it.

"Yep, it's good," I said.

"When they get hard, I nuke them for thirty seconds, gets them soft again."

I leaned back. "Mom was right, sugar attracts more bees than vinegar does. You might try that strategy yourself sometime. Make you more popular with the people you work with."

"Look, Maggie." He let out a long breath before he finished. "I'm not the bad guy, okay? I have a job to do, and being nice isn't in my job description. Now, you going to tell me why you're sugar-ing me up?"

"What I said the other night. I want you to tell me about *that* day, when Jesús got into Mike's car. You were on gang watch, you caught Nelda dealing drugs out of a phone booth and informed both Mike and Central Station, and then Boni Erquiaga showed up."

"I wondered when you were going to ask me."

"What was that day all about?"

"Gang watch." Eldon leaned back in his chair far enough so he could look up at the ceiling, as if The Word was going to come down to him from the water-stained acoustic tiles up there. "Talk about a minefield."

"What do you mean?" I asked.

"The snitches, the cops, the O.G.—the Original Gangsters, the old-timers—the kids coming up, the 'hood, the justice system, they get intertwined until you can't separate the strands." He looked over at me.

He said, "My boy, Eldon, Junior, he has this condition called neurofibroblastoma. You know what that is?"

I shook my head.

"He has blood vessels and tissue and nerves all tangled up together, and all of them growing out of control inside his face and his neck. He's a healthy, intelligent boy, and he has these purple masses growing, distorting his handsome face. Ugly things. If he doesn't get surgery to untangle the veins and the nerves so that excess tissue can be cut out, the masses will grow until they press on his brain and his windpipe and kill him. But the surgery is really risky, seventy-percent chance something gets cut and leaves him disabled or disfigured. No surgery, one hundred–percent he dies."

"I am sorry, very sorry," I said.

"That's what it's like working gang detail. No matter what you do to cut some of them out, you put someone at risk. There's no safe choice to make most of the time."

He dropped his head. Maybe he was having an emotional moment, maybe he was playing me and needed a moment to strategize. I hadn't decided if I could trust him. There was no picture of his son on his desk; I had only his word the boy existed.

"Work a neighborhood for a while, you get close to families, to kids," he said. "You get tight with other cops working out there with you."

He looked up at me with moist eyes. If he was acting, he was good at it. "You see kids grow up, you see them get hurt, you go to their weddings and their funerals. A lot of their funerals. Your buddies, they have their problems, too. You have to put up some personal barriers or you get tangled in everyone's problems to the point you can't get out again, or you don't want to get out. That's when cops get into trouble."

I pulled a Kleenex from the box on his desk to wipe my hands. He had deflected my question a couple of different ways. I tried again.

"What happened to Jesús Ramón on January 16, 1999? You were there. Tell me about that day."

"I know you've read all the reports. What's left for me to say?"

"There are some missing pieces," I said. "You holding any of them?"

"Like what?"

"Okay, let's try this. These people you considered family, would you include Nelda Ruiz?"

"No."

"Jesús Ramón?"

He shook his head, a puzzled little smile, or maybe it was something else, lifting one corner of his face.

"Boni Erquiaga?"

"Not that one, not ever. He's exactly where he belongs."

"Okay, how about Jesús' mother?"

He dropped his chin, and I had some part of an answer.

"How close were you?"

"Not what you think. Or maybe what I think you think," he said. "I admired Julia, the mom. Hardworking, determined to make something of herself. Her sister Mayra, was a hard worker, too. People kept trying to get in their way, take away what they had."

"Who?"

"Nelda, for one. Nelda was, probably still is, a predator."

"I ran into Nelda the other night, after I saw you at Central," I

said, pulling out the photo I had taken of her from my bag. "But she didn't stick around to talk to me."

"I heard about it," he said. "She get brought in yet?"

I shook my head. "She was selling drugs through a junkyard fence. She took off."

"Who's her supplier now? Any idea?"

"I don't know," I said. "Which brings us back to the day Jesús disappeared."

He shrugged. "How so?"

"I keep bumping into Rogelio Higgins, who I'm told was Nelda's supplier until someone took him out."

Eldon frowned, hesitated before he said, "Rogelio was dead a month before Jesús went missing."

"Rogelio, as I understand, had a large drug network and a fencing operation. He was assassinated, I guess you could say. And someone took over his customer base. Or tried. Who was it?"

"No *one*," Eldon said matter-of-factly. "Not the whole of it, anyway. For a while after Higgins got hit, various people tried to move into his marketplace, but they never had the supply lines that Rogelio developed, never had the contacts. And they could never come up with the volume and the variety he offered; Rogelio moved a lot of shit."

He leaned closer to me. "The thing to remember is this, Rogelio Higgins wasn't an Elay product, not out of the *barrio*, not out of the Mexican Mafia the prisons germinate. He was real mob, affiliated with the Arellano Félix gang in Baja with Colombian drug cartel ties."

"So was it a mob hit?" I asked. "The godfather came to town?"

"No," Eldon said. "Someone local, someone with hubris did it."

"Hubris?" I teased him, rolled my eyes, repeated, "Someone with *hubris*?"

He chuckled. "I may be a flatfoot, but I went to college. I studied the classics. Hubris was always the downfall of men who tried to be like the gods, or to compete with the gods."

"And that's what happened? Some local got too big for his britches?"

"That's what I think. So did Mike." He leaned back in his chair

after slipping the uneaten half of the cookie back into its waxed paper sleeve for later. "Maybe there was machismo involved, some guy who resented this outsider, Rogelio, working his home turf, working his people, getting rich off them. Or maybe someone thought he could end the drug problem by ending the life of that one guy. Mike used to call people half-smart when they had notions bigger than their abilities. That's what he said about the shooter, half-smart."

"Why half-smart?"

"He didn't know what he was up against, and he should have."

"You think the gods struck down Higgins?" I said

"One way or another, probably, yeah."

"But, there was an earthly shooter. Who was he?"

"I don't know who, but several people tried to take over Rogelio's operations." He smiled. "Boni tried to chew off a piece of that cookie."

"That's why he stole drugs from the police evidence locker? To supply Rogelio's people?"

He nodded.

"Rogelio had," I said, "from what you say, an infinite drug pipeline. How did Boni imagine he could meet demand over a period of time? His resources were limited to the stuff his colleagues confiscated and booked as evidence. He had to know he'd get caught."

"You want to go back up to Corcoran and ask him?"

That comment gave me pause. I looked at Eldon, studied the lines in his face, tried to read his expression, couldn't. But he was an experienced street cop, well-schooled in not giving away anything he didn't want to give away.

"Who told you I went to Corcoran to see Boni?"

" 'They' did."

I remembered the way Boni had said "They." Eldon was mimicking him.

"We were recorded," I said.

"Of course you were. And the tapes were sent to the D.A. And because I'm on Boni watch, the tapes came to me."

Boni watch?

"How close are you to Kenny Noble?" I asked.

"We go back a long, long way."

It seemed as if the tiny room, if you could call it a room, suddenly had ears, and no air. I could smell old paper files and the cloying sweetness of that damn cookie, and Eldon's sweat, and decades of ill-swept dust. I sat there, on a hard-bottomed oak library chair like the ones in the office of my high school principal, Sister Agnes Peter, feeling as if I had been caught again smoking behind the language lab. They always laid in wait, those well-scrubbed nuns who smelled of Lifebuoy soap, to trap you for either sins of omission or sins committed. I swear to you, in that cramped cubbyhole office I smelled Lifebuoy soap. One of the lessons I carry from my proper convent education is that, whatever the sin, in the long run, the punishment is always worse for not knowing what I should know than for doing something I shouldn't.

"You want some water or something?" Eldon asked.

"It's been a rough few days, that's all. I forgot to eat today."

He nodded.

"Boni watch?" I said. "What's that?"

"The D.A. called me out of retirement," he said. "Made me an offer. He knew I needed to get back on a public servant's medical plan, knew about my boy, and he knew my work record. My assignment is tracking both Boni Erquiaga's actions and his accusations. Boni is still trying to cut a deal that will reduce his sentence or get him sprung. He accuses other cops of all sorts of things. I try to find out if there's any substance to anything he says before the press gets hold of it and ruins an innocent man's life."

"Did Boni Erquaiga initiate the accusation that brought Mike before the grand jury looking into Jesús?"

"Everything that happens before the grand jury is secret. That's the function of the grand jury, to protect the whistle blower, the vulnerable witness, the unfairly accused."

I looked at Eldon, feeling suddenly weary, on the verge of the random weepiness that swept over me now and then, beginning from the moment I first heard about Mike's death.

"You want my job?" he asked.

I shook my head. I must have looked sufficiently pathetic because he relented, answered my question. At least part of it.

"Yes," he said. "Boni accused Mike of making Jesús disappear. He accused *you* of knowing, and helping cover it up."

"I didn't know Mike when Jesús disappeared."

"Pillow talk is admissible to the grand jury."

"Lordy," I said.

"He accused *me* of hiding the body and Kenny Noble of covering for us."

"And Nelda?"

"Innocent bystander, wrongfully accused."

"Why would you all conspire to take out Jesús?" I asked. "Why would so many people risk their careers? Their freedom?"

"They wouldn't. Remember, the whole thing got thrown out."

True, I thought, but the accusations still got as far as the grand jury. Again, I got up from the chair, walked to the window, hoped for fresh air; there was no breeze outside, only city traffic noise.

"On that day, you called Central Station when you saw Nelda Ruiz selling drugs on the street," I said. "Why not just put her in cuffs and take her in yourself?"

He thought about the question, or his answer, for a moment. Then he sighed as if he had made a decision. The decision, apparently, was to talk.

"I had instructions from Parker Center to watch Nelda," he said, turning in his chair to look at me. "She had been a dealer for Rogelio. Rogelio was dead only a few days when Nelda was already back in business. All of the people in the neighborhood we knew of who were his dealers were back in business. Downtown wanted to know how that could be. Nelda was one of mine to keep track of. I saw her do her thing, I put in the call to the head shed, Parker Center, as instructed by Mike Flint himself. Parker relayed my call to Central dispatch and it went out over the radio."

"Mike showed up," I said. "But somehow Boni got there first."

"Everything that day went according to Mike's plan," Eldon said. "He used Nelda as the lure to pull Boni in; I was waiting specifically for her. Mike knew Boni was dirty. Mike wanted the two of them in the same place, and he wanted to control when and where that was. He had the call put out to Central knowing Boni would hear it and come over to protect Nelda. Or to silence her, protect himself."

I came closer, leaned against a corner of the desk, looked at Eldon closely. "Was Nelda bugged?"

He shook his head. "Boni's car was."

"Did Boni know?"

"Can't be sure. He might have suspected."

"Did Mike get anything from the tape?"

"Nothing usable. On the tape Boni told Nelda he knew someone was trying to move in on Rogelio's territory and he thought Nelda knew who it was. Nelda denied it. It was the sort of conversation a cop could have with a suspect or a distributor could have with one of his dealers who could be double-crossing him, or someone sending up a smokescreen."

"Not a lover's tiff?"

"A video would have been better, might have caught Nelda with her face in his lap. Otherwise, zip. Boni doesn't incriminate himself, she admits nothing."

"But he thought she knew who the competition was."

"She would. He knew it, we all did." He slid the snapshot I had taken of Nelda across the desk toward me. "This is the closest that anyone I know has gotten to Nelda since she got out of Frontera."

"Yeah." I bent down and picked up my bag, swung it over my shoulder. "Don't suppose you'll repeat any of this on camera for me?"

"Nothing to repeat. I haven't told you a single thing." He rose and offered me his hand. "Not one single thing."

I nodded. I expected that answer.

Eldon came around his desk to walk out with me.

"Mike kept working that case," Eldon said. "Kept everything close to his vest. After the grand jury, he said he'd have nothing to say until he had a package of evidence to deliver so the D.A. could file a dead-bang case. I'd give anything to know what he was holding."

The possibility was that Mike was being secretive because he suspected a cop, an insider, someone like Eldon.

I turned to Eldon as I punched the elevator down button. "Is there an assistant D.A. named Tiffany?"

He nodded. "She's working family court."

"You might have a conversation with her about keeping her mind and her information channels open."

"What did she do?"

"Ask her about turning away potential information to take to the grand jury. See what she says."

The elevator doors opened and I stepped inside. As the doors closed, a question occurred to me. I reached my hand into the gap and triggered the doors to open again.

"Eldon?"

He had already turned, head bowed, hands in the pockets of his trousers, and had started back toward his cubicle. He stopped when I called out to him, and, head still low on hunched shoulders, looked back at me.

"Monday night, when I was at Central riding with Harry Young," I said. "Why were you there?"

"Mike was my friend. I wanted to make sure you were okay. Make sure you weren't in over your head."

The last thing I saw before the elevator door closed was a single tear rolling down Eldon Washington's cheek.

— 9 —

"Cue Atlanta. Send one, then send two." The news director, a man named Cavenaugh, sat next to Early Drummond, the technical director, in front of the immense control console in Studio 8 speaking to his counterparts across the country. It was three o'clock on the West Coast. East Coast six o'clock news segments were coming in to the Burbank studio live from sister studios in New York, Washington, and Atlanta to be taped for rebroadcast three hours later, Pacific Time, bookended by local news hours.

The big studio was dark except for the work lights on the engineers' console and the ranks of monitors above them, about two dozen flashing screens. Voices floated down from the tiers of plush seats rising behind the engineers in the studio, but it was difficult to pick out faces in the gloom. Somewhere up there the West Coast producer, a frizzle-haired, middle-aged woman named Ida, sat at a desk and presided over everything happening in Studio 8.

Ida's primary job was to look for inessential stories that could be cut in case late-breaking or pertinent local news needed to be patched in for the West Coast broadcast three hours later. Whatever she patched in had to be an exact fit for the time hole she cut out. The process is as much art as it is timing and science.

I leaned against the wall beside Early, fascinated, as always, by it all. My excuse for being in the news booth was to be on hand when Early fed my promo video to New York after the East Coast news feed came through, while the satellite connection was still open. In New York, the tape desk would receive the transmission, convert it to disc, and hand-carry it to the network's programming offices, booted and ready when Lana arrived for her pitch meeting with the execs Friday morning.

When the broadcast was over, Ida gave notes to her engineers in Burbank and to their counterparts in New York for the edited rebroadcast.

"There's an overturned big rig on the Pomona Freeway screwing up rush hour traffic," she said. "Let's dump the story about flooding in New Jersey and the earthquake in California. No one out here cares about rain back there and no one here felt that little-bitty quake. New York only added the quake to make them feel better about their crappy weather."

Early swiveled in his chair and peered up into the dark studio toward Ida. "Is tape coming in from the wreck?"

"Chopper's on its way there now. Microwave link should be coming in shortly."

"While we're waiting for the visuals of the wreck," Early said, "and while the bird is still open, we have this Maggie MacGowen promo to send to New York programming. Guy at the tape desk knows it's coming and where it goes."

"Welcome, Maggie," Ida said. "Wondered why you were slumming down here."

"Hi, Ida," I said. All I could see of her behind her little desk light was the reflection off her spectacles and a halo of red-brown frizz. "Thanks for the assist."

"New York got the sound check," Cavenaugh said, "and speed." He signaled Early. "They're rolling."

"We're sending your piece live time, Maggie," Early said. "It's cued up to go in five." He turned forward again, toward the bank of monitors on the wall in front of him. Cavenaugh picked up the count, "Four, three..."

My series logo graphics appeared, MAGGIE MACGOWEN INVESTIGATES, over a fast-moving assemblage of images, most of them me, usually in motion, culled from various documentaries and outtakes. The title came up: THE MIKE FLINT LEGACY. The narrative began, the visuals played, the soundtrack rocked.

At first, I was so intent on watching the promo that I blocked out all of the conversations in the studio. After maybe a minute, I became aware that the room, usually full of activity and chatter, had fallen absolutely silent. I looked around, thinking that I was

alone in the studio with Early and the sound engineer, that maybe everyone else had gone out for a break. But the crew was still there, every face turned up to watch the single monitor where my video promo ran, every face washed in the kaleidoscopic colors of the flashing screen.

A room full of the real pros, I thought, was a tougher audience than the suits Lana would face in New York. I tried to read them as they watched, waiting for the sudden drop of the head that could mean disdain, or laughter in the wrong place, or boredom. They were all markedly still. I wished I could see this project as they did, freshly, because I had seen it and its earlier versions so many times that I had lost all objectivity.

Considering the mix of stuff Guido and Early had to work with, and the time available, they did a masterful job of video and sound editing and balancing light levels and merging sharp archival footage with some of the cruder new stuff. The piece had an intentional rawness, a sense of barely contained energy that I believed captured both the cultural richness and the unpredictable nature of life in the city. A colorful olio that might spin into pandemonium at any moment; you never know what might happen next in LA. The narrative had substance, suspense, made promises I hoped we could deliver in the final, televised version of the project.

The ultimate sequence came up, Broadway running through downtown, shoppers at the end of a work day, maybe with the day's pay to spend. The scene was shot out the back of a Suburban van inching though traffic, the camera lens all but invisible to passersby. The sidewalks teemed with people, whole families laden with colorful plastic shopping bags. Randomly they walked into the street, spilling off the sidewalks like a floodtide surging over river banks. Faces in close-up as people played chicken with traffic and crossed at midblock, walking all but right into the camera lens, filling its field of vision, moving off the side. Everywhere, a colorful, noisy, disorganized parade of people. Then, close up on a light pole, Jesús Ramón's well-weathered missing person poster nearly lost among overlapping notices and ads for who-knows-what that were tacked to the same pole later. As the van moved away, Jesús became a mere dot. The music quieted from raucous *Banda* to a

single plaintive guitar. The colorful chaos of Broadway faded to gray, the last long note from the guitar died. Fade to black.

I looked at my watch: running time six minutes, twenty seconds.

The silence afterward seemed to last forever. I knew the critique was coming, wanted to hear it, dreaded it at the same time. The first voice came out of the dark behind me.

"Mr. Drummond." Ida, the news producer, had something to say, and from the sarcasm in her tone, it wasn't huzzahs.

Taking his own time to respond, Early swiveled in his chair and looked up in her direction.

"You worked on the promo?"

"Yep," he said.

"I recognized your handiwork. Good job. And Miss MacGowen, congratulations and good luck with it."

I said, "Thank you."

She came back with, "Early, you go ahead and enjoy yourself working with Maggie on this project, but when I need you in news I don't want to find you MIA, wandering around Special Projects somewhere."

He chuckled. "Yes, boss."

"That goes for the rest of you guys, too," she warned as she gathered her things and rose to leave. Her parting was, "Good job, all. Good job."

The studio was absolutely silent until the door closed behind her, and then the staff erupted in laughter.

"Ball-breaker," one of the techs groused.

"I heard that, Richard." Ida's voice from the next room crackled through a speaker.

"I meant it in the nicest way."

A click as she switched off the microphone was Ida's last comment.

I looked at Early. "Guess I was an independent too long. I keep stumbling over network protocols. Did I need a permission slip from the News Division to use the facilities?"

"Don't worry about it." He grinned, prideful I thought. "That was the green-eyed monster speaking. Everyone here, including

Ida, wants to be doing what you're doing. I really appreciate you giving me the chance to work with you."

Cavenaugh, sitting next to him, turned to Early. "You going to give us the 'anything for my art' speech?"

"Yep, that's the one." Early gave the man's chair a little shake.

Everyone laughed.

"Well, this has been fun," I said, and gathered my own things. "Thanks Early, thank you everyone. You've made this look too easy. You've made me look better than I deserve."

And then the critique began: could have done this, or that, need to do this; suggestions, good ones, about resources and technique; and lots of questions. Also, several folks offered their services and the facilities of the News Division. When they were finished, I thanked them again.

Early walked me out. "You get a little break now?"

"I told Guido I'd go find him when we finished here. He has his video crew down on Alvarado."

"I'm off after the six o'clock broadcast. I'll keep an eye out till you get home."

I didn't protest.

"Thanks again, Early. For everything."

"Take care, neighbor."

— · —

I caught up with Guido and his video crew west of downtown where they were shooting the neighborhood around Jesús Ramón's mother's *bodega*. When I got out of my car the two union men, cameraman Paul Savoie and soundman and field producer Craig Hendricks, both of whom I had worked with before, acknowledged my arrival by waving my shadow away from the camera's field of vision.

Guido had brought a six-pack of eager film students, all of them garnished with the requisite body piercings and tattoos of the hip and artsy young. When the students recognized me there was a ripple, a frisson, among them. Guido, I thought, had attached my name to some possibilities for their futures.

Guido introduced each student to me in turn, a handshake and a personal comment, some cheerleading, required for each.

The old pros sort of groaned when they saw the kids' reaction to me, and went about their work, videoing the street action around them. Sometimes I imagine how lovely it would be to be anonymous, or better, invisible when I'm working. And sometimes I like the fuss.

Guido handed me a business card with a shiny gold LAPD shield, SGT. LEWIS BANKS, CENTRAL DIVISION printed in black. Guido said, "He dropped by, hung out a while waiting for you. Said to call if you had any security issues. I don't know if he was angling for a job or for a date."

"I'll call him," I said, and slipped the card into my pocket. I wanted to talk to Banks about what he might know, but thought a formal on-camera interview might be the best way to do that. Have him on my turf, not his.

Guido was summoned to check a setup. I wandered around, looking at the scene they were videoing.

Evening in the *barrio* is family time. The air in the neighborhood that Thursday evening was rich with the aromas of food cooking, onions and cilantro, chiles and meat and hot lard. Houses in the area are small and old, two-, maybe three-bedroom prewar stucco or even older wood-frame bungalows set in small yards surrounded by Cyclone fence.

Among these small houses there are also various versions of multiple-family dwellings ranging in size from duplexes to largish apartment buildings or old-style court apartments, all of them of a certain age. Few of the units are large enough for the families that inhabit them, like the little apartment of Teresa and Xochi, and cooking on such a hot day probably made them damned uncomfortable inside.

People gathered outside in yards and courts and on the grass verges of the sidewalk, hovering over portable barbecues laden with slabs of spicy carne asada and ice chests stocked with beer and soda. Steam wafting through open kitchen windows promised savory sauces and slow-cooked meat, pork carnitas maybe, or chicken boiled with peppers and tomatillos until it falls off its bones, and vats of red or black beans and rice. This was food that would feed the families of working parents for several days, until

the next payday. I began plotting ruses to get invited into one of those yards for samples. I had managed to find a sandwich at the studio commissary, but it was hardly a meal.

Jesús Ramón's mother, Julia, leaned against the frame of her *bodega's* open door, blocking the entry, arms crossed over her chest, perhaps curious about the video crew on her sidewalk, but not so curious that she ventured all the way outside; I recognized her from news footage. When I asked him, Guido said he hadn't spoken with her yet, that he was waiting for me. I walked over to her and introduced myself.

"Mrs. Ramón?" I said. "My name is Maggie MacGowen."

"*Sí.* I know." She did not unfold her arms to accept either the hand or the business card I extended to her but she looked at the card. She said, "I heard about what the officer did to himself, that Mr. Flint. May God have mercy on his soul."

"You knew him?" I asked, knowing Mike must have spoken with her when her son disappeared, but hoping she would say more.

She nodded. "He talked to my son, my Jesús, many times. The officer wanted Jesús to listen on the street for anything he could hear about this big drug dealer that got himself shot."

"Who was that?" I asked.

"Rogelio Higgins," she said, narrowing her eyes to appraise me. "But you know."

I nodded. I asked her, "Do you know what Jesús might have told Mike Flint?"

"No. Jesús, he would never tell me about those things." She looked at me. "Do you have children?"

"Yes, one, a daughter. She's nineteen."

"Does she tell you everything?"

I chuckled at that, thinking of things my own mother never knew about me. I said, "No, I'm sure she doesn't."

When she spoke about Mike, she didn't show any sort of anger or resentment toward him. Maybe the passage of time had softened those emotions, or maybe she never believed that Mike had harmed Jesús. I leaned against the other side of her doorframe, crossed my arms, and looked out at the street where kids were mugging for Guido's cameras.

"This some kind of movie they're doing?" she asked.

"Television," I said. "We're taking another look at the day your son disappeared, hoping to find out something new. Maybe after so many years someone who was afraid to talk back then is ready to say something now."

She thought that over for a moment. "Who?"

"Don't know yet." I shrugged. "Maybe Nelda Ruiz has something to say. She was there that day."

"Ah!" Mrs. Ramón rolled her eyes and color rose in her cheeks. "That one. She is big trouble. That's why they put her in the prison."

"She made parole." That bit of information got a stir from her, a shudder as if a cold hand had run up her back. I asked, "Have you seen Nelda?"

"No. That one, she wouldn't come over here." Mrs. Ramón uncoiled her arms to wag a finger in the direction of my face. "She is evil, but she is not stupid. She will not come near me, not ever."

"Evil?" An opening line. "Why do you say, evil?"

"What she does to my family, that girl. My boy, my little sister." Her eyes flashed hot through a film of tears. "I hoped they would eat her alive in that awful place, that prison for women."

"Tell me what she did to your family."

"*Drogas,*" she spat. "She got them hooked on her garbage, got them working for her just so she would keep getting them their junk."

"Crack cocaine?" I asked.

"*Sí.*" Now Mrs. Ramón was fully animated, fire in her face, venom in her voice. She started counting off on her fingers: "And heroin and meth and marijuana. Anything you can think of swallowing or snorting or huffing or smoking or shooting up to scramble your brains, she'd get it for you. She was a regular *farmacia de los muertos*, that girl."

"Your sister?" I said, remembering that Eldon had mentioned the sister. Mike reported that he took Jesús downtown to see his aunt; she owed him money. "That last day, Jesús told Detective Flint he wanted to go see his aunt. Is that the same sister? She had a taco stand—"

"Taco stand," she said with scorn. "*Sí*, she sold tacos. And she'd sell you some damn expensive hot sauce from under her counter if you had the money."

"She sold drugs?" Maybe I said that with more surprise than I wanted to. "Aunt" conjures up in my mind a blue-haired old lady who knits scarves and slips you fivers on your birthday, not a junkie and a dealer.

"Mayra, such a pretty girl." I still heard anger in Mrs. Ramón's voice, but there was regret around the edges. "She was always the favorite, so sweet with everyone when she was little. That garbage she put in her body made her ugly. Old. A regular *bruja*—a witch."

"Now that I think about it," I said, "I don't remember reading an interview with Mayra in the police reports." I turned to her. "Did she use another name? Maybe her married name?"

"Just Mayra, Mayra Escobedo. She never got married." Mrs. Ramón shook her head. "She was ruined too soon, too young. A good man wants to marry a mother for his children, not some wreck."

"Did the police question her about Jesús?"

"*Sí*. Officer Flint, he tried." She sighed heavily. "But she was too sick from the drugs to talk to him."

"Too sick?"

She nodded. "They called me from the county hospital the day after Jesús was gone. I thought I would lose her at the same time I lost my Jesús."

"Bad drugs?" I asked, prodding.

"Bad, too good, it's the same." Mrs. Ramón looked up at me. "Pure H, they said. Uncut."

"The police said?"

"No, the doctors said. They said that if she lived, she needed to get the junk washed out of her. They said it would take months in the hospital, and they said it would cost a lot of money to make her better. We don't have insurance."

"What did you do?"

"I took her to a clinic down in Baja." Anger gave way to grief; her voice broke. "My boy was lost. We were looking everywhere

for my boy. But I left him alone, I didn't know where he was, to drive Mayra down to a clinic in Rosarito Beach. All night I drove and came home to find out, still no Jesús."

"That night, was that the first night ever that Jesús didn't come home?"

She shook her head. "He was a boy. He had a girlfriend. He did what boys do."

"So what made that night different?" I asked. "You wanted the police to go find Jesús as soon as you heard he was taken away by Detective Flint."

"The girlfriend, Teresa, told me something bad was going to happen to Jesús."

"What was going to happen to him?"

"She wouldn't say. She just said I had to go get my Jesús right now and bring him home." Tears coursed down her cheeks. "A mother feels when something is wrong. And that time I felt it. I knew Jesús was in trouble."

I put my hand on her shoulder. "I'm so sorry, Mrs. Ramón."

She wiped her eyes on the back of her hand. "You have a daughter. You know."

"Yes. I know."

We stood, halfway inside her shop, halfway out, mothers together. I wanted to tell her about the sister I lost, and my father. And Mike. How I still wake up in the middle of the night knowing some of the worst possibilities the world can offer, wondering if Casey is all right, wondering if my mother, alone in her house in Berkeley, has fallen. But I still had my daughter and my mother, and Mrs. Ramón had lost her son when he was young. No loss, no fear I could imagine could measure up to half hers. I must have sighed heavily because she put her hand on my elbow and led me inside the quiet of her store. She took a Diet Coke out of her refrigerator case, opened it, and handed it to me.

"What happened to Mayra?" I asked. "Did she make it?"

"Mayra." She looked out the door, watched the children running past, acting goofy the way kids do, uncontrolled energy. "She lost a kidney. She had a stroke. Sometimes she has a seizure and we think, this is the end. But, by the grace of God, she is still here."

"Where is she?"

Mrs. Ramón looked at me and a canny smile crossed her face. "You want to talk to Mayra?"

"Yes, very much."

"Okay." She checked her watch; it was after five. "Why not? I close at six. You come to our house tonight. Seven o'clock. Mayra doesn't get too much company."

She wrote down her address on a receipt pad, a street a few blocks over. When I thanked her, she asked, "Tamales?"

I shrugged. "Tamales?"

"I took some tamales we made last Christmas out of the freezer. You like tamales?"

"Homemade tamales," I said, feeling joy over the prospect of that particular and rare opportunity. "I'll bring wine."

This time, she patted my arm. "We'll talk. *Madre a madre.*"

I shook her hand. "Mother to mother."

She followed me to the door. "You want to bring those cameras?"

"May I?"

"*Sí.* But bring just one; my house is too small for all these people." She tipped her head toward Guido and smiled. "Bring that cute one. For Mayra."

Poor Guido had a tough choice to make, tamales and a potentially dynamite video opportunity, or dinner out with an especially attentive female film student? In the end he made the safer choice, the ethical choice: do the work and don't diddle the students.

The sun was low in the sky, good light was gone before six; the filming day was over. Guido and I spent the hour until we were due at Mrs. Ramón's sitting in his van running through the afternoon's footage, making notes, making comments: "Use this, file that, what is that?" I noticed, as we viewed some of the footage, that Guido had let his camera linger on that particular attentive student more than once, embracing her with light that flattered her contours, made her appear more beautiful than she actually was.

I nudged Guido. "Be careful."

"What?" Faux innocence.

"You know what I mean."

He rubbed his chin as if it had suddenly sprouted a beard, or been smacked. "Damn, it's hard. Youth is so pretty, so available, Maggie."

"All I can say, be careful."

Mrs. Ramón, Julia, lived in a little green house in a tidy enclave of single-family homes just north of the Santa Monica Freeway, in a pocket of similar houses that had somehow escaped the assault of graffiti and other imposed blight. When we walked inside, the aroma of savory broth coming from the tamale steamer enveloped us. Guido, holding a bottle of red wine in one hand and a dozen yellow roses acquired from a street vendor in the other, stopped inside the front door to let the richness of the scent coming from the kitchen wash over him. Guido loves food.

"Cumin, poblano chiles," he said. "And what? Nutmeg?"

"*Sí*," Mrs. Ramón said, accepting the roses with a shy drop of her head. "My sister's secret, a little nutmeg in the broth."

She called out, "Mayra, company is here."

Mayra came from the direction of the kitchen, rolling herself in a wheelchair. Her graying hair was freshly brushed, her lipstick was newly applied, her face glowed as if with anticipation; a once pretty woman, withered on her right side, a claw of a hand, a foot turned in at an impossible angle. Julia had told me that Mayra was only a few years older than Jesús, that they were raised together and were more like sister and brother than aunt and nephew. I did the math; she looked far older than a woman in her late twenties should look.

"Mayra, this is the TV lady wants to talk about Jesús."

"Maggie," I said, extending my hand. "And this is Guido."

"*Mucho gusto*." She extended her healthy left hand toward me, then Guido. "Welcome. How nice to have visitors."

The food was even better than anticipated, corn masa dough spread with a filling of spicy, stringy goat meat sweetened with raisins, rolled up in dry corn husks and steamed over seasoned broth. We unwrapped tamales and smothered them with hot, homemade green tomatillo salsa. A crisp salad, a decent red wine, here was the perfect setting for conversation.

I had expected the two women to be reserved, but they were

eager to talk to us. Mrs. Ramón said she was afraid that everyone had forgotten that her son was still missing, that no one was looking for him. She was glad we were asking questions. If his story was back on television, maybe someone would come forward. Mayra seemed to hold nothing back, had nothing to hide, expressed guilty feelings because she had not been helpful when Jesús disappeared, indeed had become a burden at the very worst time.

After we ate, Guido asked for permission to film the conversation. Both women agreed, but first, Mrs. Ramón said, she wanted to clear the table, make it look nice. She removed the plates and the pile of empty tamale wrappers and came back from the kitchen with coffee and a plate of cookies—colorful pan dulce that she had brought home out of the bakery case in her store.

While Julia set the scene, Guido moved some furniture around, lit Mayra and Julia with a spot and fill lights, found a perch behind my left shoulder and trained his lens on the two women. Self-conscious at first, after a few minutes they both seemed to forget that he and his camera were there and that they were encapsulated within a ring of bright lights.

Mayra began to speak in a soft, clear voice.

She always wanted to open her own restaurant, she said. After school, she worked for an old man who owned a taco cart that he parked downtown on Broadway. She saved her earnings and, after he had a heart attack, she bought the cart from his widow. The money she made was fair, but the hours were long. All night she would be up preparing the ingredients for the tacos she would sell the next day, and then she would be on her feet all day, serving tacos with her homemade sauces. Always, she saved her money and kept her eye out for a good restaurant location.

She didn't date: "Men, they just want to spend your money," she said, glancing shyly at Guido.

She said she did nothing except work. But the accumulated weariness of too many long days and too many long nights began to take a toll. When her old school friend Nelda Ruiz offered her something to pep her up, she accepted. A little at first, and then more and more until she wanted the drugs, the high they gave her, more than she wanted the restaurant. Her savings went into her

veins. To stay supplied, she began selling small quantities of drugs to people Nelda would send over.

I turned to Mayra. "Mike Flint said that on the day he drove away with Jesús, Jesús told him that you owed him some money and he wanted to collect it. Mike said he dropped off Jesús behind the block where your taco cart was."

"The officer told me the same thing," Mayra said.

"Did you see Jesús that day?"

"I don't know." She glanced at her sister, chagrin reddening her cheeks. "I don't remember that day, or the ones before, or a lot of days after that."

"She was sick," Julia Ramón offered, covering her sister's withered hand with her strong one. As Mayra's surrogate mother, she seemed to have forgiven more than a sister might. "She was out of her head, her memory from that time is gone."

"Because of a drug overdose?" I said.

"Yes. And the seizures."

"When did you take the drugs?"

For the answer, Mayra turned expectantly to her sister.

"We don't know," Julia shrugged. "We couldn't find Mayra when we were looking for Jesús. We wanted her to help us."

"Where was she?"

"Officer Flint called me early in the morning, the next morning after Jesús was gone. He said the police found her in some abandoned building down on First Street. When he called me, she was already in the hospital, unconscious, almost dead."

I sipped some coffee, looked from one face to another. They were waiting for a question, some help finding the answer to this puzzle.

I asked, "Do you remember owing Jesús money?"

"In a way," Mayra said. "He would make the deliveries to me from Nelda, and then he would take money back to her."

"Did he get a cut?"

"Yes. Nelda paid him, sometimes in money and sometimes in a little bit of drugs he could sell to the boys in his set. Mostly, I think, some pot, a little crack or meth. He rarely sold the hard junk."

"You overdosed on heroin because it was uncut," I said.

She nodded. "I didn't know that when I took it."

"You got it from Nelda?"

"Probably. Whatever I had, Jesús brought it to me from Nelda."

"Did anyone else get sick?"

Again, she turned to her sister for the answer. Julia raised her hands, empty of an answer.

"Did Jesús use heroin?" I asked.

"I don't know if he did. Officer Flint asked me that, too. Like I said, usually a little pot. Jesús was a pretty good boy, not loco like some of them. He told me sometimes I should kick the stuff, that it would kill me one day."

Julia looked ill, heartsick. "This world is too crazy. How can you bring up children safe in such a crazy world?"

I sipped more coffee, waited for the air to settle again.

"Mayra," I said, "do you remember seeing Detective Flint at the hospital?"

"No. Nothing from that time. I even forgot how to talk for a while."

"So when did you speak with Detective Flint about Jesús?"

"Now and then he would come to see me, maybe once or twice every year. Last time, it was around Christmas. He came over here."

"This last Christmas?"

She nodded.

A surprise answer. At Christmas Mike was having trouble with his balance, was losing sight in his right eye. He wasn't driving anymore. At least, not that I knew. But, he had a lot of friends. "Any way you can pin down the date?"

She thought, had a conversation with her sister about when she had gone to the doctor last, because it was during that week that Mike had come by. Together they decided that it had been about two weeks after Christmas

When I raised the coffee cup again, my hand shook. Using both hands, I set it back down.

"Was he alone when he came?" I asked.

"He was alone when he knocked on my door," Mayra said. "At first I didn't know who he was, because he didn't look like a

policeman anymore. He shaved his head I think. I'm not sure be-
cause he wore a hat. And he was wearing blue jeans, not a suit. He
was…" She turned up her palm, empty, couldn't find exactly the
words she wanted at first. "He didn't scare me anymore. I think,
looking at him, Maybe he is the scared one now."

"He used to scare you?" I said.

She nodded vigorously. "He was always watching me, for a long
time before all that stuff happened. I think he knew what I was
doing besides selling tacos."

"He knew about you and Nelda?"

"He knew something. One time, long time ago, he came to ask
me about her. This drug dealer got shot and he wanted to know
what I knew. He asked me if I was still getting supplied by Nelda.
After that, he used to walk over from the police station at lunch-
time sometimes for my tacos. He told me I made the best tacos."

"Do you believe he was there for the tacos?"

"Yes, I made the best tacos." A shy smile. "And I think he was
checking on me."

"Did you know anything about that shooting?"

"What people on the street said, that's all." She raised her chin.
"I was never in the gangs. I was working all the time."

"The dealer was Rogelio Higgins?" I asked.

"Yes, it was."

"You knew him?"

"I knew who he was, big car, gold teeth. He was macho, big
trouble. I stayed away from him."

"He was friends with Nelda?"

"Friends, I don't know." Mayra furrowed her brow. "I told Nel-
da when Officer Flint started asking about her, and she got pretty
scared. She stopped getting me drugs for a while after that because
that man wouldn't get them for her. She must have said something
to him."

"But you started selling for Nelda again at some point."

She nodded. "But I don't remember when exactly, but it was
after Rogelio was dead."

"Did you know Officer Erquiaga, Boni Erquiaga?" I asked. "I
heard he was a friend of Nelda's."

"I knew who he was. We went to the same parish school, but he was older than me. I know he and Nelda hooked up. I never knew if he was trying to save her or if he was getting her in trouble."

Julia interjected, "Some of the boys from the neighborhood, when they go in the police, they act like the priests, like that little altar boy, Lewis Banks. Want to save everybody. But some of them are devils."

"Like Boni?" I said.

"*Sí*," she said. "Like that one."

Guido shifted his weight. His face looked tired; he'd had a long day. There was one more question I had for Mayra.

"When was the last time you saw Nelda Ruiz?" I asked Mayra.

"After she got out of prison." Too late she realized that she had misspoken. Mayra shot her sister a quick, guilty glance.

"That woman was in my house?" Julia demanded, quietly seething. "Mayra, when?"

"A few weeks ago," Mayra said, hanging her head. "She didn't look so good."

— 10 —

I STOPPED at a gas station and bought a tall, cold bottle of chocolate milk to put out the chile-pepper fires, and a roll of Tums in case it didn't. Before I got back on the road, sitting in the station lot, gulping milk, I checked in with Guido and worked out a schedule for the following day, then I called my voice mail to see whether something needed attending to.

Harry called to report he had nothing new on Nelda Ruiz but was working on it, and Nick Pietro, who had left several messages since the funeral, called again. Kenny called.

Ever since Eldon Washington let me know that my conversation with Boni was taped, and that Kenny had set it up, set me up, I had some mixed feelings about Kenny. I needed to talk through some issues with him. And I had a lot of questions for him. So I called his mobile number and caught him at home.

"Hey Kenny," I said. "I had a long conversation with Jesús Ramón's mother and aunt tonight. I thought you might be interested."

"The junkie aunt?" he said.

"Mayra," I answered, a hint of reprimand in my tone, I'm sure. "Mayra had a special visitor a couple of weeks ago."

"Yeah?" He was being a hard ass.

"Nelda Ruiz."

"Tell me. She wanted money and a place to hide, right?"

"Actually, no. Mayra said Nelda was feeling pretty low. She had been looking for work, but all the job referrals the Parole Department gave her took one look at her résumé and her past and didn't call her back. She has no high school diploma, she has an impressive criminal record, and drug customers don't write reference letters," I said. "The only interview she got was for minimum wage working with an overnight office cleaning business, but she failed to get bonded."

"No surprise there, not with her record."

"Nelda told Mayra she was going back to her old profession," I said. "Wanted to bring Mayra back in. Offered to finance a restaurant for her if she would move drugs for her on the side, as she did before when Mayra had her taco cart."

"Where would Nelda get money to back a restaurant?"

"Good question," I said. "Maybe it was just bluster."

"Mayra thought she was serious?"

"She did."

I waited a while for Kenny to say something. Finally, he asked, "How long had Nelda been out of the slam when she went calling?"

"Maybe two weeks."

"People think that when someone is convicted he goes into an abyss," Kenny said, "into a place full of strangers. White collar criminals are often isolates, but when gangbangers go into prison they go home, into the bosom of their brethren. When they come out again, all their contacts are intact, if not stronger."

Kenny sniffed. "Department of Corrections? Correct your criminal tendencies or make you a better criminal? Which are we doing?"

"Mike wouldn't have asked that question. He would have had the answer. Not *an* answer, but *the* answer," I said. "And he would have known absolutely how things should be made right. The world according to Mike Flint was a world without a lot of room for gray areas."

"Lot of cops are like that," Kenny said, a bit of a chuckle in his voice.

"I used to tell Mike, life's too short," I said. "You fix what you can, don't get your shorts in a twist about the stuff you can't, and hope you can know the difference."

Kenny laughed aloud. "Mike didn't buy that philosophy, did he?"

"Nope. Mike always thought he could control any situation."

"Yeah, well..." He did not say, though he might as well have, that that explained the last decision Mike made.

I said, "Guido videoed the interview with Mayra. We'll be reviewing it at the studio tomorrow. I wondered if you'd like to come over to see it."

"I would. Thanks. I have a meeting first thing, but I can be there by about eleven. How's that?"

"Good," I said. "We'll do lunch."

"Uh, Maggie." He hesitated, stuttered over his next couple of words. "Can we have lunch in the commissary?"

It was my turn to laugh. "If you want, lunch in the studio commissary it is."

Years ago Johnny Carson joked on "The Tonight Show" about his studio's employee commissary. Old-timers like Kenny expect that the institutional cafeteria must teem with movie and TV stars. The talent does drop by, in and out of makeup, looking for drinks and meals like the rest of us. The fare ranges from fast food to decent, but the commissary is never a place to expect fine dining. And I have it on good authority that Johnny Carson would carry a brown bag with him to work from time to time.

"See you tomorrow," he said.

I put my phone away, declaring a long day finished. But I was still abuzz. The expectation and rush of the first more-or-less public airing of the project promo, discovering Mayra, Mike, life, death all swirled together. I knew that it was going to be damned hard to come down enough to fall asleep when I finally found my bed.

I drove up the Pacific Coast Highway through Malibu and took the turnoff to my canyon road with the CD blasting Miles Davis's interpretation of Rodrigo's *Concierto de Aranjuez*; one of Mike's favorites.

I slowed sharply for the turn onto Mulholland Highway, and kept my speed down, watched for the deer and coyotes who share that road at night, who sometimes stand in the very center of the road and wait to see whose lights approach around the mountain curves, sometimes waiting until it is too late for all involved.

The night was clear and dark, no moon. The edge of the road was defined on the right by the rise of a steep mountain sheer, on the left by the black abyss of the canyon below. The road between was a silver ribbon exactly as long as the reach of my headlights. It is always a beautiful drive, by day a wild mountainscape, by night a star-filled wonder. I opened the moon roof, glanced up to see the stars, and breathed in the aroma of dusty sage. As I drove, the cacophony of the day, all the stresses and the highs, were pushed

aside by the concentration needed to keep the car on that treacherous stretch of mountain road. The inner noise was replaced by a spreading quiet.

I drove around the back way and parked on the backside of the peak behind my house to take a quick look around. If the burglar had come over that steep, overgrown scarp to break into my house, and it was the investigators' best guess that he had, then the man was in damn fine shape. I didn't see any indication that someone had scrambled through the brush recently, but, as I said, it was very dark. I continued home.

The last curve in the road before my driveway is a sharp, nearly impossible hairpin curve. I shifted to low, braked on the way in, and as I accelerated out of the curve, snapped off my headlights so that the lights wouldn't send Duke and his friends into a noisy snit and wake the neighbors.

I passed Early's drive and gave my car a little juice to get up my own steep drive. At the top I coasted to a stop, waited for Miles Davis to finish his riff on Rodrigo's last strains. I decided not to bother parking in the garage, and to leave my day's accumulation of notes, discs, empty water bottles, and the ubiquitous bundle of sympathy cards and notes in the car when I got out. Standing on the driveway, enveloped by a soft, warm breeze, I paused to look up at the black, black sky, at the stars that seemed like a glittery umbrella that, on the horizon, merged into the rising glow of distant city lights. Not for the first time I thought that, maybe, I had found my place.

I took in another deep breath, locked the car, and turned toward the front walk.

"Hey, neighbor." I looked across to Early's house and saw him out on his front deck, glass of wine in one hand, binoculars in the other. Behind him, coming from inside his lighted house, I could hear Barber's *Adagio for Strings*, a choral version. It is a moving piece, but it sounded funereal as it wafted through the night; too sad.

I took one more step and tripped the motion sensor for the front lights.

"Good night, Early," I said, squinting past the sudden glare of the lights to see him.

"You know, I was thinking," he said. "If it's okay with you, I'd like to move the light sensor further down so you won't be getting out of the car in a dark spot anymore."

"Take it up with Duke," I said. "Mike set it where it is so we wouldn't upset the dear boy. Anyway, he always wanted me to park in the garage, but I'm finding the garage a little spooky right now, too many dark corners."

"Understandable," he said. "Duke will get used to the light. If not, I can set up a screen for him."

I looked over my shoulder at the dark stretch between the car and the outer ring of the lights.

"It's a really good idea, Early. But that's too big a favor to ask."

"What's the price of peace of mind?" he said, good-naturedly. "Glad you're home safe. Good night, now. I'll wait right here until you're inside."

"Good night."

I felt oddly buoyant. I had made a decision that would change the domestic status quo instead of preserving everything exactly as Mike had left it. A tiny decision, certainly, but a decision nonetheless. Decision two, I was going to go upstairs and reclaim my bedroom, my bed.

I went to sleep listening to the breeze ruffling through the trees outside, coyotes howling in the canyons, an owl or two in the distance, and Duke, Rover, and Red snuffling at each other and clomping around their corral together. I fell into a deep, black sleep.

When my phone began to ring I was still asleep, dreaming that an alarm clock was going off and I couldn't find it. Eventually, I stirred enough to realize the ringing was my cell phone. By the time I had turned on a light and found the phone, still in the pocket of my jeans, the ringing had stopped. The bedside clock said it was midnight.

I pulled up the caller's number, didn't recognize either the number or the area code, but because I don't give out my cell number to many people, I pushed the call-back button.

According to the woman who answered, the call came from the veterans' facility up in Sonoma where Mike's father, Oscar, was staying. When I identified myself, she put me through to the evening supervisor, a man named John Pendergast.

"Mr. Flint is having a bad night. My instructions are to inform you." Pendergast sounded cross, scolding even, as if there were something I should have done, and hadn't. "Mr. Flint went out for a walk again tonight. Highway Patrol picked him off the highway median. Mr. Flint wasn't sure of his name or where he belonged, but he knew he was a sergeant with the Third Corps Army Engineers. He got upset when he couldn't find his weekend pass. Of course, his johnny gown doesn't have any pockets to hold a pass. CHiPs knew to bring him here. It's not the first time he's gone AWOL to find a drink."

"Oscar stayed with us for a while," I said. "I know he can be determined when he wants a drink."

"I can attest to that," Pendergast said, sounding exasperated. "He may not always know who he is or where he is, but he always knows he wants a drink. The men in here are adults. Sometimes visitors bring them in a bottle or they bribe a staff member to get them something. Doesn't matter how well they hide it, Oscar can always find it."

"So," I said. "Oscar's okay. He wasn't hurt?"

"We had to put him in restraints and sedate him, so he's going to sleep for a while," Pendergast said. "But it'll happen again. The point is, he needs to be moved to a facility with a higher level of care than we can offer him. Most of the men here don't suffer from much more than being old and alone. Mr. Flint needs a more secure facility. We have orders to move him out by the end of the week."

"I didn't know. Where will you send him?"

"That's the thing. See, miss, you need to make those arrangements yourself."

"Oh" was all I could think to say at first. "Any suggestions?"

"We have a list of places. But the shortest waiting list is six months."

"If I get him on a waiting list can he stay with you until his name comes up?"

"No, ma'am." This was an adamant no. "And with his history, you might have some trouble getting him in anywhere."

"What would happen if he had no family around to make arrangements?" I asked. "You wouldn't put him out on the street."

"In that case the VA would get him right in somewhere. But he has a legal guardian, you. He's your legal responsibility."

I found a pencil and a notepad and wrote down the contact names and phone numbers Pendergast gave me, as well as a website for locating Alzheimer's care facilities. The search for a decent place for Oscar would be a good project for my assistant, Fergie, who was due back at work in the morning. And make a good theme for a horror movie.

Pendergast cleared his throat. "I told all this to Mister Flint's son, Mike Flint, a couple weeks ago. He said he'd take care of it. Then, well, because of what happened, we let it ride for a little while."

"You spoke with his son?"

"Yes, ma'am, several times," he said. "Didn't he tell you?"

"No," I said. "He didn't tell me anything."

— 11 —

Mʏ ᴀꜱꜱɪꜱᴛᴀɴᴛ, Fergie, back from her trip to Cabo, sun-burned to a crisp, her head still on *mañana* time, came into my office, notebook in hand, to take notes on the day's list of tasks to accomplish. I was happy she was back, I had missed her and her efficiency and her happy face. She didn't seem to share my enthusiasm about her return. As she sat down on the sofa she sighed heavily, kicked off her flip-flops and folded her legs under her.

"Sorry I'm so useless today," she said.

"Happy you're back safe," I said. "Good trip?"

"What I remember of it." Her heavily freckled forehead was already beginning to peel. Redheaded Kathleen Ferguson does not have the complexion for a beach vacation. "Damn. I'm getting too old to party, Maggie. I should start taking those old-lady walking tours of gardens or something."

"Whatever you do, you should get some sunscreen and a big hat before you do it."

"And sensible shoes and a one-piece swimsuit. You should see this." She pulled up her T-shirt and showed me her blistered belly. Her abdomen looked like a pizza.

"Oh, Fergie, have you seen a doctor?"

"That bad?"

"Yes. Get yourself to a dermatologist, right now."

She brightened. "Are you sending me home?"

"I'm sending you to make an appointment," I said. "And while you're on the phone, would you please call the coroner's office?"

"The coroner?" She pulled up her shirt again and looked down at her belly. "Is it that bad?"

"I've seen better-looking skin on a cadaver. But, I want you to make arrangements to set up a shoot there. Do you have the number for the county film office for permits, because they'll probably be necessary?" I said.

I waited for her to finish writing. "Get in touch with a man named Phil Rascon. He'll connect you with the people who process John Does. Tell them we want to see how unidentified bodies are registered, handled, and disposed of."

"Gross," she said emphatically.

I smiled at her. "You want to go on the shoot?"

She thought about that for a second, brightening a bit at the idea. "Maybe."

"And, before you go off to be chastised by the medical profession, would you please call Security and tell them I need to have something locked up?"

"The files you left for me to copy? Mike's files?" Fergie was beginning to get back into her groove. I would say her cheeks colored, the usual sign of her engagement with an issue, but in her present circumstance that would just be redundant. "Locked up where?"

"Somewhere secure. There must be a vault somewhere on the premises."

"Copies or originals or both?"

"The originals. Did you know my house was broken into day before yesterday?"

"I heard something." She put her hand on the boxes holding Mike's files, eyes wide. "Do you think that's what they were after?"

"I'm beginning to wonder."

"Very cool. I mean…" She searched for the right thing to say. "Okay, not cool. You probably were pretty scared. But it's interesting. Mysterious."

"That it is," I said. "I need two sets of copies made, one for me to work from, and one to hand over to the police if they get insistent. Guido has some film school interns floating around here somewhere who can help you. Making copies would be a good assignment for them."

"Good idea. Thanks."

"And just for fun, here's another little job."

I gave her the information about finding Alzheimer's facilities that John Pendergast had given me the night before and explained the Oscar problem. And then I set her free.

Fergie lumbered to her feet, headed for her desk. At the door,

she hesitated, and then, holding the doorframe, she turned to me and said, "I'm really sorry I missed Mike's funeral. If I'd known… You could have called me."

"You'd planned that vacation for two years, Fergie," I said. "You were missed, but I'm glad you were having fun."

"Well, I'm sorry I wasn't there for you, Maggie."

"You're here now," I said. "And that's what's important, now."

"Yeah." She turned again to leave. "Know a dermatologist?"

"Casey's doctor is listed in my book."

"Good. Thanks."

After she left the room, she turned around and came back, handed me my second "Sgt. Lewis Banks" business card. "I forgot. This guy came by before you got here this morning."

"Would you please call Sergeant Banks and set him up for an in-studio interview this afternoon?" I looked at the clock: Kenny Noble was on his way over. If I gave Kenny two hours… "Let's say one-thirty or two."

"Got it."

Kenny Noble watched the interview with Mayra and Julia as if transfixed. He seemed to concentrate not only on their words but also on their body language. Sometimes when Mayra was talking, Kenny was watching Julia. When it was over he asked for a copy, which Guido produced.

I couldn't be miffed with him for being less than forthcoming about my trip to Corcoran. Eldon Washington was right. Kenny did what he needed to do and I got some of what I wanted as well. I guess that made us even. And there were a few things I wasn't sharing with Kenny at the moment, including Mike's personal files, his original pocket-size notebooks, and the information Phil Rascon gave me. All of that was currently in Fergie's capable hands.

"Department should hire you two," Kenny said, pocketing the interview disc. "You ask good questions. People talk to you."

"Would I get my own nightstick if I joined up?" Guido asked.

"Sure thing." Kenny chuckled. "And I'll personally show you how to use it."

"You'll need more than a nightstick," I said to Guido, "when the Department figures out you're a Commie."

"Communism's dead, Mag," Guido said. "Didn't you get the memo?"

"Musta missed it." I tapped the ticklish place under his ribs and ducked the hand that rose to swat me away. "I promised Kenny lunch in the commissary. Will you join us?"

Guido's sardonic smile told me he was more than familiar with a visitor's interest in that particular institution. He said, "Delighted."

We ran into Early as we crossed the parking lot on our way across the midway toward the administration building where the commissary was located. I asked him to join us also.

"Kenny," I said, "you know Early, my neighbor."

Another round of hand-shaking.

Early handed Guido a disc. "Don't know if you can use this, don't know what the break-in at Maggie's was all about, but I shot some footage of the investigators at work at her house. Just in case. If this burglary has anything to do with the project..."

Kenny furrowed his brow as he puzzled over that last comment. "If the burglary has what?"

Early looked at me. "Did I misspeak?"

"Don't worry," I said. "If it did, we wouldn't hide it from the police, or they from me. Right?"

When we arrived at the next building, Guido reached first for the door, let Kenny and Early precede him. As I passed him, he patted the disc in his pocket and muttered, "Beware. Barbarians at our gate."

I muttered back, "I love only you." He thumped my backside.

The commissary has two large areas. The Primetime Grille has a service counter where one can order bacon and eggs in the morning, burgers, burritos and deli sandwiches the rest of the day. There are pizza slices and Chinese-ish offerings under heat lamps, a salad bar, self-serve coolers for drinks, sides, and desserts, and racks of chips and various other junk food. The floors are scrubbed linoleum, the tables and chairs are shiny chrome and bright red plastic; a standard-issue, utilitarian fast food venue.

On the windows side of the room, separated from the Grille by movable screens and potted palms on wheels, is Emmy's. Carpet on the floor, white linens, table service provided by a wait-staff in

starched jackets, meals ordered from a hand-written board listing the day's offerings. Usually there is a fish, a chicken or beef dish, something vegetarian, and, every day, a very good grilled-chicken Caesar salad.

Kenny glanced over both areas before he chose the relative quiet of Emmy's. Better place to talk, he said. I made certain that our table was next to a window so that Kenny could watch for the comings and goings of TV talent driving their expensive cars up the midway between the studios and the administration building. At the table next to us, the host of the network's late night talk show, a famous funnyman, was in a very serious conversation with one of the nation's leading comedians. Not a laugh or even a chuckle emanated from the pair the entire time we were there.

"Maggie." Kenny opened his linen napkin and spread it on his lap, and then he looked pointedly at me. "In all that mess in Mike's office, I didn't see any of his investigation notebooks."

He pulled one of his own out of his pocket to show me, the standard-issue policeman's *vade mecum*. "Any idea what Mike did with them?"

"I'm sure he put them away somewhere carefully," I said, equivocating; Mike's notebooks were in Fergie's hands, waiting to be copied along with his files. I was not ready to relinquish them.

The phone in my pocket vibrated. I took it out and looked at the number in the caller ID window. It was Lana, from her cell phone. Before I answered the phone, I turned to Guido.

"It's Lana, from New York," I told Guido. I turned to Kenny. "It's our exec producer calling from New York. I need to talk to her."

He shrugged, as in, You gotta do what you gotta do.

I walked out into the passageway to take the call. "Meeting over?" I asked Lana by way of greeting.

"Congratulations," she said, "Pete and the boys bought the project. We had the usual wrestling match about final content approval, but we've beaten them down on control issues before. The concern I picked up is whether the project will be large enough to fill two hours. I don't mean long enough, Maggie, I mean *large* enough."

"Big-time boffo, I promise," I said. "We'll give them sex, blood, passion, some gossip, and a couple of good recipes and decorating tips."

"How's the film coming?"

"We're hard at work. Tomorrow we're downtown, Sunday Guido's crew is filming at the morgue, and Monday a funeral at potter's field. How graphic do you want us to get?"

"Do what you need to do," Lana said, without irony. She gave me a little *pro forma* pep talk, but I could hear a whole lot of stress in her voice. I suspected that the boys in New York had given her a pretty good beating up before they signed on with this one.

Lana takes care of me because it works for her to do so. I would never hear the grim details of the meeting, how much of her soul she had to sell and how much of mine she promised. What I always have to remember is that the stakes are always greater for her than they are for me. My failure to deliver audience share would be hers, squared.

I said good-bye to Lana, and turned my attention back to Kenny. Almost immediately, my phone buzzed again. I looked at the caller ID screen. It was Fergie.

Fergie told me she was at the studio reception desk with Lewis Banks, who had told Fergie when she called him to set up an appointment that he was in the neighborhood and would just come on over for that conversation. And he had. I asked her to escort Banks to the commissary to join us. The more the merrier. Or was it protection in numbers?

A few moments later when I saw the flash of Fergie's red hair at the commissary entrance, I walked over to greet Sgt. Banks. He was in full uniform, though he wouldn't be due at work until ten that evening. I asked him to wait for just a moment, and took Fergie aside for a word.

When we were out of earshot, I whispered to her. "That little copying task? Take it upstairs to Lana's office. Have Security pick up the originals from there. Let the interns know that what they're doing is highly confidential. They shouldn't discuss it with anyone."

Fergie loves skulduggery and was happy to oblige.

I walked Banks over to join the others.

"Are you coming from or going to work?" I asked him.

He ran a hand down the front of his uniform. "Had a security job early this morning. Traffic control at a movie shoot."

I nodded. Lots of uniformed officers moonlight in Hollywood.

We joined the others. "Lewis Banks, Ken Noble, have you met?"

"We've run into each other," Banks said, shaking Ken's offered hand. I introduced Banks to Guido and Early, and Early pulled up a chair for him. Banks declined lunch but accepted coffee.

"Nice of you to come in on such short notice," I said to Banks. "After lunch, maybe you'll come upstairs and let me ask you some questions on camera."

"Concerning?" Kenny asked, scowling in Banks' direction.

"Sergeant Banks knew Mike when he was still at Seventy-seventh Street," I said. "And he was working out of Central in 1999 when Jesús disappeared."

"Ah," Kenny said. "The history. Do you call getting that kind of information deep background?"

"I won't know what to call it until I hear what Sergeant Banks has to say," I said.

Food arrived. The ceremonies of the peppermill and the bread basket followed. Drinks were replenished. When the wait-staff had finished their ministrations, Kenny picked up where I had cut him off when I left the table to talk to Lana.

"You know how Mike was." Kenny, fork poised over a very nice piece of poached cod, smiled wistfully, winked at me. "He was a thorough investigator. Very meticulous. I know he kept good notes when he was in the field. I sure would like to get a look at his contemporaneous notes about Jesús."

"Are you looking into the case again, Kenny?" I asked.

"Since you brought it up, yeah. Political pressure from above."

"Well, I'll take a look around for the notebooks."

Guido and Early exchanged puzzled, but intrigued, glances, leaned forward, and in that gesture also moved closer to each other. They both knew that I had the notebooks. We had referred to them for chronology and police lingo when we worked on the promo.

"You're fudging on the answer, Maggie," Kenny said, assertive but calm, smiling. "I know you have them. Those notes are potential evidence in an open investigation, the same as Mike's testimony now that he isn't with us, God rest his soul. We'll probably

need the originals if we ever manage to file any aspect of the Jesús case with the D.A. Think about it."

"Would you settle for a copy?" I asked.

"For now. But don't let anything happen to the originals."

"Count on it."

Conversation during the rest of the meal was mostly cop stories, two old-timers, Kenny and Banks, playing a sort of tale-spinning one-upmanship. They were interesting enough that the two fun-nymen lunching at the next table leaned in to eavesdrop.

Back at my office, Fergie had two film school graduate-level interns busy at a table in a back corner of the outer office with three-hole punches and stacks of photocopies and three-ring binders. I walked over and made sure that Kenny could only see the blank reverse sides of the pages. Fergie herself was busy with her post-vacation readjustment activities, drowning a weeklong tequila hangover with mineral water and aspirin, and making phone calls.

The interns were young and attractive and efficient, and I supposed Kenny felt obligated to say something to them. So he told them he could get them clerical jobs at Parker Center any time they wanted. Good benefits.

One of the interns managed to say, "Thanks," but the other could barely muster a polite smile.

"Clerks and secretaries hold the world together," I said. "But these ladies are graduate film students working their way toward the production suites. They have a different career path in mind."

He nodded. "Well, good luck with that. But if it doesn't work out..."

Guido took Banks down the hall to a studio to set up for the interview. Early said he was due back in the newsroom. As a courtesy, I gave Kenny the nickel tour of the studio. We walked through the news facilities where I introduced him to the on-camera talent. He had a friendly conversation with the former pro footballer-now-meteorologist about the Southern California weather prospects for the weekend; warm and sunny was the forecast, as usual. We watched some of the warm-up act before the taping of a popular situation comedy, and stayed long enough to see the actors come out and wave to the audience before stepping on their marks to tape the first scene. Then we went up to the office of the same late

night talk show host we had sat near at lunch so that I could intro-
duce them.

Laden with network logo T-shirts, caps, and mugs, Kenny was
grinning when we finished the full studio circuit and arrived back
downstairs. At the reception desk I gave him a hug, thanked him
for something or other, and expected him to say good-bye.

With his loot rolled into one of the T-shirts and tucked under
an arm, he said, "You have to decide whom to trust."

"I haven't made that decision yet, Kenny," I said. "I don't know
enough yet to do that."

When he started to argue, I said, "I know you had my conversa-
tion with Boni bugged, that you set me up to have a conversation
he wouldn't have with you. I don't blame you, but you should have
told me. You should have trusted me."

"*Touché.*" He gave me a firm, one-armed embrace.

I said, "I have three questions, and I wonder if you can help me
with them."

He laughed. "Only three?"

"At the moment."

"Shoot."

"One, on January 16, 1999, what time did Boni leave Parker
Center after he dropped off Nelda? Add to that, where did he go
after he left Parker Center? Two, who found Mayra?"

"And three? What's three?"

"Who do you think killed Rogelio Higgins?"

There was a pregnant pause. "Who've you been talking to about
Higgins?"

"Mike, primarily," I said. "His notes. But a lot of people I've spo-
ken with begin their recollections about Jesús with the death of
Higgins. The assassination of Higgins."

"Maggie, I'll help you with Jesús Ramón, but the drug trade is
another matter. That's somewhere you don't want to go. Doesn't
have anything to do with what happened to Jesús disappearing,
and you could get yourself into some big trouble if you go through
the wrong door."

"We'll see. Can you answer my questions?"

"The first one I'll have to look into for you, get back to you,"
he said. "But the third I remember. The Higgins shooting was one

of the first cases Robbery–Homicide caught after I was promoted to lieutenant. You don't forget the first ones. Especially one that dirty.

"Question two." He leaned a haunch on the corner of Fergie's desk. "Mayra was found in an abandoned factory down on First Street, down near the bridge, by a homeless woman named Orfelia Jones who was looking for a place to sleep off her load sometime before dawn. Jones flagged down a patrol car headed back to Parker Center and took the officers to the location."

"Any idea where Orfelia Jones is now?"

"That was ten years ago. You know what the life expectancy of a street person is?"

"I can only guess. But the question remains on the table."

"I'll ask health services, see if there's a death certificate on file. You might contact some of the local shelters."

"Kenny, why weren't you forthcoming with me?"

"You're press, I'm cops."

"Bullshit," I said, but I was smiling.

"Look, Maggie, I hoped you'd come to the same conclusion Mike and I did about where Jesús Ramón has been all these years and go public with it, clear Mike's reputation," he said. "Jesús was a street punk who took drugs with his aunt and they both OD'd. She was found in time. He wasn't. I thought that would be the end of your story."

"It was more than an overdose," I said. "Jesús was murdered. I believe that Mayra was the intended target and that Jesús was collateral damage, but it was still murder."

"You'll have to persuade me. Who would want to hurt Mayra?"

"Someone who was afraid she would talk."

"Know who yet?"

"Whoever tried to take over Higgins's downtown territory."

"Mike always bragged about you," Kenny said, sounding grim. "My apologies, I underestimated you."

"And here we are," I said. "What next?"

"Maggie, how many corpses did you run across in the process of reaching that supposition?"

"Counting Rogelio Higgins and Jesús, five," I said.

"Double that," he said.

"And some of them were cops," I added.

He sucked in some air. "You don't know what you're up against. You really think you know what that was all about?"

"Parts of it."

"You probably do. Give me a for-instance."

"I suspect that when Boni Erquiaga made his bullshit charges against Mike et al. and managed to get a grand jury convened, that he was showing someone else what he was capable of stirring up. A warning, as it were, to keep quiet."

"If you have half the brains I think you have, you'll keep what you figured out to yourself, Maggie."

"To myself and the television viewing public," I said.

"Let me say it this way, a little bit of knowledge can get you dead."

— 12 —

A T FIRST, I was surprised how little Lewis Banks had to tell us. Or wanted to tell us. He looked nice on camera, and we probably got a few usable bites from him when he talked about policing the neighborhood where he grew up, about arresting people he went to school and church with, or, worse, seeing his neighbors victimized by drugs and crime. He called the dealers scum, parasites, and various forms of vermin, but he also seemed to have compassion for addicts because he felt that many of them were victims of their environment. He hated the gangs.

But all he had to say about Jesús Ramón's disappearance was that there were flyers all over town within twelve hours of his exit from Mike's car, and the police had a bulletin to be on the alert for him. Lewis knew Mayra and Julia from church; he was an altar boy when they were all kids, and he had helped raise money to pay for Mayra's wheelchair and medical expenses. Through church outreach he had spent considerable time with them, he said. Thought of them as family, he said.

I asked him about the brotherhood of police. How much of that closeness was reality and how much was myth?

"Probably half and half," he said. "When you ride patrol with a guy for a while, you get real close for that time. But we get moved around regularly, especially since the consent decree. Once you get transferred, or your partner does, you start to lose touch. You run into each other at reunion steak-frys, but it's never the same. You can never get as close again as you were when you spent whole shifts together in a patrol car. Not like the way it was when Mike was a patrolman working out of Seventy-seventh."

"But you watch over each other," I said. "I've seen firsthand how you folks pitch in to help when a policeman dies or gets hurt."

He nodded. "We look after each other."

He wasn't going to tell war stories that could embarrass either himself or the department. I was ready to cut him loose, but I asked one more question, and hit a little jackpot. He mentioned that he had been an altar boy, something Julia also mentioned. Seemed like a good character issue to talk about, cops and God. I asked him whether sometimes things he needed to do while on patrol interfered with the teachings of his church.

He canted his head and thought for a moment before he responded. There was a lot going on in his face while he worked out his answer.

"There was a time," he said, "I turned my back on my faith. I was a young cop, hard-drinking, hard-driving. Thought I knew everything. Thought I had the world by the tail."

He needed to take a breath, shake off some wave of emotion.

"Did something happen to change that?" I asked him.

He nodded. "A lot of things happened, one right after the other. Rodney King, the verdicts, the riots. You gotta add O.J. Simpson, because that verdict was like the city dumping garbage on the cops. Couple of bad police scandals made things worse, Rafael Pérez at Rampart, then Boni Erquiaga. The feds came in about then and took over the department. Why do they call it a consent decree? What did we consent to? They should call it federally occupied LA."

"This was in the mid-nineties," I said.

He nodded. I thought he was just getting wound up, but he took a couple of deep breaths, calmed himself down.

"For guys like me on the job, that was a very difficult time." He dropped his volume, softened his tone, emotions contained by sheer will, but the message was still rife with anger.

"A lot of guys left the department," he said. "Couldn't take the pressure, couldn't do their job right shackled by the feds, and crime rates soared. Some guys took it out on the community. Others took it out on the people they love."

He looked directly at me. "Me, I took it out on the people I love. I admit I was a devil to live with back then, so full of crap. My pretty wife left me, took the kids; they hated me. My mom asked me not to come by one Christmas if I couldn't behave right, stay sober, keep my mouth shut."

"You're still on the job," I said. "What happened?"

"Some guys started a prayer group," he said. "One of the sergeants in Hollywood was an ordained preacher. He started the group. Met a couple of times a week to read the Bible and pray. Talk things out. A prayer circle, he called it."

"Do you still attend the prayer meetings?" I asked.

"No. Some of the group got pretty hardcore about religion, Bible thumpers, full of righteousness and revenge. After a while, I went back to my old parish, confessed my sins to the family priest, started taking my mom to church on Sundays, like when I was a kid. Then my kids started coming with us, then my wife. About that time, the prayer group broke up. But it helped a lot of us, for a while. Got us on a better path."

I thought that was a good place to end. Very poignant. I had heard officers express similar feelings any number of times. What he said could be good as foundation. The time frame worked. About the time Jesús disappeared, Banks's prayer group was breaking up, a new normality under the consent decree had settled over the LAPD.

I thanked Banks for talking with me, escorted him out.

After I saw him to the parking lot, I returned to my office to find Guido sitting at my desk thumbing through one of the three-ring binders full of photocopies of Mike's records and notes and clippings that the interns had assembled.

"Ballsy," Guido said. "Those women were putting copies of Mike's stuff in binders, and Kenny walks in on them."

"Could have been embarrassing," I said. "But all he could see was the blank back sides of the copies and office workers doing office work. Fergie had things under control; she told him it was end-of-the-month report time."

"What do you think of Banks?" he asked.

"Can't decide," I said. "Maybe he's curious, maybe he wants to be in the movies. And maybe he's flirting."

"With you?" He chuckled.

"Or you," I said.

"Doubt it," he said, pretending to read one of Mike's pages. "Anyway, I think he has some competition."

I looked at him, hard. I'd heard that particular tone in his voice before, part competitive sibling, part jealous suitor. Relationships

among long-term co-workers can get very complicated as work and private lives intersect; we often spend more time with colleagues than with family, as Banks had said.

"Just say it," I said.

"All right." He stood up to be at eye level with me. "First, I'm happy to see some flicker of your old self again. As much as I hate it when you tickle me, it's a good sign when you're being your obnoxious self again."

"Thanks," I said. "And?"

"This guy, Early. I don't think he's up to your standards."

"Standards for what?" I said, knowing exactly where he was headed. "For neighbor? For white knight? Or for technical expertise and support?"

"You know what I mean."

"Ohhh." I pulled out that single syllable. "For the old hootchy-kootch, Guido?"

"Shut up."

"You'll always be my first love."

He finally smiled, if sardonically. "Doubt that very much."

"He has a lot of talent," I said

"In this town, that and a nickel..."

"Do you listen to yourself?"

"I try not to," Guido said. He took a breath and set down the binder. "So, Mike decided a long time ago that Jesús is dead."

"So it seems," I said. "If the story Mike gave about dropping off Jesús downtown is true, then Jesús probably disappeared from that general area pretty soon after Mike dropped him. Auntie Mayra, with whom he shared drugs, took a dose of pure heroin when she finished work that day, and damn near died. We know they shared drugs. What if she gave some of the pure heroin to Jesús, his usual cut, say. And he found a quiet place to shoot up, as she did. Only she got found in time, and he never was found at all."

Guido looked like a bobblehead doll, waiting for me to finish. "Last night, when Mayra and Julia were talking, that's exactly what I was thinking. So what now?"

"We're taking a walk downtown tomorrow," I said. "I want to start at the alley where Jesús got out of Mike's car and try to retrace possible routes he took."

"What do you want for a crew?"

"I hoped you and I could do it alone, the way we did that report down in Chiapas all those years ago. Remember? You walk with the camera, I talk."

"I remember," he said. "A nightmare. Had to re-record sound when we got back because quality was crap. We can walk, if you want to, but let's do it right the first time. You need to be mic'd and we need a good sound guy."

I nodded. "Fine, but let's try to be as unobtrusive as possible."

"Sure. But you need to goop your face and comb your hair because I'm going to shoot you in front from time to time, Mag. I don't like the disembodied voice. You have to be there, in the picture. The damn program has your name on it, remember?"

"That's fine," I said. "Who do you want for sound? Craig Hendricks is off on an assignment somewhere."

"When do you want to take this walk?"

"Tomorrow morning."

He dropped his head. "You asking him or am I?"

"Who?" I asked, so innocent.

"Drummond."

"Guido," I said. "*You* want the sound guy."

"What I said earlier stands." He jabbed a finger toward me. "But he's the best field guy I know."

"Why don't you ask him?" I said. "If I ask he might misinterpret the invitation."

"So-o," he gloated, "you admit—"

"Nothing. And you'll have to get him released by the folks in News." I pulled my Thomas Guide map book off its shelf and opened it to the page for downtown Los Angeles, got a yellow legal pad and a pencil, and sat down at my desk. "You go do what you need to get ready for tomorrow, my friend. I'm going to be right here for a while."

When he was gone, Fergie put her head in the door. "I made a third copy of Mike's notes, as you asked. The courier will pick it up within the hour. It will be delivered to your lawyer's house right away."

"You're the best," I said.

"I try."

She set the day's bundle of sympathy mail on the corner of my desk, an unusually thick and irregular one.

I thanked her again and she went out, shutting the door behind her.

A tidbit I found in Mike's notes had rattled around all day long. I called Harry Young at home and caught him shortly after he got out of bed, hoping he had a good answer for that noisy little concern.

"Haven't found Nelda," Harry said. "I think she may have gotten scared after you took her picture. Looks like she took off."

"If she was smart, she did," I said. "But the reason I called is, I have a couple of questions about the good old days."

"Don't care what folks say, *these* are the good old days," Harry said with a chuckle.

"I've heard stories about Mike and his little posse of aiders and abettors at Seventy-seventh Street station, and the things they got away with on patrol, the way they covered for each other. The Four Horsemen they were called, or the Four *Whores*men," I said. "Were there other groups of cowboys like them?"

"Oh sure," he said. "Happens a lot less now than back when Mike was on patrol. Since the riots and all the federal oversight over the department now, cops can't get away with a lot of the stuff they used to pull in the name of keeping the peace. Guys like Mike and Roy Frady and Doug Senecal and Hector Meléndez were doing their jobs the best they knew how, watching out for each other. But the way they did things just wasn't always according to the regulation book, if you know what I mean. There's a whole new culture of police since the fallout after the riots."

"Did you know Tom Medina well?"

"Medina? I knew him well enough." The question made him pause. "Worked with him for a while at Devonshire before I got sent back over to Central."

"Were you close?"

"I wouldn't say that," Harry said. "He'd been reassigned from Southeast on some disciplinary beef and I was supposed to keep an eye on him, do some retraining."

"What was the beef?" I asked.

"I'm not real sure what it was all about. Medina had a tendency

to get real salty with the citizenry, had too many excessive use complaints in his jacket and got put on a 'watch' list by the Police Commission."

"Excessive use of force?"

"Yeah. He was pretty quick on the trigger," he said.

"Could it be that's why he's dead?" I asked. "Off duty officer, interrupts a robbery outside a 7-Eleven, identifies himself as a cop, gets shot. Maybe that just wasn't a smart way to handle the situation."

"Goes against training."

"You were a pallbearer at Medina's funeral," I said.

"His wife asked me. I was his last patrol partner."

"Lewis Banks was also a pallbearer."

He was quiet for a moment. "Yeah," he said slowly. "I guess he was. That was, what, five, six years ago?"

"Six," I said. "Tom Medina died the week before the grand jury convened to look into the Jesús disappearance."

"Huh. Is that right?" Another pause. "Is there a connection?"

"Who knows, Harry? That's how I remembered the date, that's all. Tom died, Mike got subpoenaed, all reported in the same edition of the LA *Times*."

"If you say so."

"Thanks, Harry," I said.

Harry was quiet long enough that I asked if he was still on the line.

"Maggie," he said at last. "Is that what you called to ask? If I knew Medina?"

"That's it," I said.

"Sure." He sounded doubtful. "I hear your movie pals are retracing our ride-along, filming where we went. I thought you had your camera out most of the time."

"They're just filling in coverage."

"How's the project going?"

"Pretty well, I think. Thanks for all your help."

"Anything I can do for you, honey, just call."

Honey. I tried to remember how many times I had been called honey or sweetheart during the last week and a half, ran out of fingers and toes and gave it up.

Eldon Washington called. After leaving the studio, Kenny had put in a call to Eldon, asked him to take a look at Boni's employment jacket to see if the answers to my questions were there. He asked Eldon to call me if they were.

"What did you find?" I asked.

"Boni left Parker Center at twelve-thirty P.M. on January sixteenth." Eldon sounded stressed, or weary. "He called in a lunch break, and reported back at Central Station at three-thirty."

"Long lunch," I said.

"He was docked some pay and he got a beef letter in his jacket, and that's the only reason I know the time he left HQ," Eldon said. "I hope that helps you."

"It just might," I said. "Tomorrow, I'm taking a video crew downtown to retrace Jesús' last day. Can you join us?"

"On camera, on record?" He sounded doubtful.

"I promise we'll only talk about Jesús."

"Why not?"

We arranged a time and a place for him to meet us.

"Do I get the full treatment?" he asked.

"What would that be?"

"My own star trailer, makeup and wardrobe girl, personal assistant?"

"You LA cops, so Hollywood," I said.

"Did a lot of moonlighting, working security on movie shoots. I saw how it is for the stars."

"The best I can offer you is your own bottle of water."

"That'll do," he said. "That'll do just fine."

— 13 —

WE STARTED downtown where Mike said he had left Jesús, at the mouth of an alley behind a block of commercial buildings that fronted on Broadway, near Third Street. Guido walked to my right with a handheld video camera that was connected by an umbilical to the recorder Early carried, and that picked up the radio signal from the microphone clipped to my collar.

It was an old-fashioned lash-up, but Guido and Early agreed it was the best way to both pick up my voice and filter out the street noise. The independent voice record would also make editing easier later.

In some parts of the world we might have looked like a parade, the three of us plus two interns carrying gear in our train and serving as security, but in downtown Los Angeles it is just awfully normal to see people walking around with video equipment.

As we walked, Guido videoed the street, catching me from time to time in his frame. I gave an unadorned narrative based on Mike's notes, later investigation reports, and my best guess, explaining where we were and why we were there, speaking in a conversational tone. Occasionally, Early would ask me to repeat something, or Guido would stop to make adjustments or to reshoot a sequence to pick up more detail, or to filter some out. Most of the time we just walked.

Mayra had run her taco business from an open-air atrium in front of a sunglasses shop on Broadway, about halfway between Third and Second Streets, less than two blocks from the alley where Mike said he dropped Jesús. We walked out of the alley, from deep shadow into bright sun, and made our way over to Broadway.

We were in the old jewelry district. Though there were still many jewelry wholesalers doing business, the area was undergoing one of its regular transformations. Broadway at street level

still belonged to vendors. Though now and then there were some chain stores, most of the shops were small family businesses whose racks of wares spilled out onto the sidewalk to the very edge of the overhang of their awnings, small stores offering everything from clothes to electronics, noisy and colorful like a Third World bazaar.

Much of the ground-floor window space on the west side of the block was taken up by massive *quinceañera* and wedding emporia, their windows full of a fruit salad of bright, ruffled dresses with silken skirts puffed huge over stiff petticoats, proper confections to celebrate the two big transitions in the lives of young Latinas, turning fifteen, and getting married. The east side displayed imported jewelry and electronics.

On the floors above the old Orthodox jewelry mart, space that had once been manufacturing, offices, and wholesale showrooms was being converted into pricey residential lofts that most of the shoppers on the street below could never afford to live in. The ornate old movie houses on Broadway, when the street had been an elegant shopping district, were now Spanish-language churches, their mission-Baroque façades intact. When the well-to-do moved in upstairs in large enough numbers, I wondered what those old palaces would become next.

The sunglasses shop where Mayra set up her business was gone and the atrium had been enclosed to make more shelf space for the denim shop that now occupied the location; the rents in the area are high, and so is the turnover rate. Even though the façade of the shop was entirely different than it had been in 1999, we stopped near where Mayra's cart had once sat and used the site as background.

Guido positioned himself to capture both my face and the front of the denim store in the frame. He had some conversation with Early about light and incidental noise, adjusted my position a couple of times, and when all was as he and Early wanted, with his eye on his monitor, Guido said, "Speed, and action," as my signal to begin telling Mayra's story.

Mayra rented space for her taco cart from Kasim al Bashara Kasim, I said. Mr. Kasim told Detective Flint that Mayra was at work, as usual, on the day Jesús disappeared. According to Mr.

Kasim, that day was like any other day. Mayra was waiting when he opened his shop at ten o'clock, holding the handle of the red Radio Flyer wagon she used to transport her daily supplies. She came with him into the shop to retrieve her taco cart, a five-foot-long sheet metal box on wheels with a propane-fueled grill on one end, a butcher-block top on the other, and an ice chest underneath.

Every day, Mayra wheeled her cart out of the shop and into the atrium, opened a patio umbrella over it, filled the ice chest and stocked it with meat, sauces, and tortillas for her tacos al carbón; grilled beef on soft tortillas, Baja style. Mr. Kasim said she did a good business. The location was only a block or so from the Civic Center and she was popular with the government workers.

Mr. Kasim knew the nephew, Jesús, and had decided from the beginning that the boy was a little troublemaker, though he had never seen Jesús actually misbehave. He did not remember seeing Jesús on that day, but it had been a busy day for him as well, and it wasn't his practice to watch Mayra.

That January evening, as usual, Mayra began cleaning up a little before five so that she could pull the cart inside when Mr. Kasim came to the front to lock the shop's street door for the day. As he usually did, he helped her pull the cart inside. She finished her cleanup chores inside while he closed out his register, and then they would leave together, usually by five-thirty.

On that January day, as Mr. Kasim locked the door behind them, Mayra said good night and, pulling her red wagon, she turned north, up Broadway toward First Street where he knew she usually parked her van. He didn't see where she went after she turned north because his bus stop was in the opposite direction. The first he knew that something was wrong was when he did not find her waiting for him the following morning.

We started walking north, following Mr. Kasim's recollection of his last sighting of Mayra.

Mayra was found comatose from an overdose of uncut heroin in a vacant building on First Street, east of Alameda Avenue, maybe a six-block walk from the shop on Broadway.

As we walked, Guido, Early, and I chatted. Guido made a thorough video record that would be edited to a few bits in the final project, as would the sound. Guido always wanted full coverage

because you just can't know what will look good, sound good, and be useful later.

At Second Street there was a stark change in the landscape. The colorful shops and the rhythms of Latin music pouring from loudspeakers were replaced by the great gray edifices of the Civic Center and the *Los Angeles Times* building. Suddenly, dark suits predominated.

As arranged, Eldon Washington met us at the corner of Broadway and First. He was leaning against a lamp post, arms crossed over his broad chest, a broad-brimmed fedora on his head, a big automatic strapped on his hip, foot traffic giving him wide berth.

"Get that," I said to Guido. He turned his camera on Eldon.

"I like the hat," I said, reaching for his outstretched hand.

"Can't take the sun anymore; skin cancers. The wife got me some damn Chinese straw thing, but I decided that if I'm going to wear a hat, I'm going Hat Squad," referring to a postwar anti-mobster, anti-subversive unit that used to meet incoming planes at the airport, sort out the undesirables, meaning Commies and East-Coast mafiosos, beat them to a pulp on the tarmac, and put them on a turnaround flight. The Squad took credit, erroneously, for keeping LA mob-free. Never mind that Ben "Bugsy" Siegel and Myron Cohen were doing land office business under the protection of a couple of those same men; several of them became judges.

I turned to an intern in our train, Guido's current pet, whose name was Madison, and held out my hand. She put a bottle of water into my palm, which I passed to Eldon.

"Your star perks, sir. As promised."

He laughed and tucked the bottle into a back pocket of his khaki slacks. Early mic'd him and performed a sound test with Guido. Then he took the bottle out of Eldon's pocket because it made a funny bulge, and handed it back to Madison.

"Is my nose shiny?" Eldon asked, teasing.

"You're okay," Guido told him, looking at Eldon's image through the camera monitor. "But you need to push back the hat brim so we can see your face."

With our parade larger by one, we walked east down First Street, headed toward the old toy factory building where Mayra was found after Jesús went missing. At Main we passed City Hall

and kept walking. At Los Angeles Street we came to Parker Center, police headquarters.

I touched Guido's arm. "I want to have a conversation with Eldon standing right here. What do you think of using Parker Center as a backdrop?"

Guido moved around, moved us around, framed his scene, turned his camera to scan Parker Center and recorded an establishing shot. As if on cue, two black-and-white police units turned onto San Pedro Street out of the police garage and came our way as if we had planned for them to be there to give context to our shot.

"It's good," he said. "I have speed."

I told Eldon I was going to ask him to recreate the chronology of events on January 16, 1999. He said he could do it blindfolded. One of the interns guffawed at his non sequitur, pleasing him.

"When you're ready," I said.

He straightened the collar of his polo shirt. "All set."

Guido gave the signal, I asked the question. Eldon began with what he saw on Alvarado Avenue, Boni leaving with Nelda, Mike leaving with Jesús. Then, after a pause, he continued:

"A few minutes after noon, Mike dropped off Jesús, four blocks away from here. At about the same time, Boni Erquiaga arrived at Parker Center and signed Nelda Ruiz into the custody of Robbery–Homicide Division on the third floor of Parker Center. At twelve-thirty, Boni Erquiaga signed out again as he exited the basement parking garage. Fifteen minutes later, Mike Flint began to record an interview with Nelda Ruiz, on the third floor of Parker Center. At that time, Mayra Escobedo was at her taco cart around the corner, doing a brisk business."

"So, between about noon and twelve-thirty, Boni, Nelda, Mike, Jesús and Mayra were all within a very few blocks of this location," I said.

"That's right," he said.

"Around twelve-thirty, Jesús essentially vanishes."

"Essentially."

"His Aunt Mayra did her own disappearing act that afternoon," I said. "She was seen walking up Broadway, pulling her wagon, at five-thirty. And then, she was gone."

"For a while." Eldon turned, gazed further east down First. "But she turned up again."

"When she was found she was comatose, almost dead," I said. "Someone slipped her uncut heroin and didn't tell her."

"That's the story," Eldon said.

"Remind us of the charges against Boni Erquiaga and Nelda Ruiz that sent them both to state prison."

"Among other crimes, Boni stole drugs out of police evidence lockers and sold them, or had them sold, on the street. Nelda was one of his dealers."

"Was uncut heroin among the drugs he stole?" I asked.

Eldon frowned, looked up, searching for an answer. Then he shook his head. "Good question, Maggie. I just don't remember. I thought I knew everything there was to know about the criminal career of Boni Erquiaga, but that one I'll have to look into, do some homework."

He went on: "Heroin usually comes into the country uncut and goes to the big-time distributors."

"Like Rogelio Higgins?" I asked.

"Like Higgins," he affirmed. "Before the stuff gets distributed to the street dealers like Nelda Ruiz, it's been cut, sometimes a couple of times. Usually, when we run across uncut H or coke, the feds get attached because it's a smuggling issue. Boni didn't get hit with any federal charges. Which all means not one damn thing."

Eldon turned to Guido. "Can I say damn?"

"Say anything you want."

"Uncut heroin isn't unheard of on the street," I said.

"But it's rare. Especially in the hands of a penny-ante street pusher like Nelda Ruiz. Anything she got her hands on to sell would already be cut, bagged, and ready to go. I'll have to do some homework, but it's an answer I can get you."

"You're assuming it was Nelda who gave Mayra whatever it was she took," I said.

"Couldn't swear to it in court, but yes."

I was thinking how easy he was to talk to when we had a camera trained on him and a young female intern carrying his water bottle for him. People are endlessly surprising.

I said, "It was Mike who told Julia Ramón that her sister Mayra

had been found and was in the hospital. But who found Mayra, and when? And who told Mike?"

"She was found inside a derelict building just up the street a couple of blocks by a homeless woman looking for a safe place to sleep."

"Can you show us?" I asked.

"Not sure the building's still there; it's been quite a while," Eldon said. "But if you want we can walk over there."

With Eldon and me in the lead, our little parade headed off east down First Street.

After we passed the Japanese Village shopping area in Little Tokyo, Eldon pointed out a new condominium project that now covered the site where there had been a parking lot in 1999. Before the condos were built, the parking lot that was here was a bit cheaper than lots closer to the Civic Center, but it still cost twelve dollars a day, too expensive for a taco vendor. Mayra negotiated an arrangement with the evening lot attendants: she brought them tacos for their dinner and they let her drive her fifteen-year-old Toyota van out of the lot without paying the day-use fee.

Mayra's van, with the Radio Flyer wagon tied down in the cargo area, was still in the lot the day after Mayra's overdose, when Julia Ramón came looking for it. Julia remembered that the daytime attendant charged her twenty-four dollars, two full days' parking, when she retrieved the van so that she could drive Mayra to a clinic in Rosarito Beach, in Baja, Mexico.

We continued down First Street, passing a couple of blocks of small, tired factories. Some were in use, some were abandoned, some were undergoing yet more expensive loft conversions, some of them labeled "artist lofts." There were colorful murals with Aztec themes, and plenty of graffiti. Everywhere there were high fences topped by concertina wire, and barred windows.

At Alameda Avenue, the landmark First Street Bridge rises to cross over a set of railroad tracks, then the two-lane-wide cement canyon that is the Los Angeles River—a trickle of brown water running along a narrow trough cut in the center—and finally a second set of railroad tracks. Old brick warehouses with their loading bays, some dating to the early 1900s, stretch in a continuous line along the tracks.

The bridge itself is a work of WPA art. Its white plaster pillars and arches and light poles are fine examples of Art Deco design, fine enough to show up in photographs on the pages of a good number of coffee table books.

Under every bridge arch there is a bench. On every bench a homeless person had taken up residence. Under the bridge, among the old factories, along the warehouse walls and docks, there was abundant evidence—shopping carts, sheets of plastic and collections of cardboard—that a very different, and far older and more elemental trend of residential conversion was underway; people lived in every sheltered nook we could see, and probably in many we could not. Phil Rascon at the coroner's office told me that it was from the underside of this bridge that a city maintenance crew had recently washed down a human skull.

Mayra was found, comatose, in an abandoned toy factory two doors west of the bridge. The factory still stood, more or less.

Guido shot the street, the neighborhood, put the lens of the camera through the bars in front of a broken window and shot the shadowy interior of the vacant factory. We walked halfway across the bridge and videoed back towards the Civic Center. Guido recorded several of the encampments on the bridge under the arches, and leaned forward to capture the tracks, the muddy ribbon of water in the river, the old warehouses, bedrolls secreted anywhere shelter could be found.

"Good stuff," Guido said. "Gritty. Don't know if we need it this time, but someday it might be useful."

Guido turned his camera from the bridge to Eldon, who was leaning on a bridge support, looking down below the bridge.

I followed Eldon's line of sight, saw that he was watching an old woman down beside the river as she rearranged her possessions in a shopping cart someone had rolled away from a Ralph's market. She took off her sweatshirt, shook it, and then carefully folded it before she placed it in her cart and covered the whole with a white plastic tablecloth.

"I never get used to this," I said.

Eldon looked at me, shook his head. "We shouldn't get used to it. Ever."

— 14 —

"J UH-HEEZUSS, MAGGIE," Fergie greeted me as I walked into the office. Her peeling nose had already begun to scab over and her face still glowed from her Baja sunburn. Or was it the obvious angst she was feeling that had reddened her freckled cheeks? "Of all the impossible things you've ever given me to do, finding a place that will take Oscar..."

"Could be, but the task will keep you indoors for another day instead of trailing off after Guido and crew," I said. "Thanks for coming in on a Saturday."

"Thanks for the overtime. I need it."

"How's your tummy?" I asked her as I sifted through the phone messages and mail she had placed in my in-box. "Still sore?"

"Better," she said, tone coming down a few notches. "Thanks for the referral to Casey's dermatologist. Without your name to drop, it would have taken two weeks to get an appointment. The doc bawled me out worse than you did, but he gave me drugs and some skin goop."

"Next time you go sunbathing, do it in Antarctica with the penguins."

Fergie handed me my day's bundle of sympathy notes and cards, an especially bulky and irregularly shaped bunch, tentatively held together by a rubber band.

I asked her, "Any progress at all with Oscar's arrangements?"

"Actually, he's already on about half a dozen wait lists. Been on them for months. The closest he is to getting a bed is at a place in Washington state, near Spokane. Best they can predict is four weeks before they have an opening." She looked at me pointedly. "Someone has to die first."

"Did you ask if they take bribes? A little tip, maybe?"

"I suggested you might do an exposé of care facilities and focus

on them unless they hurry up, but they just laughed and said that anything they can do to help you fix the nation's overburdened elder care system, they'll do it. But there's still no bed for Oscar."

"Keep looking," I said. "I know Sonoma isn't going to put Oscar out in the middle of the vineyards and abandon him. If the VA goes to court to evict him, we'll get a minimum of three months before we have to take action. By then, surely we'll have found something."

"I need a copy of Mike's death certificate," she said. "The staff at Sonoma accepts you as Oscar's guardian, happily, but the VA still doesn't have you in their system."

"Let's not be too efficient about sending documentation," I said, seeing a ray of hope offered by bureaucratic red tape. "Every delay buys us time."

"Gotcha," she said.

"Anything else?"

"We got the permit from the county to shoot at the morgue on Sunday. The county kept saying no, until they got a phone call. How did you work that?"

"Called in a debt owed to Mike."

"Should have known."

I thanked her for her efforts and went into my office to call Mike's son, Michael, to discuss with him his grandfather's situation with the VA. Michael had been to visit Oscar early in the week. Michael told me that when he told Oscar that Mike, his only son, had passed away, the information did not register. Oscar had not recognized Michael, and though he also did not recognize my mother, who had gone with Michael for support, he thought she was pretty hot. For a tall, lanky woman of a certain age, whose idea of plastic surgery is to snip the plastic ties on her rose bushes, I suppose she is.

Michael said that Oscar could still feed himself, but now he needed help dressing, and sometimes forgot to go to the bathroom to relieve himself. He could walk, but he got lost sometimes on the trip from the dining room back to his bedroom. I knew the facility was nice enough. We had visited Oscar regularly until Mike couldn't travel any longer. Michael said the staff was taking good care of his grandfather. So, for the moment, Oscar was all right.

Oscar had two daughters, but neither had spoken to him for over thirty years. Neither showed up at Mike's funeral, even though I called them. Michael had told me he saw no point in calling his aunts to talk about Oscar.

I was in my office, packing up to leave for the day, when I heard Guido's signature tattoo rapping on my door. He didn't wait for an invitation to come in.

"I'm working on the shot list," he said. "The taxi-dance place won't let us video, but we're sending in a ringer with a lapel lens to capture the scene. I like the hidden video aspect, makes it all seem more sinful. The he-shes at Club Caribe are delighted we want to video. They offered to do a conga line in the street. Lana wants sexy, we'll give her sexy."

"When are you doing all that?" I asked him.

"Next week. Tuesday, maybe. I think we'll get those two locations done in one long night shoot. But we need to get union approval for overtime pay for the crew."

"Ask Fergie to start the paperwork," I said.

"In the meantime?" he asked.

"Monday morning at ten there will be a funeral ceremony at Evergreen Cemetery before the county buries a batch of unclaimed and unidentified remains in potter's field. It would be nice if someone got to the cemetery early to video the digging of the trench; I don't know when that will be. We need to video the loading of remains at the morgue, and of course the burial ceremony itself. You'll need to work out the timing and the crew."

"You coming to the burial?"

"Wouldn't miss it," I said.

"Fergie told me she got the permit for us to video at the morgue tomorrow," he said, not with a happy lilt to his voice. "It's Sunday. Will the morgue even be open?"

"Just like our network, the morgue doesn't close," I said. "Sunday is a good day because the autopsy suites won't be in operation and your crew won't be in the way of normal activity. There won't be any cadavers lining the halls."

"That's good, but what exactly do you want us to do at the morgue?"

"Call this man." I handed him Phil Rascon's card. "Phil and Mike

were good friends and he's eager to assist us. Phil will walk you through the morgue. He's setting up an array of stored, unclaimed remains, mostly skeletal, for you to shoot," I said. "While you're there, Phil will take you across the parking lot to the crematorium. He may be able to get you inside with the same permit. If not, an exterior shot will do."

"And for dessert?"

"He'll escort you to the county Scientific Services Bureau west of downtown so you can get some footage of the forensic identification labs. He talked a technician into coming in tomorrow to show you the bridge operation, how they are sorting through the debris that was flushed down from the First Street Bridge last week."

"Good background, if nothing else," Guido said, making notes on a lined pad. "Altogether, a lovely day you've set up. I'll call you later if I have nightmares."

He read down the list, making margin notes, listing requirements for people and equipment. He looked up at me. "Tomorrow, where will you be?"

"I don't know yet," I said. "Depends. I need to start clearing up Mike's estate. I need more time with his files."

He looked at me through narrowed eyes. "Doing that will make you sad and weepy."

"Maybe I need to do some of that, too," I said, "a good sob-fest to work things through."

He was nodding as I said this. "Good idea. I'd invite you to dinner tonight to cheer you up, but I hear Mr. Drummond has dibs."

"Where did you hear that?" I asked, surprised, dismayed. No one had asked me to dinner. And no one had dibs.

"Cashier in the commissary. Big gossip of the day is that you and Early are very cozy. Whatever, you need to be careful about jumping into a relationship. Right now you're awfully vulnerable."

"Be careful around the gossips, Guido. A lie can fly halfway around the world before the truth can get its pants on."

"Mark Twain?"

"Winston Churchill."

"Same difference," he said. "They both get credit whenever something really quotable gets said."

"Quote this," I said, and fanned my chin in my favorite obscene Italian gesture, one taught to me by Signor Guido Patrini himself.

"Same right back at you." He had finished his notes. "This is a big list. Were you thinking we'd finish by end of next week?"

"Nope. By Mother's Day would be okay."

He nodded, grinning. "Better get at it, then."

"Hey Guido," I said to his back as he opened the door. "We need to go over the footage from our walk today. Why don't you come over to my house? We'll take the horses for a walk. We'll feed them, and I'll feed you. Then we can take a look at what we have."

"Whatshisname be there?"

"He will be if I ask him."

"Who's cooking, you or the cowboy?"

"Haven't gotten that far."

"I've eaten your cooking. If you don't invite Early, I will."

"Whatever," I said. "Give me a head start so I can get to the market, and I'll meet you at the house."

"You got a deal." Guido closed the door behind him.

I called Early and asked him to join us. Then I packed up the newest batch of sympathy cards and tokens, copies of the day's discs, dumped it all into my tote, turned off my lights, shut the door, sent Fergie home, went to the market, and went home.

The load in the car was too large to be carried into the house in one trip. Except for the copy of the day's footage, I decided to leave everything except the groceries to be hauled inside later. I stowed the groceries, changed into jeans and riding boots, and went back outside to saddle Duke and Rover.

All three horses were excited when I hauled Duke and Rover's tack out of the shed. They nipped at the saddles when I draped them over the top rail, nipped at each other when the blankets and bridles followed. I slipped bridles over Duke and Rover's heads and wrapped the reins over the rail so that I could brush them. Red lined up next to them, expectant, as if to say, what about me? I didn't know how to tell him he was staying home.

Duke was so happy he was going for a walk that he didn't bother to make a fuss when Guido drove up and parked next to my car.

"Which one do I get?" Guido asked as he sauntered over.

"Duke. Mike's horse."

"He's awfully big."

"This old gelding has a seat like a big sofa. He won't give you any trouble." As I smoothed Duke's blanket on his back, I asked Guido, "Have you ridden before?"

"Sure. Ponies at summer camp."

"With Duke," I said, "all you have to do is sit tight and enjoy the ride."

I gave Guido some carrots to feed the horses while I finished saddling them. Watching me cinch Rover's saddle, Red began to put up a fuss. He usually got left behind when Mike and I went out for rides, just as Early left Duke and Rover behind. The left-behinds always complained. You can't explain waiting one's turn to a horse. Red wanted what he wanted.

After Mike got sick, I would alternate riding Duke and Rover, always putting a lead on the other and bringing him or her along. But Red was too spirited for me to handle on a lead, especially when I would be with an inexperienced rider. Fortunately, Early arrived home and came to his big sorrel's rescue.

It was late afternoon when the three of us set out up the mountain trail. The light on our side of the mountain was already growing soft. Evening birds set up their calls. Coyotes began to emerge from their daylight hiding places to raid trashcans. Above Castro Peak the first star of the evening appeared, and a sliver of a moon. The air was crisp and fragrant; *dos vientos* began to blow.

We rode single file up Bull Dog Trail, Early on Red in the lead, Guido and Duke in the middle, Rover and I bringing up the rear. The conversation was easy, old friends, familiar co-workers. We paused at a meadow where we sometimes saw deer early in the morning and just before sunset, didn't see any, and continued up the trail.

After rounding a grassy knob, we left the main Bull Dog trail and took a narrow side path cut along the edge of a mountain peak. Past a dry, man-made pond, we came upon a magnificent, abandoned, Frank Lloyd Wrightesque stone house erected in a canyon notch, overlooking a landscape below that resembled Provence more than anything one would expect to find at the outer edges of Los Angeles County.

We dismounted and tied the horses to a couple of tall yucca

plants and let them feed on mountain grass while we walked up the last stretch of slope to the house.

Vandals, kids, had broken out all of the windows in the house, ripped out the kitchen and bathroom fixtures and tossed them down the slope. The inside was a shambles, but the intact shell of the house was still beautiful. We went inside, dodging broken glass, to stand at the window openings for the view spread out below.

"Wow," Guido said. "Whose house was this?"

"Nobody's." Early grinned. "Some speculator bought the land cheap when the Santa Monica Conservancy was buying up land south of here, leveled off eight building pads, built this house and waited for the Conservancy people to cry foul. The Conservancy raised money to buy the entire property at a premium price to keep the guy from developing."

"It isn't an old house?"

"Ten, maybe fifteen years old," Early said. "No one ever lived here."

Guido looked around. "I would."

"Great view," I said. "But that unpaved trail we came up? That's the only way in."

"I'd get a fleet of pack mules. Live a simple life. Plant a garden, raise a beef cow, fill up the pond and stock it with fish. Survive off the land."

"A simple life." Early chuckled. "Any idea what the monthly nut would be on a twenty-million-dollar mortgage?"

Guido shrugged. "There's always a rub."

"It's getting dark," I said. "We should get down off the mountain."

We gave the horses their heads and let them take us home at their own paces. Red was in a rush to get back to his dinner. Duke seemed to savor the outing and was in no hurry for it to be over. Rover, no feminist, she, just wanted to do what Duke did. Early tried to hold back Red, but gave up after a while, told us he'd meet us at home, and let the horse have his way.

If Duke got his way, he'd stay out all night, eating grass. I took the lead, and Duke's reins, and made him keep up with Rover. Now and then I let him drop his head to pull up a nice mouthful of

sweet grass. He'd munch as we walked, grass stalks and their flow-ered ends fluttering out the sides of his muzzle. Horse, and rider, heaven.

Families of quail ran across the trail in front of us, trilling their three-note call to urge their young to follow, quickly.

"It's great up here, Maggie." Guido sat relaxed, taking it all in.

"Come up any time," I said. "We'll ride."

"Think I'll get me some boots."

Back at the corral, we rubbed down the horses, tucked them in for the night, and went inside. I excused myself to go upstairs to get cleaned up. When I walked back downstairs, fifteen min-utes later, the men were in the kitchen. Early was seasoning the sea bass I brought home and Guido was making a salad.

"Hello," I said, picking up the glass of chilled pinot gris that apparently had been poured for me from a bottle selected from out of the special stash in the temperature-controlled wine safe, whose door stood open. I shut the safe door and sipped the wine, let it roll across my tongue and warm before I swallowed. "This is one of my favorites."

"It's good," Guido said. "We found fish, corn on the cob, salad, and rustic bread from La Brea Bakery. Anything else you intended for this feed?"

"Brownies and ice cream for dessert," I said, and began chop-ping garlic. "Thanks for getting started."

"Mike's brownies?" Guido asked, expectant, maybe hopeful.

"Sorry. Someone brought these over last week. They've been in the freezer."

"Too bad." Guido turned back to his corn. "Early was telling me he thinks you should get a good security system, now that you're up here alone."

"I'm not alone," I said as I dropped an obscene glob of butter into a sauté pan and then scooped in a generous amount of freshly chopped garlic.

"See," Guido said. "I told you, Early. She thinks she's bulletproof. Fish and butter, bread and butter, corn and butter."

"I know for a fact," I said, "that garlic takes the bad out of butter."

"And she's delusional," Guido said as he took a basting brush

out of a drawer and dipped it into the sauté pan and then began to generously slather the wonderful, cholesterol-rich mixture onto the ears of corn, along with a sprinkling of black chipotle powder. "She told me that calories leak out of broken cookies."

"They do," I said. "But to shake the calories loose you have to run one mile for the equivalent of every whole cookie."

Early had the grace to laugh.

"Did you get a chance to look at the rough footage I gave you?" Guido asked.

"Not yet," I said. "Maybe after dinner, if we're sober, we can go over it."

"Eager to see what we got," Early said. "Mind if I sit in?"

"Hoped you would." It was Guido who answered. "You going to grill or poach the fish, Early?"

"Grill," Early said. "Want to grill the corn, too?"

The only grill available was in Early's backyard; I was out of propane. The two of them left me to tend the bread in the oven and finish the salad while they went next door to play with fire. I could hear them talking, laughing, from time to time. By the time they returned with their steaming platters, the table was set and ready.

The meal was memorable. Early's sea bass was perfect, crispy on both sides and just barely cooked through to the middle. Guido's corn, grilled in the husk, was sweet and piquant at once. The best of it, again, was good conversation, interesting people.

With a crust of bread, Guido swabbed the last remnants of butter, garlic and bits of fish from his plate. He ate it with his eyes closed, a face full of true joy. And then he raised his glass to Early and me.

"*Alla famiglia,*" he said. We clinked glasses with him, repeated his toast, To the family, sipped the wine, bottle number two, and sat back, sated, smiling.

"If it's one mile per cookie," Early said, "how many miles will this meal cost?"

"I think two days of fasting in appreciation would cover it," I said.

"That said, you want to meet in the morning for Sunday brunch?" Guido asked.

"Normally, I'd say yes," I said. "But I have stuff to do in the morning. And you will be busy at the morgue."

"Thanks for reminding me."

The three of us talked about possible directions both the video and our inquiries could, or should, take as we cleared up the kitchen, put dishes in the dishwasher. With a last glass of wine each, and a plate full of brownies, we went into the work room, pulled up chairs around a computer monitor, and ran the unedited footage from the walk through downtown following Jesús' and Mayra's routes on that particular January day a decade ago. Some of the images and sequences were wonderful, some were junk. So far, where any of it might fit into the finished video was the great unknown. We talked about the footage, replayed some scenes, talked some more.

It was late when Early stood up and stretched.

"Thanks for the meal, Maggie," he said.

"Thank you," I answered. "For a thousand kindnesses. And for having a full propane tank."

"Tomorrow is going to start early. I'll say good night." He turned to Guido. "The roads around here are treacherous under the best of circumstances. A little wine makes them deadly. You're welcome to my spare room."

"Thanks, but your house is a long walk away." Guido pulled off his sneakers. "Maggie, if you don't mind, I'll borrow your living room sofa for the night."

Looking from one to the other, I asked, "Did you two plan this?"

"Plan what?" they asked in unison.

"Good night," I said. I saw Early out, tossed a pillow and a blanket and a new toothbrush to Guido, and went upstairs. Alone.

In the morning, Guido was in the kitchen drinking coffee and reading my paper when I went out for an early run in the mountains. Feeling cold and stiff at first, I struggled up the steep near end of Bull Dog Trail, eventually found my stride, and kept up an easy pace all the way to the abandoned house. I stopped at the house long enough to appreciate the morning view below and to take a drink of water. Then, following a route Mike and I especially enjoyed, I picked up Bull Dog again, circled down into a canyon,

through the site where the "M*A*S*H" television series had been filmed years ago, and then back home, coming up the back way on Crags, a paved street.

The night of the break-in the sheriff suggested that the burglar had parked on a street down below, perhaps on Crags, or on Lookout Drive above it. I turned from Crags onto Lookout, ran on the back side of the mountain from our house. I looked for possible sheltered parking places, found several, and figured out a route the burglar could have taken from there, by foot, over the crest of the knob and into my backyard. Rough going, but possible if he was in good shape and had both hands free to use.

— 15 —

Guido was gone by the time I got home from my run, off for his day at the morgue. I showered and dressed, packed a lunch, and drove in to the studio.

Like the morgue, a television studio is a seven-day-a-week enterprise. I needed more time with Mike's files, uninterrupted. Leaving the lights off in Fergie's work area, I holed up in my office with the door closed. I curled up on the sofa with a list of times and dates and copies of Mike's hand-written notebooks, reading in his own words, at least a shorthand version of his own words, where he had been, whom he had talked to, and where those conversations led him.

I tacked up the enlargements I had made of the grainy newspaper photos taken of three policemen's funerals, and studied them. I looked again at the file of drug-related crimes, pulled out names and wrote them down in two columns: perps, cops. Then I went online, accessed newspaper archives, searched and read.

By midafternoon, I felt dizzy after hours of trying to find any straight thread that would tie so many pieces together. And of trying to find a straight story of any kind. Whoever said "Never speak ill of the dead" should be disinterred and forced to tell the whole truth, just once.

I had left my tote in the car the day before, so I left the day's notes piled on the desk to be retrieved Monday, and walked out empty-handed to fetch my car.

My phone rang before I got to the freeway.

"Miss MacGowen?" A woman, whispering. "It's Mayra. Mayra Escobedo, miss. She's here, at my house."

"Who?" I hoped I knew the answer.

She said, "Nelda Ruiz. She's kind of sick. I think she's been living on the streets for a while. I think she's scared of something."

"What is she doing there?"

"Sleeping."

"I'm just leaving Burbank. Can you keep her there until I get to you?" Sunday traffic is very unpredictable, not that traffic in LA is ever predictable. In the best of circumstances I could get to central LA in twenty minutes. In the worst? Who knew? You drew what you drew. "I'll be there as soon as I can."

"Don't take too long. She's sleeping now. She's really tired," Mayra said. "But I hope you can get here before Julia gets home. She will be very angry with me."

"I'll do my best."

I had to call someone at LAPD and let him know that Nelda was at Julia's house, alone with Mayra. As I hit the Ventura Freeway headed east, I thought about who that would be, who I trusted.

Harry knew Nelda, but he wouldn't be either in the city or on duty for hours; he lived a full hour, minimum, from central LA. Besides, I didn't want to alert anybody at Central Station who might then call in Eldon Washington or Lewis Banks. I still did not know who had alerted Eldon that night I was at Central with Harry, or how Banks always seemed to know where to find my video crew. I wouldn't call Kenny for the same reason; didn't need Eldon on the doorstep when I arrived. Harvey Bing was a good possibility, as were several others.

In the end I decided that among them all, the person I trusted the most to come alone, to take Nelda into custody and protect Mayra and Julia in the process, was the man Mike trusted to take care of him after his last act. A colleague whose name had never come up in any reference to Boni or Jesús or Nelda. I called Mike's last partner, Nick Pietro.

Nick didn't need a long explanation when I reached him at Parker Center, where he was preparing for a Monday court appearance. He repeated the address I gave him and said he would be there, alone, as soon as he could get there. I asked him to give me half an hour, and he said that half an hour would probably be as soon as he could make it across downtown.

When I hung up, I was on the Harbor Freeway headed south. I kept my eye on traffic flow ahead, kept route options open, flip-

ping between radio traffic reports, always looking for the wormhole. Sometimes I reached Mach speed, sometimes I got stuck behind herds of turtles. Overall, I was pretty lucky and pulled up in front of Julia's little green house within an impressively short time. I didn't see Nick's Crown Vic. There was still a full hour before Julia would close her *bodega* and come home. And find Nelda Ruiz sleeping in her bed. I would have a few minutes alone with Nelda.

I didn't knock on the front door because I didn't want to waken Nelda if she were still asleep, or to announce myself if she were already awake. The door was ajar. I peeked through, saw Mayra waiting for me on the other side. She put a finger to her lips to quiet me as I pushed the door open, and then she pointed toward a back room.

Nelda Ruiz—I could hardly believe my good fortune when I saw her. She lay on her left side on a narrow, frilly pink bed in a tiny bedroom, facing the door, mouth open, sound asleep.

Nelda was a ruin. Her clothes were stained and she smelled like a wet dog. Her hair was covered by a grimy do-rag, but some greasy tendrils had escaped to crawl down her neck. She was also emaciated, dehydrated, eyes sunken, skin tight and dry. I took out my palm-size video camera, checked to make sure the battery had charge, and, using the room's natural light only, videoed her, for proof that she had been there in case she made a sudden flight. When I put down the camera I felt Mayra touch my hand. I looked down at her and she shrugged: Now what? was the question in her face. I turned and wheeled her back to the living room.

I knelt to be at her level. In a very soft voice, face close to hers, I said, "I called a friend of mine in the police department because I don't want you to get into trouble. When we turn Nelda over to him, you'll be all right, even with Julia."

She hesitated.

"But I want to talk to Nelda first, before the officer gets here," I said.

She nodded. She said, "I trust you," but she was shaking, frightened, so I put an arm around her to reassure her.

"You did the right thing," I said. "Everything will be fine. I'm going to go in and try to talk to Nelda. Detective Nick Pietro will

be here pretty soon. You can trust him. It would be helpful if you would wait for him outside to tell him what's happening. Is that okay?"

She nodded. "Please, yes. I don't like to be anywhere near Nelda. She is too much trouble for me."

As I stood up I had one of those brain flashes when I imagined the scene when Nelda would be frisked and taken into custody.

"Do you know if she's armed?" I asked.

Mayra reached under the pillow on her wheelchair seat and brought up a snubnosed Smith and Wesson .38, holding it by the butt between thumb and forefinger as if it were alive and might bite. "I took this from her when she was asleep."

I held out my hand and Mayra put the revolver on my palm. I flipped open the cylinder and saw that it was fully loaded, then flipped on the safety before I slipped the barrel of the little weapon into the back of my waistband and pulled out the tail of my shirt to cover it. Then we clasped hands, both of us nervous about what would happen next. I walked Mayra to the door, held the door open for her, and waited until she wheeled herself out onto the porch.

She turned and looked at me, a little smile on her face. "Smells nicer out here."

I shut the door softly and went back to the bedroom. I positioned the video camera on the dresser to capture the entire bed in the frame. When the camera was running, I pulled up a chair next to the bed, flipped on the bedside lamp, did a quick light check on the monitor, and when all was set, I said, "Nelda, time to wake up."

Nelda's eyes popped open but she didn't change her position, just lay there as if frozen in place until she could assess the danger, a con always on her guard. She blinked against the light as she looked at me, looked past me to see if anyone else was there before she raised her head to look around the rest of the small room.

"You the police?" she asked. "Parole Office?"

"No. My name is Maggie MacGowen," I said. "I want to ask you some questions."

Her right hand slid to her pocket, found it empty. She blanched.

"The gun is gone," I said. "Right now, it's just you and me. Looks like you've been having a rough time, Nelda. A few nights on the street?"

Slowly, she sat up. Her eyes were still heavy from sleep, probably also from whatever she had taken to help her sleep. She looked closely at me.

"MacGowen?" she said. "On the TV?"

"Yes," I said.

"You've been looking for me?"

"I sure have."

"Why should I talk to you?"

"I might be able to help you."

"Help me how?"

"First you need to help me," I said. "I need you to tell me about the day that Jesús Ramón disappeared."

She frowned, confused. Obviously, Jesús was not a topic she expected to be hit with. She said, leery, "That was a long time ago. What do you want to know?"

"Someone gave your friend Mayra Escobedo some uncut heroin that day. I think someone also gave uncut heroin to Jesús. She lived, he didn't." I watched for her reaction, saw rectitude replace confusion. "You used to supply drugs to Mayra."

"I didn't give her that H." Her denial was firm. "Who told you that?"

"I went up to Corcoran a couple of days ago and had a long conversation with Boni Erquiaga."

"He told you that?" Suddenly she was fully alert, both outrage and fear bringing life into her ravaged face. "He said I did that?"

"Did you do it?"

"He's a bastard," she spat. "I never did that to Mayra and I never did that to Jesús. You ask him who did it. You ask Boni."

"What will he say?"

"That lying piece of shit will say anything."

"Then you tell me what happened."

"Why should I?"

"Because you're frightened and alone and you have nowhere left to go. It isn't only the police who are looking for you, is it?"

She shook her head, fatigue overwhelming her anger. "They're going to kill me."

"Who?"

"Just some people I know."

"I can help get you safely off the streets. But I need something from you, too," I said. "Who did that to Mayra? Who wanted to hurt her?"

"It was Boni," Nelda ejaculated. Tears made runnels through the grime on her cheeks. "Mayra wanted to get clean. She was scared. This big dealer got himself shot up and a lot of people didn't want nothing to do with selling drugs no more, just like Mayra."

"These were people who were selling drugs you gave them," I said plainly. "When Rogelio Higgins was gone, were your dealers afraid they would be targeted by his killer, or were they afraid to sell for the people who replaced him?"

"Both of those. But mostly the last one."

"Boni," I said.

"It wasn't just Boni," Nelda said. "But he's the only one I know."

"Was Mayra supposed to be an example for your dealers who wanted out?" I asked.

She sighed heavily as she nodded. "No one wanted to hurt Jesús, though. But I think Mayra shared some shit with him. She owed him some money she didn't have because she put it in her veins. She promised Jesús she would give him something. And that's why she didn't die, I think. She didn't get it all. But Jesús, he was a cherry, never shot up before, and that was pure H. It didn't take very much."

"He died," I said.

When she shrugged, I asked her, "Where is Jesús' body?"

This time she reacted elaborately, eyes round and innocent. "I heard lots of things. Someone said Boni took him up to the mountains and buried him. It rained hard right after that, and I also heard he got put in the river and got washed away."

"Who said?"

"I don't remember."

I leaned forward. "Do you remember Detective Mike Flint?"

"Sure, I know him. Everybody knows him."

"Ten years ago when Jesús disappeared, did anyone ever say Mike Flint did anything to hurt Jesús?"

"No way," dismissing the suggestion out of hand. "That detective, he was trying to help Mayra get clean. He was nice to her. I think that's why Boni chose Mayra, to punish her for having someone who wanted to help her. He was afraid she would talk to the detective, be a snitch. Boni was an officer, too. He didn't want Mayra to talk."

She looked past me and suddenly bolted to her feet.

Nick Pietro stood behind me. He put a hand on my shoulder.

"Sit down, Nelda," he quietly ordered. She immediately obeyed.

"I didn't hear you come in," I said, startled by his sudden presence, unsettled. "How long have you been here?"

"A few minutes," he said. "I was in the other room, heard what I wanted to hear from Nelda."

"I don't know you," she said to him, a challenge.

He handed her his card. His shiny detective shield was attached to his belt at the left side, his side arm to the right. None of that was necessary to identify Nick as a policeman, even though he wore a suit and tie. In common with his friends on the job, you knew from the way he carried himself, from the way he entered a room, who he was.

"The way I see it you have a couple of problems, Nelda," he said. "If you stay on the street you have one set of problems, you come in with me and you have a different set of problems. From what I know about your so-called friends out there, right now I think coming in with me and facing the music solves the more immediate of your issues. At least no one will be gunning for you. What do you think?"

"I don't want to go back to prison," she said firmly.

"I can understand that," he said. "But given the choices you've made since you got out, and the choices you have in front of you now, Frontera should be looking pretty good to you."

She stood, turned her back, held out her wrists behind her and waited for him to snap on handcuffs. He obliged by pulling a set from his belt and locking them on her.

"Miss?"

I turned when I heard Mayra's voice. Behind her in the gloom of the living room beyond the narrow hallway stood Sgt. Lewis Banks.

"Nick," I said, dismayed, "did you call for backup?"

"What?" He turned and saw Banks, registered surprise and anger at once. As he finished cuffing Nelda and patting her down, looking for contraband, he said, "How'd you get here, Lewis?"

"Neighbor called. Said she'd seen Nelda in the neighborhood and she was worried about Mayra here being in trouble. I drove over to make sure everything is okay." Banks met Nelda's eyes. "How are you, Nelda? You've given us quite a chase, haven't you?"

"Bastard," she spat. "Fucking righteous bastard. Get him out of here."

Nick pulled on the cuffs to rein her in. "No need for that, Nelda. We're all leaving now."

Nick held the cuff chain with one hand, her shoulder with the other, and impelled Nelda forward, out of the room in front of him, forcing everyone to backtrack down the hall or get run over; the room was very small, the hall was very narrow. In the living room Lewis Banks maneuvered himself into position beside Nick and took hold of Nelda's elbow.

"Thanks, Detective, but I'll take her from here. We're in the territory of the Central Division. I'll take the prisoner in and book her."

"Thanks just the same." Nick shifted his shoulder and skillfully deflected Banks, maintaining control of his prisoner as he did so. "Robbery–Homicide is taking this one downtown."

"I believe—" Banks didn't get the chance to finish his objection.

"What do you believe, Banks?" Nick said, voice low and full of challenge. He nailed Banks with a narrow-eyed glare. "We both know Central doesn't have facilities for booking and holding a woman. You going to drive her all the way over to Hollenbeck yourself? You'll miss roll call. And *I* believe that it doesn't make a good goddamn bit of difference whose territory this is, Robbery–Homicide is taking this one downtown."

On the way out of the bedroom I had picked up the video recorder, and it was still recording. Lewis Banks saw it.

"You have permission for that?" he asked.

"I don't need permission," I said.

"We're leaving now," Nick announced. He stopped beside Mayra and leaned toward her. "You okay, dear?"

"Yes, sir."

Nelda turned and shot Mayra the *ojo malo*, the evil eye. "I won't forget what you did."

"Hey, Nelda?" Mayra said, assertive at last. "I won't forget what you did, either."

I kept my hand on Mayra's arm as we stood on the porch and watched Nick put Nelda into the backseat of his plain car and cuff her to the inside of the door. Lewis Banks lingered back a few paces from the curb, then seemed to give up. He got into his black-and-white, left a little rubber on the street when he sped away.

Nick came back to say good-bye. He was thanking Mayra for her courage when Julia drove up. Because Nick's car blocked her driveway, she left her car in the middle of the street, driver's-side door hanging open, as she ran across the tiny lawn toward the porch, clutching her chest as she ran, sobbing so loudly that she could be heard half a block away.

Mayra crossed herself, muttering, "Holy Mary. Now I'm in trouble."

Nick understood what was about to happen. He gestured for me and Mayra to stay put as he jogged over to intercept Julia. He had an arm around her, head close to hers, as he talked to her all the way up to the house.

"Mayra called for help as soon as Nelda showed up," he said. "She knew we were looking for Nelda and she wanted to make sure Nelda stayed put so we could bring her in. Mayra was very brave. I think I'll put her in for a citation for bravery."

"Mayra." Julia dropped to her knees on the porch and wept into her sister's lap. Mayra patted her back as she smiled up at me.

"Thank you," Mayra said.

"How much did you hear?" I asked.

"I heard what I needed to know."

"And you're all right?"

"I think so." She stroked Julia's hair. "Maybe you'll show me all that she said, later. But right now, I heard what I need."

I walked Nick back to his car.

"Thanks," I said. "I'm beholden to you. The outcome here could have been very different if you hadn't come so quickly."

I was expecting a hug or a cheek kiss or a back pat. Instead I got a lecture.

"Damn right the outcome could have been very different," he said, with force, finger stabbing the air between us. "You should have waited for me to get here before you went in. What if Nelda had been armed? What if?"

Just then I remembered the little .38 tucked into my jeans. Should have handed it over, and I would, but that moment was absolutely the wrong moment. I bit my lip, said nothing.

"We aren't finished yet, Maggie, you and me. I don't know all that you think that you're doing. But this is clear, the stench that Boni Erquiaga left behind him in this neighborhood hasn't altogether cleared up. I'm happy you called me to come get Nelda instead of calling 911 or the desk at Central, but you should have waited outside for me to get here before you went in. *Capisce*?"

"I do," I said. "I respect where you're coming from. But don't forget why I'm here."

"Keep looking into Mike, please find Jesús. But the deep-background stuff, meaning Rogelio Higgins, you should drop."

"That's the second time I've been warned off."

"Maggie." He reached up as if he were going to grab me by the shoulders and shake me, but he got control over himself before he did. Clasping his hands together he pleaded, "Listen to the warnings, please."

I looked into his anguished face and asked, sincerely, "Why? What is going on?"

"When it's safe to answer that, I will personally help you make one whopper of an exposé video. Okay?"

"Maybe."

"*Sancta Maria*," he muttered as he spun on his heel and walked

away. When he got to the car he looked back at me. "I want to see what you got on that video."

"Sure," I said. "Call me."

He had that finger aimed at me again. "But you listen to what I said, got it?"

"Got it."

He muttered something under his breath as he yanked open his car door.

"Hey, Nick," I called. He turned to me, face set as if he were already organizing a rebuttal to anything I might say. "Thank you."

He gave me a last cautionary word and drove off.

I said good-bye to Mayra and Julia—I thought Mayra had the home front under control—and headed for the Santa Monica Freeway, and home.

— 16 —

A T THE west end of the Santa Monica Freeway, the McClure Tunnel serves as an abrupt transition. You enter the tunnel with the noise, smog, and hubbub of urban LA in the rearview mirror. You come out the other end with the Pacific Ocean filling your windshield; white sandy beaches, breaking surf, barely clad people at play, a fantasy land stretching ahead as far as the eye can see. That first glimpse of ocean out the end of the tunnel is always a potent tonic, no matter what ails you.

There was less than an hour of daylight left when I came out of the tunnel onto the Pacific Coast Highway. The sun hung low in the western sky, washing the ocean below with vivid, shimmering gold. Beautiful time of day, sunset on the Pacific, unparalleled color when the sun sinks into the smog line.

Before heading up into the canyon toward home, I stopped at the supermarket in Malibu for something quick for dinner, some staples. As I bent to stow the bag of groceries on the backseat next to the tote bag I had left in the car overnight, and shielded by the open door, I removed Nelda's gun from under my waistband and tucked it into the bottom of the tote, cushioning it under yesterday's bundle of sympathy cards.

The usual weekend traffic poured through Malibu Canyon: two continuous lines of cars, one lane in both directions, like two endlessly passing trains snaking around the curves, up one side of the mountain and down the other. No point trying to push the pace or play car leapfrog. All you can do is nose into position in the queue and keep your distance from the guy ahead, hope the guy behind does the same for you.

The alternate routes are two, and neither has any appeal: head-on into the sheer face of a mountain wall on one side of the road, or a fast one-way trip down into the canyon on the other.

Like doing time, I thought as I followed the car ahead, a little convertible Beemer, and watched the one behind, braked, accelerated, let the banked road do most of the steering. Resigned myself to do what needed to be done, didn't fool around, waited my turn to get sprung.

All was fine until I neared the crest. Heading into a curve, I put my foot on the brake.... And nothing happened. I pushed the pedal to the floor. Nothing.

I downshifted, snapped on the emergency blinkers and honked my horn to get the attention of the little convertible in front of me, downshifted again, pulled up the emergency brake, managed to slide through the curve, all the time looking for salvation. After that wicked curve, the road began its steep downhill descent. Gravity took a hand. The emergency brake burned out, started to smoke and squeal, the car accelerated. And I could not stop it.

The Beemer in my path had nowhere to go except into the back of the massive yellow Hummer in front of him. At first the driver had a panic reaction seeing me bearing down on him, tapped his brakes, saw that the action only brought my fast-approaching front end closer to his rear, accelerated until his front grill tapped the Hummer in front of him, putting his face just about eye level with the Hummer's license plate.

I had a flash of my car pushing that little convertible right under the yellow behemoth, shearing off anything in the Beemer that was higher than the Hummer's bumper.

I made the only decision I thought I could, and steered to the right at a diagonal, cut a route across the narrow shoulder and hit the mountain obliquely, held the wheel to the right, scraping along until I plowed into a truckload of road scrapings dumped on the shoulder by a road crew after a rock slide. And stopped dead.

Front end buried in dirt and gravel, right side accordioned: the car was totaled. I thought I was okay. I didn't realize how much racket there had been until there was no sound anymore except the dying pings and hisses of my car's engine and the clunk of occasional rocks falling off the mountain onto the roof and hood.

On impact, grocery bag and tote bag had taken air, littering the car, covering my lap with their contents. The little .38 I had put

at the bottom of the tote ended up wedged atop the dashboard. I had enough presence of mind to grab it and stash it back into the waistband of my pants. For no good reason except I couldn't at that moment think what else I should do, I picked up the tote, at rest upside down in front of the passenger seat, and began putting everything into it that I could reach without taking off my seat belt: a dented carton of milk, a box of strawberries, some sympathy cards, a funny-shaped box wrapped in white paper—odd, I noticed that the box was addressed only to MacGowen, the name of the studio, Burbank, and nothing more, and that the post office had delivered it the day after it was postmarked—the digital camera full of footage from Mayra's house, one tube sock, random other things. All of this probably occurred within the first half a minute after impact, but it seemed to take an infinity of time.

People banging on my window made me look up. Some man with a very red face seemed to want me to unlock my doors. So I hit the button to accommodate him. But he couldn't get the door to open. Car frame's bent, I thought, sitting there dumbly. I saw half a dozen people standing on the side of the road with cell phones to their ears and remembered to pull mine out. Problem was, I couldn't think who to call.

"Hey, lady." The big red face was suddenly right there beside mine, full of concern. He had come in through the back door and was leaning between the seats. "You okay? Anything broken? What happened?"

I said, "No brakes."

"No brakes?" he repeated.

"Yes, no brakes."

I don't remember how it happened, but next I was standing on the side of the road, surrounded by concerned people. One of them was a doctor, who listened to my chest, looked me over, pronounced me sound, and handed me half a cup of Starbucks.

"Take this," he said. "You need the caffeine. You'll wake up sore tomorrow, effects of adrenaline rush, and you'll have chest contusions from the seat belt. No big collision here, don't think you'll have to worry about whiplash." He gave me his card and said, "Call me sometime. Love to buy you a drink, get to know you."

Things were beginning to compute enough by that time that I

understood he was making a pass. Which, under the circumstanc-es, I thought was very odd.

I don't know how emergency personnel got through. It took quite a while, but they got up the canyon. By the time they arrived I had become good friends with some of my fellow commuters. But after traffic flow was restored, they left me alone with the service people: the tow truck drivers, a road maintenance crew, a female deputy sheriff named Olsen, and my poor car. Before the car was winched onto the tow truck bed, I gathered up my belongings, leaving the groceries in the wreckage. By that time, it had been dark for hours.

I rode back down the mountain to Malibu with Deputy Olsen. "What happens to the car?" I asked her.

"It goes to a bonded body shop in Malibu. Mechanics will take a look at it, see what happened to the brakes." She gave me a game smile. "Then, I get to write reports. Lots of reports."

I called Triple A and made arrangements for a rental car to be delivered to me at the sheriff's Malibu substation, where Deputy Olsen took me. The car had to come all the way up Pacific Coast Highway from LAX, so I settled in for a wait.

I called Guido and Nick and Lana and Early and my daughter, Casey, reached no one, left messages for all of them.

Sitting on a wooden bench in the lobby of the Malibu substation, waiting for something to happen or someone to call me, I searched in my bag for coins for the vending machine. My hand hit that odd little white package again, the one addressed only to my name, at the studio. I was intrigued by its trapezoidal shape, and by the optimism the sender had in the efficiency of the U.S. Postal Service that spare address implied.

This was not the only little hand-addressed package I had received. So far, during the two weeks since Mike's death was announced, I had received five boxed rosaries with prayer cards; a silver guardian angel pin; a slim leather-bound edition of the Gospels, embossed with my name, misspelled, with a mushy gift card signed *Love Mike* enclosed, and a bill—a skeezy scam effort, one of several; and various other tokens. So I had no expectation about what I might find inside this little package.

The wrapping was ordinary white copier or printer paper, the

box inside had once held a printer ink refill cartridge. I untaped one end of the paper, opened the box, and looked inside.

With shaking hands, I dialed Guido's cell phone again. This time he answered.

"Where are you?" I asked.

"You don't sound very good, Maggie. What happened?"

"Where are you?"

"At the studio," he said. "We just got back from the morgue. My hands were full when you called a few minutes ago, I couldn't pick up your call."

"Do you have the disc Early gave you that has the footage he shot after the house was broken into?"

A pause. "Yes. It's here. What—"

I interrupted him. "Would you please load it?"

When he said he had the video in front of him, I described the little white figure I found inside the box. "Can you see it?"

"That little Japanese thingy you gave Mike? Yeah, I see it," he said. "It's on the floor in front of Mike's desk."

"Miss MacGowen." Deputy Olsen loomed over me. I looked up at her. "We're impounding the car."

"Impounding the car?"

"For evidence. Mechanic says your brake lines were deliberately severed."

A KNOCK at the door wakened me from a fitful sleep. I wasn't in my own bed and it took me a moment to remember exactly whose bed I was in. I sat up and looked around, heard the surf pounding outside my window: The Breakers Hotel, Santa Monica, standard queen bedroom, fifth floor, middle of the corridor.

I pulled on the pants and shirt I had draped over the desk chair the night before and went to the window to look out. It was early, barely dawn. But I could see that the same dark blue Crown Victoria car that had delivered me to this pleasure palace the night before was still parked outside the entrance. Maybe it was a re-placement dark blue Crown Vic. The important thing to me was that the car was there.

I slid Nelda's .38 into my waistband under my shirt anyway, just in case. If someone was bold enough to sever my brake lines and break into my house, twice, then getting past the pair of sleepy policemen in that car and through a hotel room door might not be too difficult.

I knew what Mike would have said about the gun: "You're more likely to shoot off your own ass than to stop anyone coming through the door," but I liked the weight of the gun at my waist.

"Maggie?" The voice of Nick Pietro accompanied the second knock at the door. "Breakfast is served."

When I opened the door, Nick held up a damp-looking McDonald's bag and grinned.

"Good morning," I said, backing into the room so he could enter. He bolted and chained the door behind him. "And thanks, but the network will spring for room service."

"You should watch more TV, TV girl." Nick set the bag on the desk, opened it, and took out a cup of coffee and an Egg McMuffin. I accepted the coffee, declined the muffin.

"Don't you know?" he said. "The bad guy always sneaks in

disguised as the room service waiter, pulls out a Tommy gun from under his cart, and..."

"Thanks, Nick." I was grateful for the coffee. "What time is it?"

He checked his watch. "Sun'll be up soon."

He looked like hell, and I told him so, invited him to sit down. I asked him, "You weren't sitting up all night out there with my watch dogs, were you?"

"No. And they weren't sitting in the car, they were right outside your door all night." He ran a hand over the stubble on his chin. "I sat up with Nelda a good part of the night."

"Did she talk to you?"

He nodded. "Don't know how much of it was self-serving BS and how much of it was the truth, but she talked to us. Me and Kenny and Eldon ran a relay on her."

"Where is she now?" I sat down on a corner of the bed, facing him, blowing on the coffee to make it cool enough to drink.

"In a high-power unit at Metro Detention downtown, in federal custody. Super segregation. She had a long, rough night, but we got her through processing in time for a nap before breakfast. A shower, a meal and a cell to herself, she'll probably sleep all day."

"What did she tell you about Jesús?"

"Pretty much what she told you," he said. I didn't expect Nick to say anything more, yet, but he did.

"One interesting nugget I owe to you, from a lead you gave Kenny."

"Tell me."

"You told Kenny that Teresa Galba, Jesús' girlfriend, set off the panic to find Jesús as soon as Mike drove away with him." He took a deep breath and stifled a yawn. "So I went over to see Teresa."

"Did she tell you anything?"

"No. She took her kid and left the country again," he said. "Same thing she did when the grand jury subpoenaed her."

"She knows something."

He cocked his head and studied me. "Why do I think you have a pretty good idea just what that something might be?"

"I've given it a lot of thought and asked more than a few questions," I said.

"And?"

"Teresa told me that when Mike drove away with Jesús, Nelda was standing with Boni beside his car. I think that Teresa just may have overheard, or Nelda told her, that Boni was going to silence Mayra by giving her the uncut heroin. And Teresa understood what that meant for Jesús. The kid would get a share, because that was the arrangement with his aunt."

"You think Boni would talk like that out on the street?"

I shrugged. "May have had no choice if he suspected the car was bugged, and it was."

He shook his head. "Pretty risky for him."

"Maybe, but maybe it would be even riskier to deliver Nelda into Mike's hands for questioning without scaring the bejesus out of her first. If he could take out Mayra, he could take out Nelda."

Nick's attitude about the notion was hidden behind his detective poker face.

"That's my best guess, anyway," I said. "If I'm anywhere near the mark, then if Teresa had told Mike or Julia the truth that day then both Jesús and Mayra would have been spared."

"Spared what?" Nick had a sardonic smile, a wise-ass grin that reminded me of Mike. "Mayra and Jesús would have continued using, and odds are that drugs or the street or their friends would have killed them both by now. For blabbing, Teresa wouldn't have lasted through the day. The one person who could have been saved by the truth that day was Mike. And I doubt that Teresa gave Mike Flint's well-being one nanosecond of thought."

"No wonder you and Mike worked so well together," I said. "That's exactly what I would expect Mike to say."

"Yeah?" He looked at his watch again, but I saw some color rise in his face. He liked being compared to Mike. "We should get going. How long do you need to get ready to blow this cushy pop stand?"

"Fifteen minutes," I said, rising to my feet. "Twenty if the shower here is any good."

"You mind if I wait right here? This chair feels damn comfy right now."

"Suit yourself." I turned my back as I headed for the bathroom.

"But, Maggie." He rose enough to catch my hand as I walked past him. "Give me the gun first, please."

I took it out from under my shirt and laid it on his open palm; it must have made a bulge.

"Where did you get this?" he asked, turning it over in his palm.

"Mayra took it from Nelda when she was sleeping. I forgot to give it to you yesterday."

"You forgot? You've been walking around with a gun on your hip since yesterday? You run your car into the side of a mountain and..." He opened the chamber, saw it was loaded, gave me a reproachful glance, dumped the bullets into his hand, snapped the chamber in place and then slipped the gun into one pocket and the bullets into the other. "Holy Jesus, Mary and Joseph. Odds are you'd shoot off your own—"

"Don't say it," I said. "I already know the amateurs-and-guns speech. I heard it from Mike more than once."

He just shook his head.

I took my meager possessions into the bathroom and closed the door. Turned out to be a very good shower indeed, steamy hot water delivered with a lot of pressure through a massage setting on the showerhead. It felt so good that I lingered. When I was at last blown dry, dressed and as presentable as circumstances allowed, I opened the door expecting to find Nick pacing impatiently. Instead, I found him stretched out on the unmade bed, arms folded over his chest, sound asleep.

"Nick?" I took hold of the toe of one of his polished black brogans and gently shook it. "Nick?"

He opened his eyes enough to check his watch. He yawned before he sat up. "Long night."

"Would a shower help?" I asked.

He stroked his chin again, considering the offer. He said, "No time, but do you have a razor I can borrow?"

"I left a disposable on the tub," I said.

He was in the bathroom long enough for me to finish my cup of by-then lukewarm coffee and to pack up the few things I carried in the night before. I turned on the television and caught an early morning newscast. There it was, Live Breaking News: filmmaker saves lives of other motorists by crashing runaway car into a mountainside. Sheriff's Department investigators believe the brake lines were deliberately tampered with. Fuzzy video of

my poor smashed-up car in the dark behind a locked grate at the Malibu garage where it had spent the night. News hen standing in front of the Malibu substation reported that I was inside with law enforcement, and "thankfully" was uninjured.

"Thankfully," I repeated into the room as I snapped off the TV. My muscles ached and my chest was black-and-blue from the seat belt. Thankfully, because of the angle of the collision the airbags had not deployed. What a nightmare that would have been, trying to steer across a mountain sheer with an airbag going off in my face.

I had spent a good chunk of the night before in the Malibu substation. LAPD arrived to join the sheriff's grilling: who, how, where? A deputy was dispatched to Early's house to retrieve a copy of the disc that showed the netsuke on Mike's office floor amid the mess the burglar had made during the first break-in. Obviously, the burglar had come back for a second look around, and wanted me to know it.

By the time I was released, I felt like a one-woman crime wave, screwing up the statistics of the entire neighborhood. In the history of my neighborhood, I was told by Deputy Olsen, there had been only two home break-in reports. Both of them were mine. And one car tampering. Also mine. I thought that the suggestion, from the LAPD, that I spend the night away from home was a good one.

Nick drove me away from the hotel in the second Crown Vic in a convoy of three traveling down Pacific Coast Highway. I thought we were expected downtown, so I was curious when, instead of turning off to catch the freeway, we kept traveling north.

"Where are we going?" I asked Nick.

"Don't you need to pack a bag?" he asked.

I glanced back at the follow car and saw that it was still right with us. "For how long do you expect I need to pack?"

He held up his hands; he had no idea, either.

From the car I called Lana and gave her the short version of developments. She had already been notified by the network that I was under police protection. Though Lana sounded genuinely concerned for me, she didn't even pretend that she did not understand the various potentialities my current situation offered the project in progress.

As I slept at the hotel under the watch and care of LA's finest, my project grew in stature and sex appeal in the eyes of the network. The programming troika in New York was in a state of ecstasy about the "hook" and "platform" we would have for promoting the production in the weeks leading up to sweeps week.

When news got out, the publicity department would be able to book me onto any talk show or news show in the nation. With perseverance they might get a magazine cover, but they were assured of at least cover banners, as well as lots of newsprint. "Maggie MacGowen, under police protection as she uncovered—"

Actually, I still didn't know exactly what I had uncovered, or had given the perception of having uncovered. Whatever it was, when Lana threw in mention of Mike's suicide, she had her "boffo" to the nth degree.

When I heard a helicopter overhead I craned to get a look at it, to make sure the network hadn't sent its news bird out to video my "convoy of protection," or whatever crap tag they might dream up. Fortunately the bird was only routine traffic patrol.

The shave and quick wash had revived Nick. Mike could do that also, stay up all night, get a nap, a shave and clean shirt—the last of which Nick did not get—and he could function well all of the next day. Like combat troops and medical interns, police need to be able to function for excruciatingly long periods of time. Patrol cops often work all night long and then spend the entire following day in court, testifying or ferrying suspects, and then go straight back to work.

Police patrol is a young man's job. Both Mike and Nick were too old for that schedule. After a thirty-six-hour stint on the job, they needed a full twelve in bed, followed by a meal and more sleep. I had Nick's full attention for the rest of the day. But I knew that tomorrow he would disappear.

We became the lead car as we headed into the canyon. We made a quick stop to look at the divot I had taken out of the mountain and various bits of car I had left behind, and continued up.

I asked Nick to take the back road so that I could see the road behind my house. At just about that place where the burglar most likely parked, I saw Crown Vic number four, as I expected.

Number five was on the far side of my driveway, parked in the dirt off the side of the road just before that last horrific hairpin curve.

Nick gave the car some juice to get it up my steep driveway, and parked in front of my garage. The other two cars peeled away, probably to set up watch posts somewhere below.

"This is a lot of attention when law-enforcement budgets are tight," I said.

"You were Mike Flint's girl," as if that were sufficient explanation.

"I'm not entirely clear, Nick," I said. "Am I being protected or detained?"

"Depends," he said, pocketing his keys as he grinned at me. "Just depends."

A uniformed policeman sat on the horse corral rail, talking to the kids, quieting them. I thanked him, patted muzzles, gave the officer carrots to feed the horses, while Nick looked around as if he were assessing access and escape routes.

Inside the house, at about the same instant that I smelled coffee, I noticed, with interest, that boxes that held copies of Mike's files and notes, boxes I had not been allowed by the sheriff's deputies at the Malibu substation to remove from the trunk of my car the night before, were stacked next to Mike's office door.

As I came around the corner and into the kitchen, following Nick, I stopped dead, did a comic double take I'm sure. Eldon and Kenny were comfortably seated at the kitchen table, sharing my morning newspapers. The pot in the coffeemaker was half-full and they had steaming mugs in front of them. They also had eggs and toast and orange juice in front of them. My skillet was soaking in the sink.

"Hello," I said, hesitant to approach closer.

"Get a good night's sleep, Maggie?" Kenny rose and pulled out a chair for me, but I stood where I was, working through this odd tableau. "Cup of coffee? Hope you don't mind if we raided the fridge. I'll fry you a couple of eggs. Nick, can I get you anything to eat?"

"I'll do my own, thanks." Nick put a couple of pieces of bread into the toaster, rinsed and dried the skillet, put it on a stove

burner, turned on the gas, dropped in some butter, broke in three eggs from the open carton on the sink and scrambled them with my spatula. "Maggie, how do you like your eggs?"

"No thanks," I said. I took a mug out of the cupboard and poured myself coffee. "Make yourselves at home. *Mi casa es su casa.*"

"Sorry, Maggie," Kenny said, grinning sheepishly. "Didn't mean to help ourselves. But we been waiting here a whole lot longer than we thought we would have to. We had a long night, and oh hell, being here together like this is like old times, isn't it?"

"Not exactly," I said; Mike wasn't there.

Eldon said, "So Nick, what kept you?"

"Fucking PCH," Nick said, deadpan, licking butter from his thumb after he buttered his toast. "Never know about traffic on PCH."

I laughed. No mention of the long, hot shower I took, or his nap. Or that traffic on Pacific Coast Highway had flowed at a steady fifty. Nick winked at me and smiled.

Kenny was right, though, it did feel like old times. When Mike was still working and the two kids, his son, Michael, my daughter, Casey, were still at home, Kenny and Nick and various other co-workers, his and mine, as well as friends of our kids, often stopped by the house in the morning as the family was getting ready for the day, stayed to eat breakfast while we packed lunches and filled Thermoses with coffee or juice and sorted out rides into work and to school. Finding friends and sometimes the barest of acquaintances in my kitchen helping themselves to the refrigerator seemed normal, part of the life I shared with Mike.

After Mike got sick, a lot of the same people were in the house, but it was different then. No hustle or energy about that time. A quiet death watch, Mike had said one day about the parade of friends who came to help care for him. I said it was a life watch, and he said, "Bullshit."

"So." I pulled out the chair next to Kenny and sat. "I hear you had quite a night."

"We did. Learned a few things."

Nick set his plate on the table, fluffy scrambled eggs and almost over-done toast. The smell was wonderful. I said, "That looks good. I think I'll make myself something after all."

He put the plate in front of me. "You have these. I'll make some more."

I thanked him, poured some milk into my mug of coffee, and looked around the table. They were all watching me. I ate a forkful of scrambled eggs, complimented Nick, and they were all still watching me.

"All right," I said, putting the fork on the edge of my plate. "What's up?"

Eldon reached under his chair, scrabbled around under there, and then pulled up the sheaf of my notes I had left with the copies of Mike's files that were in the other room. Among my notes was a county map that I had festooned with sticky notes, based on Mike's collection of clippings, to designate certain types of crimes and their locations, looking for event clusters. Someone, maybe Eldon? had reduced the map to an irregular bundle. Many of the sticky notes had fallen off or gotten stuck together randomly, out of place, or now adhered to the floor under Eldon's chair. One clung to the side of his shoe.

I looked at the bundle, made eye contact with all three of them in turn, and then gave my full attention to Nick's very good scrambled eggs, without saying anything.

Eldon was the first to speak.

"You've come damn close, Maggie," he said. "We never imagined you'd get this close."

"To what?" I said.

"The key guy," Kenny said.

"Who is it?" I asked.

"You don't know?"

"Eeny, meeny, miney." I pointed a finger at each of them in turn. "Am I warm yet?"

They laughed, if nervously. Kenny shook his head. "You're cold. Very cold."

Nick set his plate on the table and sat down opposite me, tucked a paper napkin into his collar to protect his tie and, with fork poised, asked, "It's the million-dollar question, isn't it? Do you know who was in charge in this string of crimes, Maggie?"

"I can profile him," I said.

"Go ahead," Nick said as he began to eat.

"He is or was a policeman, a street cop, probably worked gang or drug detail; they overlap. He's paternalistic, manipulative, loves to mess with people on the street, has an inflated notion of his own power, and thinks that he is above the law—oh!—he is the law."

I sat back and took a breath; all three of them were still watching me.

After a moment, Eldon said, "You done?"

"One more thing," I said. "In his mind, he is a missionary of sorts. It is his obligation, his calling, to protect the righteous by converting society's miscreants and slackers to the right and the true, to put them firmly on the path toward salvation, or to remove them altogether. I'm not talking about religious salvation here but behavioral salvation. Toe the line or pay the consequences."

"That's pretty good, Maggie," Kenny said with a chuckle. "You've just described about ninety percent of all the beat cops in the country."

"That's the point," I said.

"I didn't hear you say sociopath, lowlife greedy murderous bastard," Eldon said.

"Someone like Boni?" I said after swallowing the last of the eggs. "Not necessarily."

Eldon narrowed his eyes. "What?"

"I wasn't looking for Boni," I said. "To use Eldon's word, Boni's own hubris brought him down."

Both Kenny and Nick snapped quick glances at Eldon. Nick said, "Hubris, Eldon?"

Eldon blushed.

"As far as the 'key' guy in the suburban war on drugs?" I said. "There isn't one. But you were all very clever with your phrasing. Who wrote your script? I would have used 'missing link' for its contextual punch but 'key guy' suffices."

Kenny shook his head, but he was smiling in a self-deprecatory way. Eldon guffawed. Nick put his head in his hands as if it hurt; after the night he had, it probably did.

"What was all that stuff you mapped out?" Eldon asked.

"Mike thought Boni wasn't alone in seeing some possibilities when Higgins was gone, but possibilities with more pure intentions than moving in on the Higgins turf," I said. "Did maybe some

cops on drug and gang detail in various towns take advantage of the drug supply vacuum immediately after Higgins was gone to try to sweep their communities clean, to finally get ahead of the drug problem in their neighborhoods before a big operation like the one Higgins worked for moved back in?"

"Vigilante cops?" Kenny said. "An underground task force?"

"Nothing so organized as a task force," I said. "But there was a lot of similar thinking. I'm certain that from time to time cops covered for each other when one of them crossed the line and trampled on due process. And that they felt righteous when, for instance, a match got thrown into a meth lab operating out of the kitchen of a suburban house and the business shut down. The proprietors, if they survived, most likely would go to prison on a plea deal without a trial and the neighborhood would feel safe again."

I continued, as they studied me. "If the guy who was cooking meth cried 'arson,' who would listen, or even care? And if that someone said cops did it? Who are you going to believe, some scum who was ruining the quality of life in town or Officer Joe who coaches youth league basketball?"

I sipped my coffee. "If the bodies of, say, three notorious and persistent crack dealers were found shot dead in the trunk of a car parked up behind Puddingstone Dam, how large a priority would an investigation be?"

"That's fantastical, Maggie," Kenny said. "You're saying all those events Mike was looking at were the work of sworn peace officers? Bull."

"Some, not all, I don't know the percentages," I said. "I believe there were opportunities taken. I think there were liberties taken."

There was another round of exchanged glances that conveyed neither joy nor enlightenment. Nick started to speak, but Kenny took over.

"So you're saying that there was a six-month frenzy of police vigilantism after Rogelio Higgins was taken out?" Kenny said. "Then what? Spontaneously they all settled down again?"

I shook my head. "Mike was looking at events of a particular variety that happened six months before Higgins, six months after Higgins, two years after Higgins. I went online yesterday and did a search for last year. You know what?"

"I'm afraid you're going to tell us," Eldon said.

"There was no six-month frenzy of police vigilantism," I said. "It preceded Higgins and it continues, ten years later. Vigilantism isn't the word Mike would use. Neighborhood housecleaning, maybe. Handing out just deserts, maybe. Local anti-terrorism, perhaps. Pro-active police work?"

"Can you prove any of this?" Kenny asked.

"Depends on what you mean by 'prove.'" I rose and took my plate to the sink, rinsed it under the tap. "I can show patterns, the patterns Mike found, but that's all."

I put my plate into the dishwasher, dried my hands, and looked back at their three closed faces.

"Oh, please," I said. "I know how it is out there. You arrest someone and the next day he's right back out on the street doing his thing again. I know how that makes you feel. Especially since the consent decree. I would be with Mike and he'd see some obvious punk, a troublemaker, and he'd say, 'In the old days, we'd just shoot a guy like that.'"

"He was trying to get a rise out of you," Nick said.

"Sure, but there was always a kernel of something pretty angry there. And superior. And more than a little frustrated." I picked up Kenny's empty plate, Eldon picked up his own and Nick's, and we took them to the sink. He rinsed, I filled the dishwasher.

"Mike never told me stories about you, Eldon," I said. "But about Nick and Kenny, he had plenty of them. None of you can persuade me that everything you did, that you do, out there is strictly according to the police procedure manual."

"I certainly never torched a meth lab," Nick protested.

"Maybe not," I said. "But you did crowd control once while Mike gave a rape victim instructions on beating her attacker with a nightstick so it wouldn't leave marks, and then you stood there and cheered her on as she beat the shit out of her assailant while he was handcuffed and helpless."

Nick grinned, remembering. "God, seeing her whack that guy was better than a month of therapy for the whole neighborhood. That guy had been terrorizing those folks...."

"Exactly my point," I said. "And when said rapist tried to tell the judge that you sanctioned his beating, the judge wouldn't listen."

"Yeah, but that was because of Mike," Nick said, still grinning. "So the judge asks Mike if he gave the woman his stick, and Mike makes this innocent face—you know how Mike did—and he says, 'Your Honor, does that sound reasonable to you?'"

"You prove my point," I said.

"If what you're saying is correct," Kenny said, "and I'm not saying it is, then what is the point?"

"There was one big fish that Mike was looking at, Rogelio Higgins," I said, "He, too, was cleansed."

"By a cop?" Kenny said, trying to seem incredulous and dismissive, but failing.

"Plural, I think," I said. "One shooter maybe, but others who knew, others who covered."

"Who?" they bellowed, like a chorus trying to reach the top balcony.

"I only know three of them," I said quietly. "And they're all dead, Rod Pearson, Art Collings, and Tom Medina. I'd feel a lot safer if I knew who the survivors are, especially because they've broken into my house twice now looking for something. And sliced my brake lines."

"For chrissake, Maggie." Kenny's face was a dangerous shade of red. "Isn't that enough for you? Honey, you gotta stop."

I picked up the coffeepot. "Anyone want more coffee?"

We all looked up when there was a knock at the patio door. I turned around to see who it was. A plainclothes officer stood on the other side of the glass with Early beside him.

"You know Early," I said. "My neighbor, my co-worker."

Kenny gestured for him to come in.

"You okay, Maggie?" Early asked. "Sorry your mishap got so much air time."

"Part of the cost of doing business," I said. "Have you eaten?"

"I'm good," he said. "I've been delegated to talk to you about the funeral at Evergreen today. Guido says you can't reschedule, because there won't be another burial in potter's field for a few months. He can go ahead and video it. I know you wanted to be there."

I glanced at the kitchen clock. "I want very much to be there, but I don't have a car. Triple A delivered a rental to the Malibu

substation, but I was swept away by the police so it's probably still there. I don't want to feed the news beast by arriving at the studio chauffeured by armed security."

"I'll be happy to drive you in. Let me know when you're ready to go," Early said. "I'll be next door."

I thanked him and saw him out. Then I turned to the gray suits, knights at my round kitchen table. "Gentlemen, if you'll excuse me, I need to get ready for work."

Kenny gathered up the bundled map and asked me, "Where are Mike's files?"

"You've already found the copies I made you." I flipped the edge of the map they had taken out of one of the boxes of copies. "Take them with you, with my blessing."

"I need the originals. All of them."

"You keep forgetting," I said. "I'm a bona fide, dues-paying member of the Fourth Estate. I've cooperated with you so far, and you've been helpful to the extent that it worked for your interests. But I get to choose what I tell you about my sources, and you'll need a warrant before I'll think about handing over my own notes, or anything further of Mike's that I, as his executor, believe to be off limits to you."

"Maggie," he said, exasperated. "In the wrong hands—"

"Honestly, Kenny, I'm not at all sure at this point where the proper hands are," I said with some heat. I gave each of them a long and hard look, and they all three met my eyes without flinching, but with those men that was an indication of nothing. "If I could know where the three of you are at all times, how necessary would all this security fuss be?"

"I don't get you," Nick said.

"Think about it," I said. They looked from one to the other. "And I'm beginning to think I'd be better off, safer, without a police escort."

"Now, that doesn't make sense." Kenny got to his feet and shadowed me as I walked back and forth between the table and the sink, picking up the last of the breakfast things, the butter and milk and eggs, and while I wiped the table, always dodging around Eldon and Nick, who had joined the kitchen cleanup. Kenny's plaint that I not dismiss police protection grew increasingly strident,

frustrated. I stopped fussing with the cleanup, crossed my arms and faced him. He only stopped talking when his cell phone rang. With ferocity, he barked into the phone, "Noble."

As he listened his red and angry face suddenly paled. Unsteady, he reached for a chair and nearly toppled with it, obviously distressed, badly needing to sit down. Both Eldon and Nick, who had been contributing their own arguments, stopped talking and watched Kenny.

Into the phone he said, "How is that possible?"..."When?"... "How?"..."Who?" The answers he received only heightened his misery. When he closed the phone he dropped his head onto arms folded on the table and made great, heaving sighs.

I put my hand on his shoulder and knelt down so I could see his face. I was afraid he was going to pass out, or worse.

"What is it, Noble?" Nick asked, flanking Kenny on the other side.

Kenny took a breath, raising his head as he did so, and wiped his eyes.

"They got to her," he said. "Nelda was in her cell, asleep. Someone got to her."

— 18 —

AFTER MIKE'S funeral I took off the new gray dress my daughter and mother bought me for that occasion and draped it across the back of a chair in our bedroom where, along with a few books, several nearly clean shirts, some notepads and my Thomas Guide map book for Los Angeles County, it had remained. For the burial of the unidentified remains the coroner had been holding on to for the last three years, I needed a funeral-appropriate dress again.

I picked up the dress, gave it a shake, ran it through a dryer cycle, shook it again, and my funeral dress was fine to wear again. Saying a few words of gratitude for wrinkle-resistant fabrics I slipped it on, remembering to put a few tissues into the pocket. I fluffed my hair, put on makeup and the new funeral heels, and went next door to catch a ride into Burbank with Early.

As we drove down the mountain we were followed by a single Crown Vic all the way to the studio. The rest of the police stayed behind; for a second time, the house was a crime scene.

Early checked the rearview mirror. "Who was that guy, a few years ago, investigative reporter looking into the Posse Comitatus? Can't remember his name. Bunch of skinheads came after him, did their best to take him out."

"What happened?" I asked. "Did he get hurt?"

"No. The network created a shield around him, scrubbed all of his contact information out of the system so no one could reach him directly. Network put him up in a safe house until it was over. Network will set up something for you, too, if you're worried."

"I won't say I'm not worried," I said. "I've had so many people warn me off that I really wasn't all that surprised when something happened. I just didn't know what it would be or the direction it would come from. And I don't know what's coming next, except something will come."

"You should listen to your instincts, take precautions," Early said.

"I'm not ready to go underground," I said.

"I moved the light sensor down your driveway," he said. "You'll trip it as soon as you drive in."

"Thank you. I appreciate all your help, Early."

"And I put in a second sensor out back. You'll be able to see anything, including coyotes, that gets within six feet of the patio."

"Whoa." I turned to look at him, saw dark circles under his eyes. "My God. I had no idea you were doing all that."

"I added another set of light sensors at the end of the front stairs. If you ever have to go out at night, before you reach the bottom step the lights will come on."

I was nonplussed. "What next, Early?"

"I'm investigating alarm systems," he said. "I'll let you know what I find out."

"How many break-ins have there been in our neighborhood?" I asked. "Ever."

"Two."

"Both mine. I think we can save ourselves a lot of expense and effort, and poor old Duke a lot of grief, if we just find our bad guy, or guys."

"Right," he said. "But until then."

I repeated, "Until then."

Guido and our video crew were ready to go and waiting for me when we arrived at the studio. I said good-bye to Early and joined the crew. We left the studio in a convoy, network Suburban full of video gear, with Paul Savoie and Craig Hendricks, working with us again, in the Suburban. Guido and I followed in his SUV, with the Crown Vic between us and the battered Civic carrying Guido's graduate interns at the rear. The lovely object of the attentions of Guido's camera lens was in the Civic's backseat.

When Guido is tense the corners of his chiseled jaw look hard as stone. I saw the rigid set to his jaw first thing but waited for him to bring up the source of his concern, though I had a very good idea what that issue was. Generally, he prefers to work things through before he speaks. Safer that way.

After a while, eyes straight ahead, he asked, "What happened this morning?"

"Someone on the inside at Metro Detention got to Nelda," I said. "She was asleep in a single-person cell, in high-power segregation. Somehow, someone got close enough to shank her, slit her throat, severed the carotid. Quick and quiet, but messy. She kicked off her blanket during the attack, but no one admits hearing anything. She'd been dead for less than an hour when routine patrol found her."

"Who did it?" he asked.

"Don't know, but there are a lot of candidates. Kenny Noble is really beating himself up because it was his idea to take Nelda to Metro instead of booking her downtown. He thought she would be safest at Metro, in federal lockup. And maybe she was. She lasted five whole hours there. Could have been less in the city lockup. Nelda made a lot of enemies."

"I thought you told your police tail to go away."

"Didn't work."

In the side-view mirror I could see the Crown Vic behind us.

He checked the tail in his rearview mirror. "They sure know how to stick."

"I told them where we're going."

We were quiet for a few minutes. I turned to him. "You haven't said anything about your day at the morgue. How did it go?"

"We had a good time. Your friend Phil was very helpful. The footage of the techs sifting through the debris flushed out of the bridge is priceless."

"Did they find any more parts that belong with the lady's skull?"

"Maybe," he said, nodding. "The techs found two toe joints, a femur, and a bloody blue-striped T-shirt with a Gap label. Don't know if they belong to the same person, but they are human remains. The point they made is, that pile of debris is the proverbial haystack. They're looking for a needle they aren't sure was ever in there."

He laughed. "Should have chosen a different metaphor; they found plenty of needles and other paraphernalia."

"Glad you had fun."

"More than you did," he said, patting the edge of my seat. "Forgot to tell you. That cop, Lewis Banks, came by the shoot looking for you."

"What did he want?"

"Didn't say. Maybe he wanted to be on camera again. Maybe he has a crush on you. He said he was in the neighborhood and thought he'd drop by."

"Dropped by where?"

"The morgue."

Our convoy left the freeway, exited at First Street and went east, away from downtown. Evergreen Cemetery is on First Street, as is City Hall. But the cemetery is on the other side of the river, on the other side of the Santa Ana Freeway.

When the cemetery was established in the mid-1800s, at the beginning of California's Anglo era, it lay way beyond the eastern fringes of the raw young city. Los Angeles, always inclined to sprawl, quickly grew outward to encircle the site. Now the cemetery is an artifact, a quiet green island embellished with ornate marble angels and fanciful urns and carved black monoliths surrounded by the dynamic bustle and flow of the Boyle Heights *barrio*.

The cemetery always represented the great cultural diversity of Los Angeles, and also represented the well-defined social boundaries of the old city. The names carved on the largest and most ornate headstones, if not the oldest—Los Angeles was a Mexican town long before the gringos came—are clustered together in the middle of the First Street side and read like the names on a local map: Lankershim, Van Nuys, Hollenbeck, Bixby, Workman, Chapman; these were the founders of modern Los Angeles.

The southwestern corner, isolated across a small stream with a bridge, was reserved for black residents until after World War II, when the stream was breached and African American graves spilled into the general cemetery population at the same time that African American families began to spill out of the Adams Avenue neighborhood and into the suburbs south of Slauson Avenue, and beyond.

North of the old black section, beginning in the 1890s and continuing to this day, are the Japanese. The Japanese section is now

the most active and has the largest number of recent memorials; Little Tokyo is a half mile west. There is a Jewish section, a place for war dead from every war since the Spanish-American War, another for children and victims of the flu pandemic of 1918.

The middle was once generally Anglo, with German and French enclaves, while some headstones on the east side have Hispanic surnames; the old Catholic cemetery is further south, in East LA. This eastern section is where the second largest number of new graves is to be found. Too many of the headstones here have laser-engraved portraits of very young faces, most of them male, teenagers with nicknames like *Sleepy Jefe, Outlaw, Notorius, Little Dog* carved between their Christian names and their fathers' family names. Jesús Ramón's older brother is here, and if he had been found, Jesús would lie next to him.

In the far southeastern corner, behind a chain-link fence, the nameless, friendless and the impoverished are interred anonymously in potter's field. The markers here are flat stones carved with numbers only. Beyond them, and outside the cemetery walls altogether, land was set aside in the nineteenth century for Chinese burials. Somehow the Chinese graveyard became forgotten or was disregarded and got paved over by the extension of First Street as the city grew outward. Recently, during construction on a new section of the Gold Line, the downtown-to-Pasadena light rail route, over one hundred of those old graves were discovered under the road bed, halting construction, heaping shame on the city's segregated past. Makes one wonder who else was paved over and forgotten as the city expanded.

Guido and I, and his students and my tail, parked in the small public lot and walked across this map of urban social history to join Savoie and Hendricks at the trench dug for the interment of the county coroner's current accumulation of unclaimed cremated remains.

The trench had roughly the dimensions of a standard grave, but shallower. There were flowers, a minister and a priest, representatives from the Board of Supervisors and the mayor's office, a few good-hearted citizens who make it a point to attend these rituals regularly, and a bugler. Julia Ramón had brought her sister Mayra in recognition of the possibility that Jesús, if any part of him had

ever been found, was interred in a similar plot with a number, no name.

Phil Rascon from the coroner's office was there, possibly, I thought, because he was feeling proprietary about our being there. My good friend Rich Longshore was beside him, both dressed for the occasion in dark suits. I walked over to them.

"Maggie," Phil greeted me. "Want you to meet Sergeant Richard Longshore from the County Sheriff's Homicide Bureau."

"The Bulldogs," I said, extending my hand. "Never let one get away. Good to see you Rich. A nice surprise."

He reeled me in for a hug. "How's my girl?"

"Doing fine," I said, face against his broad shoulder.

"I watch the news, Maggie," Rich said, patting my back. "I'm concerned."

"So am I." I pulled away so I could look him in the face. "Can we talk later?"

"I'll be right here, keeping an eye out. Let me know when you're ready."

I turned to Rascon. "How do you know my friend Rich?"

"Sergeant Longshore and I go back a long way," Phil said. "When he was the sheriff's big canyon diver he used to bring me a lot of business. But now they have him working cold cases I don't see so much of him."

"Canyon diver?" I bit at the opening, though I knew the story. Savoie had his camera trained over my shoulder, Hendricks held a mic. The conversation became an interview, potentially for the video.

"In my long-ago youth I was an Army Ranger, in Vietnam," Rich said, standing straight, abs pulled in. "So after the sheriff sent me from SWAT up to Homicide Bureau, seemed like every time remains were found down the side of a ravine, I got sent out to put on my rappelling gear. I liked the opportunity to get out of a suit now and then, but I got a bit senior to be rappelling down canyons in the San Bernardinos. That's rugged terrain."

"One of his cases is getting buried today," Phil said. "Remains of a lady he found down Placeritos Canyon a few years back."

"You never identified her?" I asked, though I'd heard the story before. Maybe this would be the fall season opener of my series.

"Not yet," Rich said. "Maybe I never will."

Phil nodded in agreement. "It's the sad truth."

"This one got to you," I said.

"They all do," Rich said, and again Phil nodded. "Young woman dead, someone must be looking for her. A lost hiker found her in a ravine about four years ago and I went down to retrieve her. I took Phil everything I found, an arm bone tangled in the sleeve of an expensive silk robe. Visited a lot of lingerie shops before I found where it came from, a Rodeo Drive boutique, sold the Cacique label; someone spent a lot of money to make her look pretty."

He looked at me as if to ask, Enough?

I kept him talking, moving toward the question I actually wanted him to answer on camera. "That's all you found, an arm and a fragment of silk?"

"I also had some hair, the femur, and the top of a skull. Phil helped determine her sex, her age, her background and how long she had been dead: she was twenty-five to thirty-five, probably of Japanese heritage, and she had been exposed to the elements for about two years before a hiker slipped off a trail and literally fell into her while sliding down the ravine. Phil can't tell me how she died, but I have a pretty good idea she didn't die while hiking because who goes hiking in an eleven-hundred-dollar silk robe?"

"You're working backwards on that case," I said. "What about someone who has gone missing and no one can find the remains after ten years?"

"You're talking about Jesús Ramón," Rich said. "We all looked for that kid. To this day, every time I get something that could even remotely belong in that pocket I take it straight to Phil."

"You and Mike Flint were good friends," I said.

"Sure. Too much is made of competition between county and city departments. Mike and I worked more than a few cases together. He was maybe the best detective I ever worked with. He had that sixth sense that old cops develop."

"Do you have it, that sixth sense?" I asked.

He grinned, dipped his head, looked up at me with his turquoise eyes. "I seem to."

"Among the possibilities you took to Phil, none of them fit Jesús?"

"On the contrary. There are at least a dozen John Does that could fit Jesús. But there isn't enough left of any one of them, or salvageable DNA, to prove that it is or it isn't Jesús."

"I was told there were rumors that Jesús might have been dumped into the Los Angeles River during a rainstorm or was dumped into a canyon."

"Who said that?"

"Woman named Nelda Ruiz."

Rich thought that over for a moment.

"I'll be seeing Nelda tonight," Phil said. "Only she won't be answering any more questions."

Good place to end the conversation. The coroner's van had arrived and the minister and the priest moved into position at the head of the trench. Savoie and Hendricks went off to video the removal of the remains from the coroner's van.

"What are you doing after the service?" I asked Rich.

"I'd planned to go straight back to the office, but I'm at your disposal."

"Thanks." I kissed his cheek, and walked over to stand with Julia and Mayra.

Mayra reached for my hand and pulled me down closer to her. She whispered, "They killed her."

"Yes," I said. "I'm so sorry."

"Live by the sword," Julia said. I straightened up and put my free hand around her shoulders. We stood in that three-part clutch and watched as the doors of the coroner's van opened and the boxes were carried out.

Savoie's camera followed the procession of the remains from the van to their placement in the trench, lined up like a stack of plastic bricks on the black earth. During the service Savoie focused on the various people assembled, glanced at Guido occasionally for instructions, turned to capture the perfect view of the downtown skyline that the cemetery offered. Hendricks was in position behind him with a synchronized sound recorder, capturing the service. The two men were long-time pros, unobtrusive and at the same time everywhere.

I was impressed by the gravity of the service, by the sincerity of the people who came. Phil Rascon said a few words about how

difficult it was to finally consign someone to anonymous interment when there might be family searching. Rich talked about the young woman in the silk robe. Julia asked for a prayer for her son, Jesús, because he might already be in one of the numbered graves around us.

It was one of the saddest funerals I had ever attended. I caught Savoie videoing me as I blew my nose into a sodden tissue. I made a mental note to have that piece removed. It would not belong in the finished project and I didn't want publicity to flaunt it if it turned up.

After the service it seemed appropriate to have a wake or reception of some kind. Most of us, including my tail, traipsed across the street to a Baja-style fish taco stand for tacos and beer. We filled the patio seats and overflowed onto the sidewalk. The conversation was lively, an interesting collection of folks brought together by an unusual circumstance.

"Normal," the proprietor said when I apologized for the sudden morning rush when he was preparing for the lunch-hour crowd. He told me that he frequently fed large groups of people after funerals.

I walked up to my caretakers. "You getting enough to eat?" I asked.

"Yes, thank you." The officer was young, dark-haired and buff, as was his partner. Instructed to keep a low profile, they wore polos and khakis instead of starched shirts and neckties or midnight blue regulation garb, but the posture, stance, and side arms would tell any observer who they were.

"Is this your normal assignment, personal security?"

The two exchanged glances and in the interchange seemed to decide who would be the spokesman.

"No, ma'am. It's overtime," he said. "I work juveniles in the Valley, Ray here is community liaison. I don't know if what Ray does counts as 'normal' police work, but they let him wear a badge."

Ray guffawed. "Jack's a babysitter. He likes these OT jobs so he can play with grown-ups for a change."

They told me that besides working the occasional overtime assignment, they frequently did work for the film and television industries, location set security and crowd control, airport pick-

ups and paparazzi evasion. Now and then they got into movies as extras, or got paid for giving technical advice. The money was good, the hours were flexible, and they saw how the other half lived. My guards told me that the agency that set up their moonlighting jobs would consider hiring just about any licensed and currently employed law enforcement officer.

I knew that many policemen had second jobs, frequently working in security. Mike had a string of moonlight jobs before he made detective-grade pay. Harry Young told me that four days a week, after his night watch shift, he put in four more hours watching over the Central Produce Market before he went home to bed.

We were still talking when a black-and-white police cruiser pulled up and parked in a red zone beside a fire hydrant. Sgt. Lewis Banks got out and swaggered over to the group. He greeted my watch cops with a handshake, and nodded acknowledgment to Julia and Mayra, who turned their heads away.

I didn't know why he was there or why I should be wary, but Early had reminded me on the ride to the studio that morning to listen to my instincts about people, and this man made me wary. His behavior at Mayra's house when Nelda was taken in bothered me. Given a chance, I would have asked Nelda why she reacted to him the way she did, some combination of rage and fear, I thought. But I didn't get the chance to ask her.

Banks seemed to know one of my guards, the one named Ray, so this unannounced visit, so far, had nothing to do with me. Maybe he was driving by and saw someone he knew. Still, I was glad there were so many people around.

I eavesdropped on their conversation.

"You still moonlighting with Magnum?" Banks asked his acquaintance. When he got affirmation, he said, "I work through them, too. Good enough pay, decent hours. You doing the seven-to-three shift?"

"No, mid-shift, nine to six," he was told. A little more conversation, and they shook hands. Banks made his way over to me.

"You're a hard person to catch up with," he said, one hand resting on the butt of his holstered weapon, a typical cop stance.

"What can I do for you?" I asked him.

"I was thinking more along the lines of what I can do for you.

This is my beat, I know it better than just about anyone you can name."

"Thanks for the offer, Sergeant," I said. "I'll keep it in mind."

"I heard about Nelda Ruiz," he said and dropped his head for a moment. Sadness? Chagrin? "Hope you don't feel responsible. I mean, it was your call that got her taken in, but..."

"I'm certainly upset about what happened to Nelda," I said. "But I don't feel responsible. Nelda was taken in because she violated her parole. The enemies she made? That was her doing as well."

He nodded, agreeing. "As long as you aren't losing sleep over it."

"I sleep pretty well, thanks. And as I remember yesterday, if I hadn't made that call you would have taken in Nelda yourself."

"I sure as hell wouldn't have taken her to Metro." He sounded defensive.

"Because she would be safer among her old friends and neighbors in a local lock-up?"

"Hey." He held up his hands and backed up half a step. "I wasn't accusing you of something."

"And I'm not accusing you of something."

Rich Longshore strolled over as my watch cops set down their food and moved closer.

"Banks?" Ray said.

Rich moved in tight beside me. "Got a problem here?"

"Do you know each other?" I asked.

Rich studied Banks before he shook his head. He held out his hand, but it was not a friendly gesture. Rich had six inches of height on him. "Sergeant Richard Longshore, County Sheriff's Homicide Bureau."

"Banks. Lewis Banks. I work command at Central."

Rich looked around as if searching for a sign post. "Aren't we in Hollenbeck territory?"

"Yes," Banks said. "I was just driving by. Happened to see some people I know. Thought I'd check on Maggie here, make sure she's okay. She had a pretty rough day yesterday."

"You okay?" Rich asked me.

"I am," I answered.

"Well then," Rich said to me, pointedly with his back to Banks, "if you still want to talk to me and you're ready to go, you want to

follow me over to my office? I don't know if you've ever been there, so I better give you some directions. Easy to get lost because we're situated right in the middle of the convergence of the Five and the Seven-ten freeways so the surface streets can get to be like a maze. Pretty confusing even if you think you know where you're going."

"Thanks," I said. "Let me say good-bye to some people, and I'll get Guido."

I said good-bye to Mayra, Julia, Phil, the crew, and even to Lewis Banks. Because I didn't want to lose them, I told my shadows where we were going, and they fell right in behind.

Rich was right, the streets around the freeway junctions were a tangle. I hoped Guido was paying attention to how we got in so he could get us back out again later.

"That cop, Sergeant Banks," Guido said, "why does he keep popping up?"

"I really should ask him that very question, but whenever he shows up I feel like I should run for cover, so, you know me, I dig in my heels and get confrontational."

"Maybe you were right and he just wants to be in the movies."

I laughed at that. "Yeah, maybe."

The Northridge earthquake of 1994 did so much damage to the sheriff's headquarters in the old Department of Justice building downtown that the building was condemned and the headquarters functions were scattered into available spaces all around the county. The Homicide Bureau moved into a vast warehouse-like structure in an industrial park in the City of Commerce. The detectives had found this space to be perfectly adaptable to their needs: good parking, working air-conditioning, movable partitions. After more than a dozen years in their temporary quarters they were still in place, and showed no restlessness about moving.

Rich gave us a quick tour of the detectives' bullpen, an immense open area filled with double ranks of desks, the long walls lined with filing cabinets, bulldog mascot paraphernalia everywhere. Rich, assigned to cold cases, worked in a back ell off the bullpen where cold case files were kept. On his desk he had a ceramic lamp in the shape of a bulldog under a silk shade and pictures of his grandchild in silver frames. Around his desk there were filing cabinets, file boxes, stacks of expandable files.

He pulled up chairs for us.

I said, "Would you mind if Guido videos this conversation?"

"Okay," he said. "But if we get into certain areas I might ask him to turn it off."

"Fair enough," Guido said.

I had to take a deep breath, compose myself, because my first question for Rich was a tough one. Stalling, I asked Guido if he was ready. He said he was, frowning, puzzled, because he had already told me he was ready. I sat up straighter, looked Rich in the eye.

"Mike chose a Monday to be his last day in this life," I said. "After Mike became ill, on Monday mornings you regularly came over to keep him company. Ever since that last Monday, I've wondered if there was something in particular he wanted to talk to you about."

"Hmmm." Rich furrowed his brow, studied his hands. "That morning, from the minute you brought Mike down for breakfast until I left him after lunch, he seemed unusually fine. Happy."

"That morning, he was," I said. "I think that he had made his ultimate decision and he felt as if a great burden had been lifted from him. From us. But did he have a last story to tell, a last message to impart?"

"He brought up Jesús right away," Rich said; I remembered that he had. They were talking about Jesús when I left for work. "We hadn't talked about the case for a long time. We went over the details again. He told me about that afternoon when he learned the mother was in a panic about not knowing where her kid was. Told me how he had proceeded."

"What did he do?" I prodded.

"When the call from Mrs. Ramón reached Mike, he was at Parker Center talking to Nelda Ruiz about the Rogelio Higgins shooting. Mike thought she knew something. He kept up his interrogation until Nelda's lawyer showed up, sometime midafternoon, talking deal, offering to swap Nelda's cooperation for a lesser charge. Mike called in someone from the D.A.'s office, and a proposal was offered."

Knowing that Boni had never snitched on Nelda, I asked, "Did they take a deal?"

"No. Over Mike's objections, the D.A. released Nelda into the lawyer's custody, so they could talk things over, with the promise that they would be back in the morning."

Rich sliced the air with a hand: "Never give a shyster time to sleep on something. Overnight he went over Nelda's assets, got her to sign her house over to him to pay his fees, and they decided to go to trial. Lawyer got the house, Nelda got twenty-to-life. And she never testified about Boni, said she had nothing to say."

"Why didn't Mike go right out looking for the kid when the call came from Julia?" I asked.

"Because he didn't think there was a problem," Rich said. "What did Julia give him to go on? She had a bad 'feeling.' A mother's bad feeling isn't enough. But to pacify her and to cover the department's ass, after Nelda and her lawyer left, Mike pulled up a recent mug shot of Jesús, made some copies, and went out to find the little creep. He showed the mug shot to some people, talked to Mayra at her taco cart. She said she hadn't seen Jesús, but later, after it was clear that Jesús really had gone missing, Mike thought she probably lied to him.

"When he got no hits from anyone who might have seen Jesús, Mike put out a missing juvenile bulletin with the kid's mug shot on it and Mike's contact information, and had copies delivered to the watch commanders at Central, Newton, Rampart, and Hollenbeck," he said. "And then he went home and had dinner with his son, Michael."

"Because he wasn't worried about Jesús," I said.

"That's right," he said. "Jesús did a lot of roaming. Mike believed all along that Jesús would show up. If the kid saw Mayra he probably had some money or drugs in his pockets to get into trouble with. When there wasn't any more, he'd go home."

"The something in his pocket was probably a lethal dose of heroin," I said. "The question is where he got it. And why."

"I suppose."

"Every time I ask someone about the day Jesús disappeared, the conversation begins with Rogelio Higgins," I said. "But every time I ask about Rogelio Higgins, people warn me off. There's a connection no one wants to talk about. What is it?"

Rich didn't say anything right away, looked from me to Guido,

tapped his pen on his blotter. He looked down, he sniffed, he made eye contact again.

"You want to talk about Rogelio Higgins in some context with Mike Flint or with Jesús Ramón?" he asked.

"Both, either. I know there is a context."

He glanced sidelong at the camera and shook his head.

"Guido," I said. Guido turned off his camera and set it on the floor.

"Thanks," Rich said. "Can we talk off the record here? Friend to friend?"

"Yes."

"First," he said, "why don't you tell me what you think happened to Mr. Higgins."

"I think he was assassinated by someone, or several people, in law enforcement who didn't want his kind doing his thing in their neighborhood."

"His kind being a drug-dealing, gangbanger-enabling child-murdering s.o.b.?"

"Child-murdering?"

"What do you call it when a grown man sells hard drugs to a ten-year-old?"

"You illustrate my point, Sergeant Longshore. I think that when law enforcement couldn't stop Higgins legally, someone 'cleansed' him."

"Do you know who that Mr. Clean is?"

"I have my pet candidates, but I don't know to a dead-bang certainty."

"Candidates, plural?"

"Yes."

"Now I understand why you have a tail." He indicated my two shadows, who had found the break room and a couple of canned sodas and were now on the far side of the bullpen, comfortably seated, shooting the breeze with some sheriff's detectives.

"Off the record, friend to friend? Rich, I'm scared. Someone breaks into my house, tampers with my car. And then that happens to Nelda."

"What do you think the intruder wanted from your house?"

"Nothing big. Remember, he hiked in and out over a mountain crest," I said. "Both times, I think he was looking for something in Mike's investigation files, or maybe he just wanted to find out what Mike knew and to prevent anyone else from getting certain information."

"Both times?" Rich frowned. "You were broken into twice?"

"Yes, twice." I told Rich about the netsuke that had been removed from Mike's office after the first break-in, and mailed to me. I said, "The first time, I think I scared him off before he found what he wanted. The next day, I took Mike's files out of the house. Probably made the guy mad when he went looking for them again, and found them gone."

"Or it scared him."

"So he tried to scare me off, or warn me," I said, "by sending me something he took from my own house. You tell me the message I was supposed to get when my brakes were tampered with."

Rich frowned, thinking about something, watching me. "That thing you got in the mail, the netsuke you called it, was that the ugly little doodad Mike used to fool around with, used to rub it like a worry stone?"

"You've seen it?"

He nodded. "He liked to bring it out and tell this story about what it meant, malice pretending to be mercy or something."

"Right, malice in the guise of the goddess of mercy."

"Wolf in sheep's clothing."

"Murderer wearing midnight blue," I said.

Rich leaned back in his chair, gazed off into some far corner, working something through. When he brought his gaze back to me, he asked, "Where are Mike's files?"

"The originals are somewhere safe," I said. I shifted the topic. "What do these names mean to you?" I reeled off three names: Rod Pearson, Art Collings, Tom Medina.

"Holy cow, you have been digging, haven't you?" He pushed back from his desk and stood. "Wait here a sec."

When he was gone, Guido said, "I need the loo." He walked over to speak with the sheriffs engaged in shop talk with my shadows. One of the sheriffs walked Guido away. They were still gone

when Rich came back with an aged and much-handled manila file folder. He sat down again, slipped reading glasses out of his pocket, opened the file, and began to read to me.

"Rod Pearson, accidental death, fall from ladder, December, 1998. Art Collings, accidental manslaughter, stray bullet to top of cranium, source unknown, New Year's morning, 1999. Jason Kelly, accidental death, severed spine, single-person collision of personal watercraft with boulder, blood alcohol .12, at Pyramid Lake, August, 2000."

"Jason Kelly," I said. "Mike didn't have any clippings about Kelly."

"Kelly wasn't on the job anymore when the accident happened, so his accident wouldn't have attracted the sort of press that the death of a cop, on or off duty, draws. He'd left the LAPD the January before he died, stress related, his jacket says. He started selling insurance for his father-in-law in Calabasas. Coroner listed cause of death as single-person collision, possible suicide, because of the stress angle."

"Does Kelly belong with the others?" I asked.

Rich tossed the file aside. "Do any of them belong together? We looked at Kelly because he left the P.D. on the first anniversary of Jesús' disappearance."

"Tom Medina went down just six years ago, off duty, about the same time the grand jury subpoenas went out."

Rich frowned as if sorting out what he knew. "Except for the coincidence of approximate age and occupation, is there a link?"

"You tell me," I said.

"My dad was a career officer in the Air Force. Wisest man I ever knew," he said. "He used to tell recruits that horses, cars, and young men weren't reliable—actually he said they weren't worth a bucket of warm piss—until they had the stupid ridden out of them. Some of these young officers didn't live long enough to get the stupid ridden out of them. Medina was older than the statistical norm when he died. Maybe he was also dumber. He should have known better than to identify himself as a cop to a guy outside a 7-Eleven holding a gun."

"Maybe it takes some folks longer to get the stupid ridden out

of them than others," I said. "And maybe Medina recognized the man with the gun and hesitated."

"You sound like Mike." He smiled. "I wouldn't have looked at these deaths together if Mike hadn't asked me to. He never said why he thought there might be a connection, but I did some checking. They weren't in the Academy together, they were never all assigned to the same division at any time, they didn't all work the same assignment, live in the same neighborhood."

"But they did know each other." I opened my bag and took out a big envelope that held the enlargements I had made of the three funeral photos, three dead cops, that I'd found in the clipping file Mike labeled OBITS AND PALLBEARERS. I found what I was looking for, a news service photograph from Rod Pearson's funeral, the first of the three to die, and handed it to Rich.

"Recognize any of the pallbearers?" I asked. "They're listed in the caption."

"Jason Kelly, Art Collings, Tom Medina, Lewis Banks, Harry Young, Boni Erquiaga." He let out a breath and watched Guido walk back into the bullpen, stop to talk with the guards and the detectives. "He never showed me this."

I took out the other funeral photos I had enlarged and laid them in a row on his desk. Except for Harry Young and Lewis Banks serving as pallbearers at Tom Medina's funeral, none of those men was pictured together again, though some of them were pallbearers at the other two funerals. And there were a few other familiar faces in those photos, including Eldon Washington and Mike Flint.

Rich studied the enlarged photos for another moment, nodding his head as he held up each one in turn. He sat back when he had finished and folded his arms, looked at me.

He said, "Mike wanted to know if I could come up with explanations for any of the deaths other than accident or quirk of circumstance."

"Could you?"

"Sure. Though the New Year's Eve lobotomy would be hard to replicate, even that wouldn't be impossible to set up. I suggested to Mike that the coroner who received Art Collings's corpse on

New Year's morning might have been predisposed to interpret a gunshot to the top of the head on that particular night as a holiday mishap, might have rushed to a wrong conclusion.

"I went over the autopsy report, where the coroner explained his finding, but there was no stored evidence for a second look, nothing left to corroborate or challenge the finding. Would have liked to get a look at the bullet, but it seems to be long gone, missing from the file. Ballistics report is also missing, but because that was an officer-involved shooting, the bullet and the ballistics report might have gone to any number of desks and gotten lodged there. I couldn't find either the file or a log to track it. So, that inquiry became a dead end. The rest of the deaths are fairly easy to explain away, including the last one, Medina's."

"One more question," I said.

He looked at me. "Fire when ready, Gridley."

"Why were you at the burial service this morning?"

"I told you, remains from one of my unsolved cases went into the ground."

"Why else were you there?"

He smiled his slightly off-center smile as he studied me. "Phil Rascon knew I worked with Mike. For some reason it was real important to him that I meet you; he didn't know you and I are old friends."

"The woman in the silk robe?" he said. "My heart breaks for her and the family that doesn't know where she is, or that she died a long time ago. But I have a sad and unidentified case go into the ground just about every time the burial is held, it's part of the line of work I'm in. I make it to about fifty percent of the burials. So does Phil. And then we go to lunch and talk shop."

"Mike confided in you because you aren't LAPD," I said. "He was no more confident about whom he could trust than I am."

I handed him the photos; I had them on disc. "Keep these. If you get a chance, look at them again."

"I will."

I took a deep breath. "I'm not sure where to go from here, Rich."

"Assuming you won't just put this all aside and go up to the cottage for a while, go fishing?"

"Assuming that."

"Ask yourself, What would Mike say?"

"Mike?" I saw Mike sitting in Rich's chair, asking the difficult question. Mike had handed me a conundrum. I knew he didn't expect that I would get hurt, or he thought I could protect myself. Maybe he had overestimated me. "Mike..."

Dammit, I started to cry. Rich stood up and drew me up into his arms. I made a wet mess of the front of his very good glen plaid jacket. There were no more dry tissues in my pocket, and that made me weep all the harder. To my further mortification Guido and the shadow men got up and started toward us, as did a couple of the sheriffs. Rich waved them away. He also handed me a box of tissues from the desk next to his.

"Oh shit," was the best I could manage to say. With his big arm around me he led me out of the bullpen and into the seclusion of the break room. He sat me at a Formica table and gave me a bottle of cold water from a machine. I still had his colleague's box of tissues in my hands. I blew my nose a few more times, had another, smaller, breakdown, managed to pull myself together enough to begin breathing regularly again.

"It's the funeral today," I said. "This damn dress."

"What's wrong with the dress? It looks very nice."

"I wore it to Mike's funeral."

"Ah." He put coins into the machine and got a bottle of water for himself. "At Mike's funeral I wasn't looking at what people wore."

He sat down beside me and put an arm around the back of my chair, leaned his head close to mine. He said, "Sorry we didn't have this conversation a while ago. But I didn't know what you were looking into until Phil called me yesterday."

"I love Phil," I said, trying to speak past the mass in my throat. That was the best I could do.

"He's one of the good guys," Rich said.

I gulped some water, thumped my chest, managed a breath that didn't catch on something barbed.

"Did you know Mayra Escobedo before today?" I asked.

He shook his head. "But I knew who she was."

"Last time she saw Mike, she said Mike looked scared."

"I think he was." He raised my chin. "You know, he loved you.

He finally got his life together the way he always hoped for, with you up on the mountain, and then, well. He didn't want to lose it."

"If you're trying to make me feel better," I said before the tears rose again.

"Hey, Maggie," Rich said, smiling at me. "You haven't answered my question. What would Mike say?"

I blew my nose. "He'd say, you know what you have to do."

"Well then?"

"Guess that's what I need to do."

He took my arm as we walked out. He said, grinning, "I'll light a candle and pray for you."

I stopped short, looked up at him, reminded of something someone said. It took me a second to remember who.

"Light a candle?" I said. "I didn't know you went to church, Rich."

"I don't." He shrugged. "I don't know why I said that. Bad attempt at humor, I guess."

"Sometimes Mike would say the same thing." I turned and headed back toward his desk. "I need to look at something."

The three enlargements were still on Rich's desk. I spread them out and looked at each in turn, saw what I had not picked up on before. With Rich peering over my shoulder, I touched one face in each picture.

"See?" I asked.

"I do. What about it?"

I fished in my bag for the little leather holder where I stash business cards people give me. I sorted through them, found the card I wanted, and handed it to Rich.

"Can you bring him in for questioning? But bring him here. Not Parker Center."

"I can invite him in." Rich was puzzling through the request. "But will you tell me why?"

I did.

— *19* —

"G OD BLESS the federal bureaucracy," Fergie greeted me. "Nice dress, by the way."

"Why the burst of patriotism?" I asked.

"Well, even though that Mr. Pendergast in the Sonoma VA place is really happy to accept you as Oscar's legal guardian, the feds say you have to go to court to do that. Just because you say you're willing to take responsibility for someone who is incompetent to take care of himself doesn't mean you get to do it. Mike had to go to court to get himself appointed as Oscar's legal guardian, but he was Oscar's son, so it wasn't very difficult. But you," she did a little pirouette, "even though you were married to the guardian, Mike, you are nothing to Oscar. You can't just claim him because you say so. Hell, you might just go spend all of his money if they let just anyone off the street claim an old person."

"I have to go to court if I want to move Oscar?" I repeated this bit of news just because it felt so good to say it.

"Exactly," she said. "You have to go to court."

"And if I don't?"

"By default, Oscar is right now the legal ward of the VA. Unless or until a responsible blood relative or other interested party goes to court and claims him, he jumps the wait-list queue and goes straight to a facility that can take better care of him. Does not stop, proceeds straight to Go. He'll be moved by the end of the week."

"Hallelujah."

"I told you," she said. "God bless the fucking bureaucracy."

"Any other good news?"

"Good news?" she said. "Yes. Your rental car will be in your driveway in the morning."

"How will it get there?"

"I called the network travel office and they'll send it over."

"Bless you," I said. "Have you seen Guido?"

"No, but he called to say he's down in an editing bay if you want to talk to him."

"Thank you very much."

I went downstairs in search of Guido, found him where he said he would be, with that certain quite attractive graduate student leaning over his shoulder while he showed her the video footage shot at the cemetery that morning.

"Look at this," he said, enlarging a sequence to point out something. "See how Savoie used the light here? This face looks naked, open and vulnerable." He ran forward a few frames. "And here, the lady turned very slightly, leaving half her face in shadow. Now she's secretive, guarded."

Guido had a personal thing developing and I didn't want to interrupt. Without saying anything, I turned away from the door and started back down the hall.

"Maggie?" He apparently had heard me, excused himself from the acolyte, and followed me. "Did you need something?"

"Just came to see how things are going. I'll call you later."

He walked alongside me. "Everything okay?"

"Everything's falling into place."

"Uh, you sure?"

I thumped him on the back. "Absolutely."

Back in my office, I opened the bottom drawer of my filing cabinet and took out the jeans, sweatshirt, and sneakers that I keep there. With the door closed I changed out of that particular gray dress, hung it on a coat hook, consigned the high heels to the same file drawer, and, comfortable again, sat at my desk to check messages. Lana wanted to talk about progress on the project; she would be back from New York in the morning. I had my assistant call her assistant, as is the protocol, to make an appointment for the next afternoon.

Michael was still up at the cottage; his fiancée had joined him. I shared the news about Oscar with him.

"I'm relieved," he said. He had only two more days of leave coming before he had to return to his unit in Afghanistan. "I really didn't want to leave you to deal with Granddad by yourself."

We talked for a few minutes about what was going to happen

to the cottage now that Mike was gone. The place was Mike's baby. He had worked very hard to transform it from a summer shack to a tight, beautiful home; redwoods for a backyard, Pacific Ocean for a front yard. Michael offered to buy it from me if I ever decided to sell. I had no intention of selling the cottage, but I let Michael know that the house was in a living trust and he was listed as the survivor trustee after me. Title would pass directly to him if, when, anything happened to me.

After I said good-bye, I asked Fergie to make an appointment with my lawyer.

Guido came up to deliver a copy of the disc with the day's footage. He said he was going home to go to bed early, it had been a very long day. I didn't ask him if he was going home alone, but the intern, Madison, whose cinematography lesson I had interrupted earlier that afternoon was hovering in my outer office just then, waiting for him. I gave him a hug and thanked him for his many kindnesses, and then, glancing at the intern, wished him good luck. He had the grace to blush.

Alone, I turned on some music, upbeat vintage Paul Simon headed for Graceland, and slipped the cemetery disc into my computer, routed the image to a large flat-screen monitor and let it run in the background while I made notes about the day and my recollections of the conversation with Rich.

Every few minutes I glanced up at the screen and watched for a moment or two, but I wasn't paying close attention. When the disc finished I started it over and let it play again. The second time I watched closely.

The cameraman, Paul Savoie, was a craftsman. As Guido had explained to his protégée, Savoie skillfully used the morning light, the long shadows, to create atmosphere. He captured the contrast of the still cemetery with the buzz of traffic outside the fence, new graves of the very young with the gaudy and crumbling mausoleums of the founding families, the nearby single-story storefronts covered in bright Mexican-motif murals with the towering *éminence grise* of the downtown skyline in the distance. Good stuff. He shunned cheap emotionalism, found compassion. I wrote him a note to tell him how wonderful I thought his work was. I also told him that if I ever decided to take over the world I would hire

him as my chief of propaganda. In the wrong hands his level of skill at manipulating images in our media-driven world could be dangerous.

The day had begun early and I was ready for it to end. I couldn't leave for home until six when the security patrol's shift would change and another Crown Vic and two fresh sprigs of the law would replace the pair who had followed me around all day.

Rich called. "I asked your guy the questions you posed, and he answered them. He was pretty upset when he left here."

"He left? How could you let him go?"

"Maggie, he's a sworn police officer. To hold him, I need that little thing the courts keep harping about. You know, probable cause. I don't have, you don't have, probable cause."

"He might get hurt."

"He's a big boy," Rich said. "And he has a big gun on his hip and probably a little one strapped to his leg and the experience to know how and when to use them."

Rich gave me the answers to the questions I asked him to pose. When he finished, he said, "I've already called Nick Pietro and given him this information, just in case you forgot to."

"Thanks, Rich. I appreciate the help."

"Watch six," he said before he said good-bye.

Fergie appeared at the office door. "Reception called. There's a guy here to see you."

"Let me guess, Lewis Banks."

"No. Nick Pietro."

"Thanks, I'll go get him."

On my way out, I told her she should go home.

I found Nick downstairs in the lobby looking at a glass case full of awards. There was every sort of award represented, from Emmys to baseball trophies; our coed softball team had kept Fox from getting the TV League championship six years in a row. We liked to credit the team manager's elaborately ornamented logo baseball caps for the winning streak, which made the opposition feel underdressed.

"Any of these yours?" Nick asked when I walked up beside him.

"Not unless my pie baking trophy is still in there," I said. "My producer keeps all the real gelt we haul in up in her office."

He looked at me, doubtful. "You bake?"

"Mine was the only entry. So, what brings you here tonight?"

"Couple of things."

"Want to get a bite to eat?" I asked. "Cup of coffee? You look like you could use something."

"Okay. Sure."

I walked him out across the midway toward the commissary.

"What's the first thing?" I asked as we walked.

"That .38 you took off Nelda Ruiz?"

I waited for it.

"Well, Scientific Services ran the ballistics, as is the routine, and got a hit. It was reported stolen from a sporting goods store in the Valley about a dozen, thirteen years ago." He paused, for effect I thought, to build some suspense. "It's the gun that killed Officer Tom Medina six years ago."

"How did Nelda get it?"

"Wouldn't we all like to know that?"

We puzzled the question over for a while and got a pocketful of supposition, but the only concrete conclusion we could come to was that during her short life, Nelda chose to walk a treacherous path.

"That's one thing," I said. "You said a couple of things."

"This morning at your house, you told us there was no key guy behind that string of drug-related cop crimes you said Mike looked into." He opened the outer door for me. "Then just a few hours later you hand Rich Longshore the key guy. What's that all about?"

"I think I said 'catalyst' when I talked with Rich, not key guy in the sense you implied this morning. Not the linchpin," I said. "This morning I didn't have enough pieces of the puzzle to see the big picture."

We walked into the commissary and I handed Nick a tray from the stack beside the steam table.

I told him, "Rich said something to me that made one great big puzzle piece fall into place."

"What did he say?" Nick chose a plate of meatloaf and mashed potatoes, piled on a heaping serving of green beans, and ladled brown gravy over all of it.

"He said he would light a candle and say a prayer for me." I went for hot dogs, two of them, and loaded them: mustard, relish, onions, tomatoes, cheese.

Nick set down his tray rather hard, turned, and looked at me; puzzlement on his face.

I said, "Mike had a file labeled 'Obits and Pallbearers,' right?"

"Yeah." Arms folded now, a barrier, a challenge.

"I was looking at the pallbearers when I should have paid more attention to the funerals." When he held up his hands in a so-what? gesture, I said, "The same minister officiated at all of them. Not the police chaplain, but a street officer who was also an ordained minister. Lewis Banks told me that man, that preacher cop, put together a prayer group for officers who were struggling with the pressures and conflicts of the those ugly post–Rodney King years."

Nick began to see the light, nodded. "I know who you're talking about."

I continued. "Banks said the group was good at first, helpful to him, but he got uncomfortable after a while because some of the guys in the group became, in his words, 'pretty hardcore.' Lewis went back to his own church."

"Ha! The *eureka* moment." He looked at me. "I get it. 'Pray for you.'"

"That's it," I said. "You see how the well-trained investigative mind works?"

He picked up his tray again. "A hellfire-and-brimstone preacher talking about rooting out the devil among us, cops feeling they were under siege, shackled by outsiders who didn't understand what they were up against, shackles that kept them from protecting their community; a catalyst."

"Where is the guy?" I asked.

"The preacher? He's still on the job."

"Where is Lewis Banks?" I asked.

"Getting loaded for all I know."

"Nick?"

"Can't find him." Nick wouldn't look at me. "He didn't report in to Central, and his cell phone says his line is 'engaged.' But don't worry. We came up with a plan. Your neighbor guy, Drummond, says he'll drive you home."

After Nick left, I dropped by Studio 8 to check with Early. His producer, Ida, accosted me as I walked past her office, did a body block across her studio door to keep me out.

"You can't have him," she intoned in her distinctive croak, a sound that seemed to come from some cavern deep within her nasal sinuses. "Every time I go looking for Early lately he's off somewhere fooling around with you guys. He was taping an interview with the governor this morning and we got cops traipsing in and out of the studio, disrupting things. The governor, for godsake."

She slammed her clipboard against the door. "MacGowen, it's got to stop."

"Hi, Ida," I said, normal tone and volume. "May I speak with Early?"

She rolled her eyes before she pinned me with a glare and moved away from the door. "He's in the studio. For once."

I apologized to Early for any grief Ida was giving him. He suggested that we invite Ida along on a field shoot sometime, share the fun, make her happy. Early told me the cops had indeed come to call on him a couple of times about the break-ins. And that he had agreed to drive me home after the six o'clock news went up. I told him to call when he was ready to go, I'd be in my office.

A few minutes after seven he called to say he would meet me in the lobby. I logged off the computer, gathered my things: dress, heels, notes, discs, laptop, camera. The dress I draped over an arm, threaded my fingers through the shoes' sling-back straps, packed everything else into the tote, turned off the lights, locked the door, and took the elevator down to meet Early.

"How did the interview go with the governor?" I asked as we crossed the parking lot.

He laughed. "I tape him, I don't listen to him. Especially I don't listen when the topic is California education reform because you and I both know that next year he'll have a completely different plan, and the system will continue to limp along underfunded, unfocused, and unable to service the actual needs of our kids. All I know is that the kids deserve better."

"Spoken like a schoolteacher's son," I said, chuckling. If Early had ever met my father I would have accused him of mimicking

my dad when he made that speech; Early's mom and my dad had both been college professors. But as he talked, I looked at him closely; Early was always surprising me.

Before we got into Early's car, we alerted the tail that we were on the move, headed into Malibu Canyon and home. Early made sure the men in the follow car had full directions, in case we got separated.

Rush hour was long over, but that does not guarantee an easy drive through the Valley, ever. A fender bender, a median-wall repair, a repaving project, different presentations of the usual possibilities slowed us from time to time. But we got off the freeway and into the quiet of Malibu Canyon unscathed, for which I am grateful every time it happens.

There was only the smallest crescent of a waxing moon. Early's headlights and the lights of the tail car lit Mulholland Highway when we made the turn. Twice, as we came around curves, our beams reflected off the eyes of creatures lurking at the side of the road, yellow bulbs against the black of the brush.

Early handed me a clicker.

"What's this?"

"You can trigger the outside lights now from anywhere inside the house," he said. "If you hear anything, push the green button; you'll light up like a roman candle."

"Duke won't love that," I said.

"That's the point." He laughed softly in the dark. "So far, Duke's the best alarm system we have. But, just so we don't overly agitate the old boy, the clicker can disable the automatic lights if you know it's just a coyote or a deer looking for your trashcan. But if you ever get scared or need help, flip the lights on and off a couple of times. Even if I don't see the lights, I'll certainly hear the horses."

"Thank you, Early," I said, fighting back tears again. "This is a tremendous comfort."

When we came around the last hairpin curve before our houses, Early flipped off his headlights as a courtesy to Duke's sensitivities, and as he approached his driveway he tapped the new clicker to block the yard lights from popping on. Our tail car continued past Early's driveway and went up my driveway next door. I wondered who instructed them to do that, or how they knew to do that, but

so far police security had been very thorough. Probably one of the policemen who had spoken to Early during the governor's interview had asked him about the lay of the place.

No one told the tail about Duke's issues with headlights, however, so when they drove up my driveway their lights sent Duke into full rant mode, and he set off his two buddies.

As we gathered our things from Early's backseat, our guards came over to introduce themselves. They were both very athletic-looking, keen-eyed young men. Confident, cocky.

"My partner and I want to secure the premises before you go inside, ma'am," I was informed. "So, if you'll please give me the house keys and wait right here with Mr. Drummond and my partner, I'll go inside and have a look around. When we're secure inside, my partner will secure the perimeter."

While we waited, Early and I walked over to the corral to calm Duke, Rover, and Red. Carrots and muzzle-scratching quieted them. Red and Rover strolled away for a drink of water, but Duke stayed at the rail as long as we were there, his eyes bright and trained on the policeman behind us, his ears straight up and on the alert.

Early turned to me as he stroked Duke. "You've been playing different music lately. More classical pieces."

"It's my stuff. Mike preferred jazz," I said. "The house is so quiet now, I like to have some sound for company. I hope it's not too loud."

"No, it's fine. I like it," he said. "The thing is, I have season tickets for the LA Philharmonic. I always go on Sunday afternoons, have an early dinner afterward, make a day of it. The program this Sunday is Sibelius, Debussy, and Mahler, and I thought it was a program you might enjoy."

"Early," I said, looking into his face, "thank you for asking me, but it's just too soon for me to think about..." I could hardly say the word: "Dating."

"Call it what you want to. I'd call it friends out to the symphony and dinner, but suit yourself."

I thought over his invitation for a moment. It was too dark to read his expression, but his posture and his voice were comfortable, no nervous-suitor edge there. And he was good company.

I said, "Thank you. I would love to join you. What's the dress code?"

"I manage to get myself into a suit and tie. Something like the dress you wore today would be fine."

"I'm burying this dress," I said, pushing it over my shoulder. "But by Sunday I think I'll be able to find something appropriate."

While our man kept a watchful lookout outside, staying a respectful distance from us, the other searched inside. We followed his progress from room to room, upstairs and down, by watching lights go on and off.

Early told me he tries a new restaurant every time he goes to the symphony. We compared favorite places and shared some duds.

I said, "You've taken care of the tickets. I'd like to take care of dinner."

"Sounds fair," he said.

I said I'd do some research and make reservations, surprise him. He thought that was a fine idea.

The inside man came out the front door and down the steps. We walked up to the house to meet him. My tote bag was heavy, with a laptop, notepads, files and a camera inside. So, while we talked, I set it down on a lower step, draped the gray dress over it, and set the heels on the top.

"Looks all clear," the officer said. He asked Early about the yard lights. Then we went inside with him to test the new remote that could, theoretically, turn the lights on or off from inside the house.

The outside man began his rounds of the perimeter.

"Don't you get frightened up here, ma'am?" the officer asked. "You're pretty isolated. The property is so extensive, and there are so many potential places where the property can be entered, I think you should think about a good alarm system. And some better locks. I understand an intruder jimmied a patio door and came in."

I told him I would look into an alarm system. I didn't say that until now I never thought one was necessary. He made certain that the light sensors worked and handed me the clicker.

He wrote a number on the back of a card and handed it to me. "My cell is on. Any concerns, call. As soon as I see you're locked

in here, I'll move the car further down the drive, outside the light-sensor zone. We can see the house, you can see us. We can all see if an intruder approaches because the place will light up."

Sounded reasonable to me. I did not feel that there was imminent danger, but if my burglar, who so far had been less than efficient, made a drive-by I believed the presence of my watch cops down near the road would be sufficient deterrence and he would just, as Mike would say, keep to steppin'.

The policeman said good-night and reminded me to check all the doors and windows in case he had missed something, and then he went outside to rejoin his partner.

Early walked through the house with me, making certain that all the doors and windows were locked. When we had made the circuit, he checked the clicker a last time, walked with me to the back door, and waited to make sure I had bolted the door behind him; someone had installed a new bolt, probably Early. When the lock clicked in place, he waved and started toward his own house. But something seemed to occur to him and he hurried back.

"What time do you need to go in tomorrow?" he asked through the glass. "I need to be at the studio by noon."

"Thanks, but I'll have a car."

He nodded and waved again. "See you tomorrow."

I walked through to the front of the house, feeling more spooked because of all the fuss about security than I ever had when all I had to rely on were my own ears and instincts, and Duke. And Mike. It occurred to me that I had not lived alone since I was a very young woman, by choice. I felt a moment of panic, and then a flash of anger. This was not the way Mike and I had planned for things to be. What happened to "Grow old along with me"?

I took a deep breath and reminded myself that I was not entirely alone. Through the front window I could see that the two officers had moved their car down the driveway and parked, apparently, outside the "zone." I thought I could discern that someone was inside the car, but I couldn't be certain; lights and shadows play tricks. I wondered if I should have offered them the use of the bathroom before they settled in for a long vigil, and considered calling them and making that offer, but they were pros, certainly equipped to handle their own needs. And I was reminded of my

mother's words when we went hiking in the redwoods: they could pee in the woods like the bears.

I saw the glow of Early's living room lights illuminate his deck and knew he was inside, close by. The horses were snuffling around as usual. Coyotes howled in the canyon. Night sounds settled in.

It was too early to go to bed, to try to sleep. I went to the kitchen and poured a glass of wine from a previously opened bottle, went into the living room and turned on the television. I watched most of one rerun episode of "Law & Order", flipped channels, decided there was nothing I wanted to watch.

I was restless, probably the adrenaline reaction that roadside lothario of a doctor had mentioned the day before. I certainly was muscle-sore, as he predicted.

The remedy I chose was a long soak in a hot tub with some music playing, a second glass of wine, and a book. Replenished glass in hand, I crossed the living room to pick up my bag. But the bag wasn't in its usual dumping spot just inside the front door. Then I remembered that I had left it outside on the steps.

Grousing under my breath, I unlocked the door, flipped on the stair lights and, leaving the front door wide open, went out to get my bag off the steps. I waved at the car in case my men were inside, to let them know I was fine. If they waved back I could not see it. I couldn't see either of them.

I clattered down the wooden steps, picked up the high heels, slung the dress around my neck, but as I bent to grab the handles of the tote bag, the dress slithered off my neck and down a few steps before coming to rest against the base of the rail support. Probably I swore as I walked down to retrieve it. Stooping awkwardly, shoes and bag held by the same hand behind my back so that I didn't let any part of me past the bottom step to set off the yard lights, and thence Duke, I reached out for the dress.

A gloved hand came around from the dark beneath the stairs, gripped my wrist and pulled me off balance. I caught my fall by wrapping the arm holding the bag around the far stair rail. It was stupid to keep hold of the bag, but my first thought was, Don't break the laptop and the camera. My second thought was more practical as the shape of the man still gripping my wrist emerged up from the dark and reached for a more substantial hold on me.

I made the best windup I could and clocked him with the bag. The blow didn't fell him but it surprised him enough that he relaxed his grip enough for me to jerk free. I knew I couldn't get up the steps and away from him and into the house safely; he was bigger, he was better built, and he was doubtless faster. And I did not want to risk being dragged into the house and behind locked doors.

I was frightened, surprised, but not panicked because I expected the dome lights in the police car to pop on as my protectors flung themselves out of their car, or for two hunks of manhood to come barreling from wherever they had been lurking. But when I glanced toward the car I saw it was still dark. I thought I saw a dark shape in the front seat and swore, thinking that if it were a man and not a trick of light and shadow, that he was sleeping. Whatever, whoever, if, the darkness behind the windshield did not move.

Duke pawed the dirt and whinnied loudly to express his distress. Hearing him, I knew immediately where to go. Instead of running up the stairs, I jumped down, hit the ground hard and ran toward the corral. I triggered the sensors and suddenly the yard was flooded with bright, silver light.

Just steps before I reached the corral I felt my pursuer fluff the air behind me as he lunged to grab me. I dove for the ground, rolled under the bottom iron rail of the corral, and came up in a crouch on the far side of Duke. Duke nuzzled me hard enough to roll me over; I saw the rage in the old horse's eyes. His agitation had set off Rover and Red.

Rover charged across the corral and butted Duke's rump with her head, hard, as if they were conspiring together, pumping each other up. The heel of my pursuer's shoe clanged on the top bar of the corral as he climbed over, coming after me. Duke pivoted toward the man, reared up on his hind legs, punched the air with his front legs and screamed into the night as he backed the man against the rail. I saw the glint off the barrel of a handgun rise and aim toward Duke's huge belly.

I screamed, "No," picked up the closest object at hand, a five-gallon bucket of water, and flung it at the man. The bucket hit him in the stomach, water exploded up over his face. I think he roared, but maybe it was me. He turned the barrel of the gun in my

direction, but he was off balance, sputtering as runnels of water poured down his face, trying to defend against Duke at the same time he tried to draw a bead on me. I dove forward and body-slammed him into the iron rail, hitting him square in the solar plexus with my shoulder.

I heard his "Oof," as my blow forced the air from his lungs, felt something in my shoulder give. The gun glowed in the yard lights as it flew in an arc, coming to rest beyond his reach. Before I landed on my butt in the soft, churned dirt and muck of the corral, I knew who he was.

I rolled back to my feet looking for the next thing I could throw at him, when Rover turned her capacious rump toward him, rocked her weight forward and shot out her powerful hind legs, dropping him with a mighty jackrabbit kick square to his temple. A horse's iron-shod foot connecting with bone makes a terrible, unforgettable sound.

Harry Young slid into a pathetic, motionless heap.

I skirted the horses, reached under the rail, and retrieved the gun Harry dropped when I hit him, though from his limp and inert posture and the dark stream spilling from his head into the dirt I knew he wouldn't be fighting me for it anytime soon. My concern at that moment was the cops. Where were they? Who were they? And whose friends were they?

Friends, I thought, a clique, a set, or a gang. In December of 1998, some young patrolmen, bolstered perhaps by righteous fury after a prayer meeting, decided to take out the boogey man, Rogelio Higgins, a Christmas present for the community. Of those men, one was in prison—he got carried away with possibilities at some point, before or after—three were dead young, and perhaps Harry would be the fourth to perish. Among the men Mike identified, only Lewis Banks was left, though there could be others. I half expected Banks to come walking out through the trees, guns blazing. Where the hell was he? And where were my cops?

Rover and Duke pawed the dirt around Harry's motionless form. Red came over and gave Harry's middle a push with his nose as if trying to roll him under the rail and out of his corral, away from Red's friends.

I took a handful of Red's mane and pulled him away from Harry,

but I stayed inside the corral with the horses, in the shadows, my back against the tack shed, holding Harry's gun, a powerful Beretta, raised with both shaking hands as I searched the dark beyond the ring of light for some sign of movement, some glint of lights off metal.

The horses were still agitated, pacing in tight circles around me to work off their excess steam. I thought Rover was gloating over her take-down. She went over again to nuzzle Harry's shoulder, just to humiliate him, I thought. I wondered what she would do to Harry if he had happened to fall completely inside the corral where she could use her hooves on him again.

Though it seemed to last an infinity, the struggle with Harry from beginning to end probably lasted no more than a minute. Certainly not as long as two.

I heard Early's front door slam shut and heard him come down his front steps. I turned and saw him running toward the corral.

I called to him. "Early, take cover."

"Maggie, where are you?"

"In the corral."

He came through the trees instead of walking through the open. As he got his first leg over the top rail he caught sight of Harry and paused in mid-movement. Early carried a huge six-cell steel-case Kel-Lite flashlight, the sort that the police aren't supposed to use anymore because they make deadly cudgels; the consent decree said so. I remembered that Harry had carried a Kel-Lite on patrol. When Harry had shone that light into the fenced yard where Nelda was selling drugs, was he warning her away, or locating her for himself?

Early shot the light onto Harry. "What the hell? Who?"

"Sergeant Harry Young. But I don't know where the others are."

Early climbed the rest of the way over the rail, patting and pushing the horses out of his way, but they stuck close to him, nudging him, competitive. They seemed to demand his reassurance or his praise. Who knows? Whatever their itch, they were certainly demanding something from him.

Early made his way toward me. Slowly, he raised a hand and then lowered it a little as if to ask me to turn down the volume. "Could you lower the gun, please?"

"Sorry." I slipped on the safety and held the gun down to my side.

"Do you still have the phone number the cop gave you?" he asked.

I pulled the card out of my pocket and gave it to Early. He took his cell phone from the case on his belt and dialed the number. We heard a phone ring inside the dark car. Early flipped on his big flashlight again and aimed it at the car's windshield.

The inside of the car was suddenly illuminated, giving a clear view of the head and shoulders of the officer who had searched the inside of the house, the man whose name we had not asked for. I took the card from Early and turned it over. Sgt. Ronald Kalunian worked patrol out of Pacific Division. I hoped he wasn't married with a houseful of small children, because the funny angle of his neck made me think he wasn't going home again.

Early was already dialing 911. He asked for the sheriff, and for the paramedics to come up from the fire station on Cornell Road just below Mulholland. "Officer down," he said first. Then he told the dispatcher that a second man had been kicked in the head by a horse, that he was breathing, but he wasn't moving. And a third, the second policeman, was unaccounted for.

There was a stack of freshly laundered white towels in the feed shed that were used for wiping down the horses. I grabbed several, gingerly lifted Harry's head enough to slip a couple underneath, and tried to stanch the flow of blood with another. I was afraid to move him. The kick could easily have broken his neck, among other damages. I wrapped a third towel over the compress as best I could and tucked in the ends tightly to keep pressure on the wound, and hoped that the paramedics arrived quickly. I knew from experience that the sheriff would take a while to come up from Malibu, but the paramedics were at the fire station just down the road.

Harry was breathing regularly, his pupils were equal size and responded to light, but no one was home to answer when I pinched him. There was nothing more we could do for him except keep the horses away from him.

Early and I walked slowly over closer to the Crown Vic. There wasn't much doubt in my mind what we would find, but in case

there was something we could do for Sgt. Kalunian, we had to check. Early, still on the telephone with the 911 dispatcher, was close beside me. From a distance of about six feet he flashed his light through the windshield again. Kalunian sat upright in the front seat, facing forward, and it was clear that he was beyond help. Whatever Harry did to him had been quick and apparently bloodless, if not painless. A garrote from behind? That would be a question for the cops and the coroner.

I had just said, "Where is the other man?" when we heard a groan coming from the shrubbery on the far side of the driveway. We found the second officer lying in a heap, his fly open, the front of his trousers damp. Harry had apparently caught him in the act of relieving himself, probably had waited until he was away from his partner and vulnerable. There was an ugly knot growing out of his temple, but he was beginning to come around. I knew better than to move him; the 911 operator told Early that the paramedics were on their way.

"We should probably go out where we can flag down the paramedics," I said.

We touched nothing near the car, and retraced our steps back to the corral. I unlatched the door of the tack shed again, went in and set Harry's Beretta atop a bale of alfalfa hay, and while I was there, to quiet Duke, Red and Rover, I took some carrots out of the bag. We fed the carrots to the horses to distract them, and then stood beside the corral, leaning against the rails, waiting. The horses leaned their muzzles over the rail, too, and stood beside us as if waiting as well for the paramedics to come up our canyon.

"He hurt you at all?" Early asked me.

"No. He surprised me."

"It's okay for you to cry," he said. "Perfectly understandable if you do. This has all been pretty traumatic."

"I think I'm okay. How are you?"

"I think I'd feel a little better if you would sort of break down here. Let me see your eyes." He took my chin and angled my face into the light. "You're in shock."

I turned and looked at him. "Now, how do you suppose that happened?"

"Let's just stay quiet a minute. It'll hit you in time. If you think you're going to pass out..."

"I'm okay, Early." I looked up into the trees to avoid seeing the outline of the man in the car. Even if I couldn't make out the details of his distorted face from where I stood, I knew what he looked like. I would never forget it.

After a moment, Early said, "Want to take the horses for a ride first thing tomorrow morning?"

"Good idea," I said. "I owe at least that to Duke and Rover."

Duke perked his ears as flashing lights poured around the hairpin turn, but he was too busy getting a drink of water to bother kicking up a fuss.

— 20 —

THEY ARRIVED together bearing gifts, like the three Magi. Eldon, Kenny, and Nick, each with a wife, and each with a party offering: several bottles of a nice Chilean pinot, a huge homemade chocolate cake, and a big bowl of guacamole made from avocados that grew on the Pietros' backyard tree.

When they arrived, Lana was lounging on a patio chaise with a scotch, her party offering, in her manicured hand while she kibitzed with Early and Guido about how they should cook the huge fresh salmon my mother had iced and express-shipped down from Humboldt; she had been staying at the cottage with her old friend, Jane Jakobsen. Jane, despite her best efforts not to, had landed the fish on a deep sea fishing trip two days before.

Guido's graduate student, a new one, was in the kitchen with Fergie chopping fruit, onions, fresh herbs and peppers for a mango-papaya salsa, the recipe for which Fergie had cut out of a magazine she found in the dermatologist's waiting room. Golda, Fergie's partner, was pouring margaritas out of the blender into huge frosted, salt-rimmed glasses.

I did what I do best, chop garlic and melt butter. Upon Guido's instructions, I also sliced a dozen lemons and a dozen limes into wheels and chopped a mound of fresh cilantro, basil and oregano to season the fish.

Julia and Mayra brought tiny potato tacos and spicy red pepper sauce for the hors d'oeuvres, a specialty of Michoacán, their parents' home state in Mexico. My daughter, Casey, and her roommate, Zia, brought their appetites and plenty of youthful energy, and two bags full of dirty clothes. Our soundman, Craig Hendricks, and his wife, Carol, showed up with a chafing dish full of Brazilian-style rice and red beans. Our cinematography guru, Paul Savoie, carried an amazing-looking chilled, grilled vegetable

platter that his wife, Janis, had prepared. Ida had the commissary make a pot of chili for her contribution.

I asked Ida where Cavanaugh and the rest of her news staff were and she told me someone had to put on the news; they'd be arriving late. Besides, she said, reaching for her first margarita, too much fun wasn't good for them.

Phil Rascon brought a woman that he met at Scientific Services the day he took Guido and company there, and a pair of home-made flans for dessert.

I saw Lewis Banks hesitate before he knocked on the door. After a short argument with his wife, she nudged him and he knocked. I gave him a hug: sometimes that inner voice lies. I was very wrong about him. Lewis had been hovering around me, certainly, but he had been watching over me, afraid for me, knowing what might come of my snooping around about certain people. He did not know precisely who had killed Rogelio Higgins, but for a long time he suspected it was one or more of the men from the peace officers' prayer circle he had once belonged to, a group that included Rod Pearson and all of his pallbearers.

Lewis had told me that at their meetings they discussed the disparities between God's laws and divine retribution, and man's laws and civil justice, and their obligations as servants of the community to protect those who could not protect themselves. Rogelio Higgins was a frequent topic because he seemed immune to both sets of laws, and he was a menace. When Higgins was murdered, some of the group openly asked if any one of them shot him. Pearson was the first to speak out, to demand that the shooter confess, to save himself. And Pearson was the first to die. Could have been an accident, or the hand of God, they said. In any case, the group disbanded.

Over the years, Lewis kept his eye on the men from his prayer circle as one by one three died, always the apparent victims of happenstance, until there were only himself, Boni, and Harry left. Whenever Lewis had doubts about what actually might have happened to the others, he would blame Boni and his criminal connections. Never Harry.

He began to change his mind about Harry when my house was

broken into. When my car was tampered with, he knew because except for Boni, there were only the two of them left.

Later, I asked Lewis why he hadn't warned me, or his department, sooner, when he first suspected. He said, "I knew you would be okay. Harry would never hurt you."

And then he said, shaking his head, "Maggie, if you had just kept looking for Jesús and stayed away from Rogelio Higgins, none of this stuff would have happened."

I told him I found Jesús early on, not the body maybe, but I knew his fate. Jesús wouldn't be dead if Rogelio Higgins hadn't been murdered by someone in Harry's prayer circle. The two deaths could not be separated.

In the end, it was the call from Rich to Lewis that set Harry's final act into motion. After his conversation with Rich, Lewis called his old friend Harry. He told him the gig was up, that he had to turn himself in before someone else got hurt. Specifically, me.

In response, Harry did what Harry always did. He took control of the problem, his way. Except, things didn't come out as he planned.

About that, Mike would have said, "God save us from getting what we wish for."

Lewis still believed that Harry must have gone over the edge, desperate to protect himself from going down for the Higgins murder, a murder he still thought was righteous. Nelda's as well, though there was no evidence that he had anything to do with her death; Nelda had many enemies. Above all, Harry was desperate to shield the family that came to him so late in life.

Lewis was now on administrative leave, visiting the department shrink twice a week, trying to work his way back to the reality of the ramifications for so many people when he did not speak out. This evening would be the first time he would see any of his old colleagues since he found out about Harry.

Lewis contributed a basket of empanadas, apparently a specialty of his wife's Salvadoran mother.

The theme of the meal seemed to be *nouvelle* Western Hemisphere, but that was happenstance. I had merely told people to bring what they wanted to bring. Funny how potluck meals seem

WENDY HORNSBY

to pull themselves together, isn't it? Maybe the heat of the day, a midspring Santa Ana episode, had influenced us all to slip into a tropical mood.

The only contretemps happened in the kitchen when Craig Hendricks made a take-over move on Golda's margarita production. But after the first round of both versions of drinks the issues seemed to get resolved when Rich Longshore declared a draw. What one margarita version offered in potency, the other offered in piquancy, he said.

Rich had brought flowers from his garden, bright long-stemmed irises and early tulips that Casey and Zia arranged in various vases and jars, whatever they could find in the cupboards, for the tables.

We ate on the back patio at two long plank tables that Early put together from sawhorses and, well, planks. Candlelight and propane heaters, bright flowers, day fading from the canyon, lots of libations, good and noisy conversation, wonderful food; the salmon was memorable. The entire scene could have been staged for a home-and-garden magazine photo shoot, it was that beautiful.

Guido and Early had set up a huge movie screen on the lawn beyond the patio and plugged in a DVD projector. After dinner, when chocolate cake, flan and coffee were served, and another round of drinks for those who would not be driving cars later, it was time for the big event, the pretext for this gathering, the first more-or-less public showing of our new project.

When Guido and Early signaled that they were ready, I walked over and stood in front of the screen, wineglass in hand because I was going no further than upstairs later. Spoons clinked against glasses, there was some shushing, and then there was an expectant silence.

I said, "Welcome to the grand opening of the Earl E. Drummond Backyard Dinner Theater. First I want to thank all the cooks." Everyone stood and applauded each other. "And the salmon who gave its life that so many could feast." More applause. "And to Early and Guido who took care of the physical arrangements so that we could enjoy this beautiful evening outdoors. And who cooked said fish to perfection."

Guido and Early bowed to their standing ovation.

When all were quiet again, I said, "Most importantly, I want to thank all of you for what you contributed to make our project a singular work. For all of us, this was a very personal endeavor. Your heart, your skills, and your love for Mike Flint, for Jesús Ramón, for film craft, and more importantly, for the truth, are what set this project apart from anything that I have ever been associated with."

They cheered very loudly at that line.

"We are together tonight to examine the events that occurred on a warm January day, a decade ago. On that day, Jesús Ramón climbed into the backseat of Mike Flint's car and seemed to fade into oblivion. We may never know exactly what happened to Jesús, but we have a very good idea. We know how important finding good answers was to Mike. And we certainly know all of the trouble that we stirred up along the way." I heard some of my detective guests say, "Hear, hear," in stentorian tones.

I looked from Guido to Early. "Cue lights." Lights switched off, candles were blown out, leaving only the rosy glow from the propane patio heaters to light the night.

I said, in my best emcee voice, "Ladies and gentlemen, and my friends, may I present, 'In the Guise of Mercy, Detective Mike Flint's Life and Death Search for Jesús Ramón,' a Maggie Mac-Gowen Investigates Production.'"

More nervous about the reception this film would receive, even from this audience, than about anything I had ever made, I walked to the side of the patio and stood between Guido and Early, positioned to watch the faces of our guests.

Applause died down with the first notes of opening music, network graphics appeared, my series logo and signature film clip sequence, production credits—here more hooting when names were recognized—then the title emerged before a diffuse pale gray-green background, music surged and fell, the title faded, footage from Mike's funeral service at the Police Academy accompanied my voice-over.

"In April of this year, Detective Mike Flint, of the Robbery–Homicide Division of the Los Angeles Police Department, cheated

fate, the death by cancer he had been dealt, and chose his own
time to go. Before he left us, Mike made a last request. He wanted
his survivors, one more time, to look into the disappearance of
sixteen-year-old Jesús Ramón.

"Mike's request triggered a wide-ranging, multi-agency re-
examination of a decade-old mystery. In the course of that re-
examination, a deadly network of corrupt cops, street gangs, and
drug dealers was exposed."

And so it unfolded. The video was beautiful, a modern ver-
sion of "To an Athlete Dying Young" times two, a farewell to a boy
lost to the streets and to a detective who wanted to make those
streets safe. It was also a story of two men, Harry Young and Boni
Erquiaga, who were brought down by their own hubris—there
was a ripple around Eldon when I used that word in the narra-
tion—one acting for the greater good and one for personal gain.

We told the story in a straight linear narrative illustrated by
vivid scenes of the city, by day and by night, and through portrait-
like interviews with the people who were involved.

Dinner was wonderful; the drinks were strong and plentiful
and did not stop flowing after the film started. The very biased
audience was enthusiastic as they watched. Catcalls and whistles
punctuated the evening air when a friend or a spouse appeared or
spoke.

Sometimes folks who are unaccustomed to seeing themselves
on a big screen cringe at their appearance. Julia hid her face in
her hands when she saw herself, peeking out between her fingers
the way kids do during the scary parts of horror movies. When
his face filled the screen Nick said, very loud, "Damn, I'm good-
looking." His wife kissed him wetly.

The topic was serious, but the only new element of the film and
the story behind it to this carefully selected audience was seeing
their own influence on the final project. After the initial surprise
of finding themselves writ large, they settled down to watch. They
were especially quiet when some of the more elusive threads were
tied in, or when there were sad or poignant moments. Julia, talk-
ing on camera about her grief, losing her second son and almost
losing her sister, bringing tears to the audience. Mayra, talking

about how determined she had been to make a better life by her own efforts, how she had managed to avoid the gangs and other temptations of the street, and then succumbed to drugs; there was a general air of sympathy. Lewis, publicly confessing his errors.

Bits and pieces made the whole, though there were, and will always be, some blanks. Life is like that.

One day, Boni might come clean to save his immortal soul. If he does, I would only trust a small part of what he might say. I would like for him to apologize for sullying Mike and all of the men and women, their colleagues, who are committed to making this world a safer place.

Guido's student brought him coffee and dessert and somehow laced herself into him as he ate and watched the reactions of the audience. Early and I stood together, good neighbors, good friends; he had begun to date a woman, another neighbor, whom he met on a trail ride. She was expected to arrive as soon as her evening shift at a local hospital was over. I intend to continue to fly solo for a while longer.

A pan shot of the noisy, colorful shopping-day crowds on Broadway fades from the screen. Strains of music fall. Segue to the cool green of the redwood forest behind the cottage Mike loved so dearly, the house where we had hoped to spend our old age. Light filters through towering trees, the sound of crashing surf in the distance.

The coda is a short clip from an interview with Nick. He's packing up the contents of his cluttered desk at Parker Center; headquarters is moving to a new building. His shirt sleeves are rolled up, tie loose. He's looking down when we first see him, contemplative, studying a framed photograph. Then he looks directly into the camera, shakes his head, and smiles wistfully.

"Mike Flint was a legend around this place. A true legend."

Fade to black.

— . —

Wesley Allison

About the Author

Wendy Hornsby is the author of seven previous mysteries, five of them featuring Maggie MacGowen. Hornsby won an Edgar Award for her story "Nine Sons," which appeared in *Sisters in Crime IV*. Her books have won the Grand Prix de littérature policière, and readers' and reviewers' choice awards, as well as nominations for the Prix du Roman d'Adventures and the Anthony Award.

Hornsby lives in Long Beach, California, where she is a professor of history at Long Beach City College. She welcomes visitors and e-mail at www.wendyhornsby.com

MORE MYSTERIES
FROM PERSEVERANCE PRESS
💀 *For the New Golden Age* 💀

JON L. BREEN
Eye of God
ISBN 978-1-880284-89-6

TAFFY CANNON
ROXANNE PRESCOTT SERIES
Guns and Roses
*Agatha and Macavity Award
nominee, Best Novel*
ISBN 978-1-880284-34-6

Blood Matters
ISBN 978-1-880284-86-5

Open Season on Lawyers
ISBN 978-1-880284-51-3

Paradise Lost
ISBN 978-1-880284-80-3

LAURA CRUM
GAIL McCARTHY SERIES
Moonblind
ISBN 978-1-880284-90-2

Chasing Cans
ISBN 978-1-880284-94-0

Going, Gone *(forthcoming)*
ISBN 978-1-880284-98-8

JEANNE M. DAMS
HILDA JOHANSSON SERIES
Crimson Snow
ISBN 978-1-880284-79-7

Indigo Christmas
ISBN 978-1-880284-95-7

KATHY LYNN EMERSON
LADY APPLETON SERIES
**Face Down Below
the Banqueting House**
ISBN 978-1-880284-71-1

**Face Down Beside
St. Anne's Well**
ISBN 978-1-880284-82-7

Face Down O'er the Border
ISBN 978-1-880284-91-9

ELAINE FLINN
MOLLY DOYLE SERIES
Deadly Vintage
ISBN 978-1-880284-87-2

HAL GLATZER
KATY GREEN SERIES
Too Dead To Swing
ISBN 978-1-880284-53-7

A Fugue in Hell's Kitchen
ISBN 978-1-880284-70-4

The Last Full Measure
ISBN 978-1-880284-84-1

PATRICIA GUIVER
DELILAH DOOLITTLE
PET DETECTIVE SERIES
The Beastly Bloodline
ISBN 978-1-880284-69-8

WENDY HORNSBY
MAGGIE MACGOWEN SERIES
In the Guise of Mercy
ISBN 978-1-56474-482-1

NANCY BAKER JACOBS
Flash Point
ISBN 978-1-880284-56-8

DIANA KILLIAN
POETIC DEATH SERIES
Docketful of Poesy
ISBN 978-1-880284-97-1

JANET LAPIERRE
PORT SILVA SERIES
Baby Mine
ISBN 978-1-880284-32-2

Keepers
*Shamus Award nominee,
Best Paperback Original*
ISBN 978-1-880284-44-5

Death Duties
ISBN 978-1-880284-74-2

Family Business
ISBN 978-1-880284-85-8

Run a Crooked Mile
ISBN 978-1-880284-88-9

VALERIE S. MALMONT
TORI MIRACLE SERIES
**Death, Bones, and
Stately Homes**
ISBN 978-1-880284-65-0

DENISE OSBORNE
FENG SHUI SERIES
Evil Intentions
ISBN 978-1-880284-77-3

LEV RAPHAEL
NICK HOFFMAN SERIES
Tropic of Murder
ISBN 978-1-880284-68-1

Hot Rocks
ISBN 978-1-880284-83-4

LORA ROBERTS
BRIDGET MONTROSE SERIES
Another Fine Mess
ISBN 978-1-880284-54-4

SHERLOCK HOLMES SERIES
**The Affair of the
Incognito Tenant**
ISBN 978-1-880284-67-4

REBECCA ROTHENBERG
BOTANICAL SERIES
The Tumbleweed Murders
(completed by Taffy Cannon)
ISBN 978-1-880284-43-8

SHEILA SIMONSON
LATOUCHE COUNTY SERIES
Buffalo Bill's Defunct
ISBN 978-1-880284-96-4

An Old Chaos
ISBN 978-1-880284-99-5

SHELLEY SINGER
JAKE SAMSON &
ROSIE VICENTE SERIES
Royal Flush
ISBN 978-1-880284-33-9

NANCY TESLER
BIOFEEDBACK SERIES
**Slippery Slopes and Other
Deadly Things**
ISBN 978-1-880284-58-2

PENNY WARNER
CONNOR WESTPHAL SERIES
Blind Side
ISBN 978-1-880284-42-1

Silence Is Golden
ISBN 978-1-880284-66-7

ERIC WRIGHT
JOE BARLEY SERIES
**The Kidnapping
of Rosie Dawn**
*Barry Award, Best Paperback
Original. Edgar, Ellis, and
Anthony Award nominee*
ISBN 978-1-880284-40-7

*REFERENCE/
MYSTERY WRITING*

KATHY LYNN EMERSON
**How To Write Killer
Historical Mysteries:
The Art and Adventure of
Sleuthing Through the Past**
*Agatha Award, Best Nonfiction.
Anthony and Macavity Award
nominee.*
ISBN 978-1-880284-92-6

CAROLYN WHEAT
**How To Write Killer Fiction:
The Funhouse of Mystery &
the Roller Coaster of Suspense**
ISBN 978-1-880284-62-9

**Available from your local bookstore or from
Perseverance Press/John Daniel & Co. at (800) 662-8351
or www.danielpublishing.com/perseverance.**